T0059929

PRAISE FOR *TALES FROM LA VIDA*

"This is comic book storytelling at its best. These deftly constructed stories shake us to our core selves, waking us and the world to the sweeping spectrum of Latinx identities and experiences. Mind blowing!"
—KEITH KNIGHT, *THE KNIGHT LIFE* AND *K CHRONICLES*

"You want cutting edge? *Tales from la Vida* showcases the best of the best. This bounty of Latinx talent opens eyes and hearts to the extraordinary possibilities of comic book storytelling!"
—JEFF SMITH, *BONE*

"It's a feat that would perplex even the most dastardly comic villain: how do you disappear 58 million people? Well, incredibly, in American pop culture, when it comes to Latina/o people, something like that has happened. As writers, producers, and directors, our massive community is incredibly underrepresented. But Aldama's masterfully curated collection of Latina/o storytellers is an antidote. The stories show us that our voices are varied, strong, passionate, critical, and creative. In comics today, in film and television tomorrow, this collection is evidence that we are—and always will be—present!"
—ALEX RIVERA, *SLEEP DEALER*

"*Tales from la Vida* gives me *vida*! The sheer volume of testimonies bearing witness to the depth and complexities of being Brown and Latinx, of being an interesting sentient being, of being a *vato*/a nerd, of being a wordsmith and visual creative—and the broad range of intelligence and artistry displayed in these biting comics is mind-bogglingly astonishing, and stands shoulder-to-shoulder with any seminal, canonical anthology of American poetry or prose. We are *gifted* here with double-barreled throwdowns of resistance, rebellion, and love from some of the most genius Latinx (and American!) comics creators in the land— all mitigated by the judicious and generous inimitable scholar-artist himself, the Good Doctor, Frederick Luis Aldama! Vaya!!!"
—TONY MEDINA, *I AM ALFONSO JONES*

"*Tales from la Vida* is an inspiring comics anthology with depth and variance filled with insights and the brilliance of self-determined Latinx expression."
—ELIZABETH LAPENSÉE, AWARD-WINNING DESIGNER, WRITER, AND ARTIST OF INDIGENOUS EXPRESSION IN VIDEOGAMES AND COMICS AS WELL AS COCREATOR OF *DEER WOMAN: A VIGNETTE*

"Aldama's masterfully curated *Tales* showcases to the world the brilliance of our Latinx millennial comics creations where not even the sky is the limit in the dazzling reconstructions of our resplendently myriad ways of life today, yesterday, and tomorrow. Established and up-and-coming Latinx comic book creative talents invite us to join them on their journeys that celebrate the pains and joys of life. This is Latinx comic book storytelling at its best!"
—KATHRYN BLACKMER REYES, DIRECTOR OF CULTURAL HERITAGE CENTER, SAN JOSE STATE KING LIBRARY

"Bracing, harrowing, and touching, *Tales from la Vida* breathes life into the varied ways Latinx creators have been pushed to society's margins. The panoply of comic book voices shows, too, the spectacularness of outsiderness, resonating deeply with me as a gay cartoonist and others of us who've been forced into inhospitable spaces. *Tales* is the real deal. At once heart-wrenching and rapturous, each unique voice powerfully pushes margins into centers. It affirms all of life!"
—HOWARD CRUSE, *STUCK RUBBER BABY*

"Vibrant narrative art by a myriad of Latinx creators breathes life into a dazzling array of stories of alienation, unbelonging, and everyday triumphs that will captivate all readers."
—ANGELA DOMINGUEZ, ALA PURÁ BELPRÉ ILLUSTRATION HONOREE AND AUTHOR OF *STELLA DÍAZ HAS SOMETHING TO SAY* AND *MARIA HAD A LITTLE LLAMA*

"This extraordinary collection is, by turns, piercingly incisive and heartbreakingly personal. The legion of creators Aldama brings together revel in (and on occasion explode and subvert) the graphic narrative form in order to reveal the complicated, manifold experience of being Latinx (Chicano, Quisqueyano, Boricua, Chapín, etc.) in the US. From the dark, beautifully drawn father-son drama by José Cabrera, to Zeke Peña's sun-bleached take on the porous border between past and present, to Liz Mayorga's cheeky, white-on-black windows filled with monsters and history, the stories the creators tell stay with you long after you've turned the last page."
—SABRINA VOURVOULIAS, *INK*

"*Tales from la Vida* does more than entertain: it resists simplistic notions of what it means to be a Latinx in an ever-changing and complex world while wholeheartedly celebrating and embracing individual vision and the entangled 'betwixt' of identity. By collecting in one volume varied representations of the inexhaustible creativity that exists in our communities, Aldama confirms, once and for all, that Latinx comic book creators, and our stories, are here to stay."
—OCTAVIO QUINTANILLA, *IF I GO MISSING*

"*La Vida* is an important, mind-bending, culture-asserting, *gente*-empowering collection of graphic art and literature straight out of the community. This book belongs in the library of anyone interested in comics, art, stories, the barrio, Latinx life, or the human experience. It's a beautiful collection of flashes and stories presented by artists and writers who need to raise their voices—voices we need to hear. I celebrate this book and the spirit of these artists!"
—DANIEL CHACÓN, *THE CHOLO TREE* AND *HOTEL JUÁREZ: STORIES, ROOMS, AND LOOPS*

"A powerful collection that explores the depths of Latinx identity, made more powerful by the medium chosen to present it. Each comic beautifully reflects the anthology's themes and the individuality of the storytellers behind it. *This* is using the medium to its fullest potential."
—ALLY SHWED, EDITOR OF LITTLE RED BIRD PRESS AND AUTHOR OF *SEX BOMB STRIKES AGAIN*

# TALES FROM LA VIDA

## A Latinx Comics Anthology

Edited by
**FREDERICK LUIS ALDAMA**

Mad Creek Books, an imprint of
The Ohio State University Press
Columbus

Copyright © 2018 by The Ohio State University.

All rights reserved.

Mad Creek Books, an imprint of The Ohio State University Press.

Library of Congress Cataloging-in-Publication Data

Names: Aldama, Frederick Luis, 1969– editor.

Title: Tales from la Vida : a Latinx comics anthology / edited by Frederick Luis Aldama.

Other titles: Latinographix: The Ohio State Latinx comics series.

Description: Columbus : Mad Creek Books, an imprint of The Ohio State University Press, [2018] | Series: Latinographix

Identifiers: LCCN 2018014668 | ISBN 9780814254936 (pbk. : alk. paper) | ISBN 0814254934 (pbk. : alk. paper)

Subjects: LCSH: Cartoonists—United States—Biography. | Hispanic Americans—Biography. | American literature—Hispanic American authors—History and criticism. | Comic books, strips, etc.—United States—History and criticism. | Autobiographical comic books, strips, etc.

Classification: LCC PN6725 .T35 2018 | DDC 741.5/97308968073—dc23

LC record available at https://lccn.loc.gov/2018014668

Cover design by Jason "Gonzo" Gonzalez

Text design by Juliet Williams

Type set in Adobe Palatino and Futura

Printed by Pacom in the Republic of Korea

♾ The paper used in this publication meets the minimum requirements of the American National Standard for Information Sciences—Permanence of Paper for Printed Library Materials. ANSI Z39.48-1992.

For Corina Isabel Villena-Aldama—
and all her fellow Gen Latinxs

And in memory of Mark Campos—
one of our great Latinx comic book creators

# CONTENTS

# CONTENTS

CONTENTS

## BENDING TIME, SPACE, AND FORMS

## BODIES THAT MATTER

## POP CULTURA IS NOSOTROS

CONTENTS

# PREFACE

This collection brings together more than eighty of our extraordinary Latinx creators. Their carefully crafted visual-verbal narratives showcase the huge variety of styles and worldviews of today's Latinx comic book creators. Taken together, the creators and their works show the world that when it comes to Latinx comics, there are no limits. As we travel from one story to the next, our hearts and minds wake to the complex ways that Latinxs live within and actively transform our world.

Contributors were asked to reflect upon the most significant moments in their lives, and each section of the book brings together vignettes exploring different facets of Latinx experiences—language (and our names) and Latinx identities; growing up in a racist U.S. society; family, community, and precolonial Latinx myth, lore, and fairytale; identities that don't fall neatly into individual national spaces, ethnicities, and races; repurposing sci-fi, manga, fotonovela, codex, social satire, and the lyric; sense of self as shaped by the body; and recreations of U.S. pop culture.

With pen, ink, and paper (and scanner and computer), the Latinx creators collected herein are actively complicating notions of what it means to be Latinx.

Frederick Luis Aldama

# NEW TONGUES *UNTIED*

Samuel Teer (with Marina Julia), "MIXED"

Amber Padilla, "Wongo-Wongo"

Stephanie Villareal Murray, "A Veces Sueño en Español"

Lila Quintero Weaver, "La Charla"

Carlos "Loso" Pérez, "_____-American"

Alejandro "Jandro" Gamboa (with DT Watson), "What Concerns Me"

Adam Hernandez, "No Time for Titles"

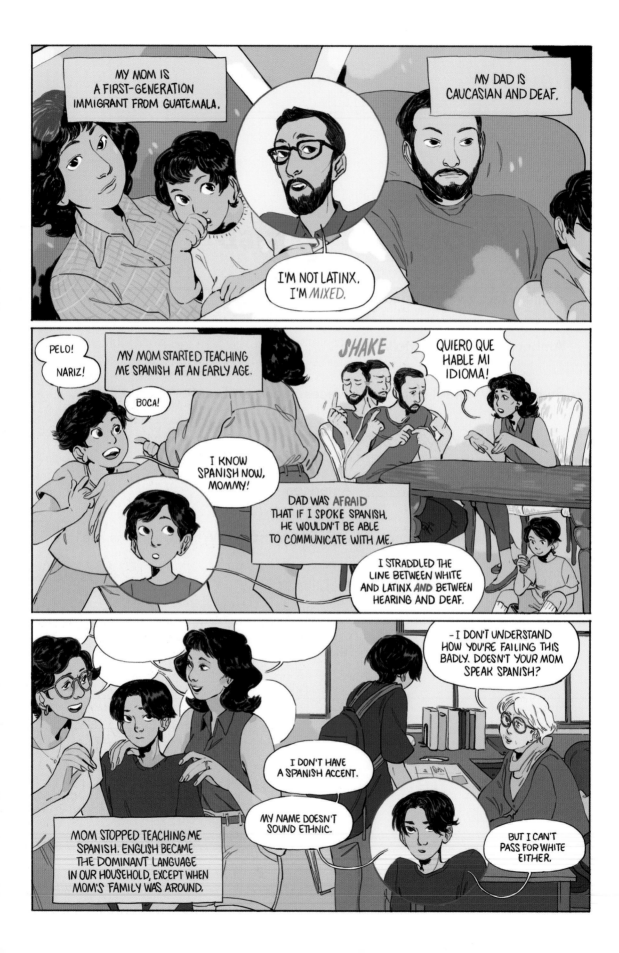

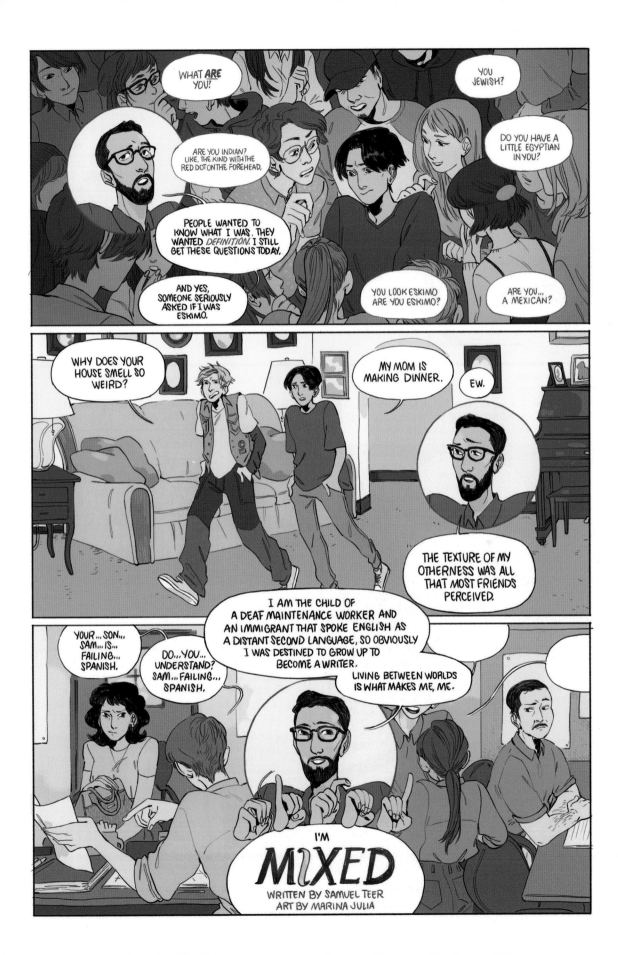

I'M
# MIXED
WRITTEN BY SAMUEL TEER
ART BY MARINA JULIA

# WONGO-WONGO
## BY AMBER PADILLA

I GREW UP IN ORANGE COUNTY, IN A CITY CALLED SANTA ANA.

YOU MAY ALREADY HAVE A PICTURE IN YOUR HEAD OF WHAT ORANGE COUNTY IS ALL ABOUT.

YOU MIGHT THINK ABOUT THE REAL HOUSEWIVES.

YOU MIGHT THINK ABOUT THE MOVIE STARRING JACK BLACK AND COLIN HANKS.

OR MAYBE YOU JUST THINK ABOUT DISNEYLAND.

BUT WHEN I THINK ABOUT IT, I THINK ABOUT SOMETHING SLIGHTLY DIFFERENT. SANTA ANA IS A PREDOMINANTLY LATINO COMMUNITY* AND RARELY RECEIVES THE SAME TYPE OF REPRESENTATION.

10.4% ASIAN

9.3% WHITE

78.8% HISPANICS/LATINOS

*NUMBERS FROM WWW.CI.SANTA-ANA.CA.US/FACTS/

BASICALLY I GREW UP AROUND PEOPLE WHO LOOKED LIKE ME. HOWEVER, THAT DIDN'T HELP MUCH FOR MY SENSE OF BELONGING.

UN SOLO IDIOMA NUNCA ES SUFICIENTE.

SÍ

NO HABLO...

¡HABLEMOS DE ELLA!

ELLA NO LO SABRA.

BEING FIFTH GENERATION MEXICAN-AMERICAN, MY LATINO ROOTS HAD SHRIVELED. INSTEAD, OUR FAMILY POSSESSED A STRONG SENSE OF AMERICANISM THAT HAD BEEN CEMENTED BY THE MANY RELATIVES WHO HAD SERVED IN THE US MILITARY.

I KNEW THAT MY GRANDPARENTS SPOKE SPANISH, BUT BOTH MY PARENTS DID NOT. I ASSOCIATED SPANISH WITH LATINO/HISPANIC IDENTITY. WHO WAS I TO CLAIM THAT I WAS LATINO IF I DID NOT SPEAK SPANISH.

Spanish

THE SECRET TO YOUR CULTURAL IDENTITY

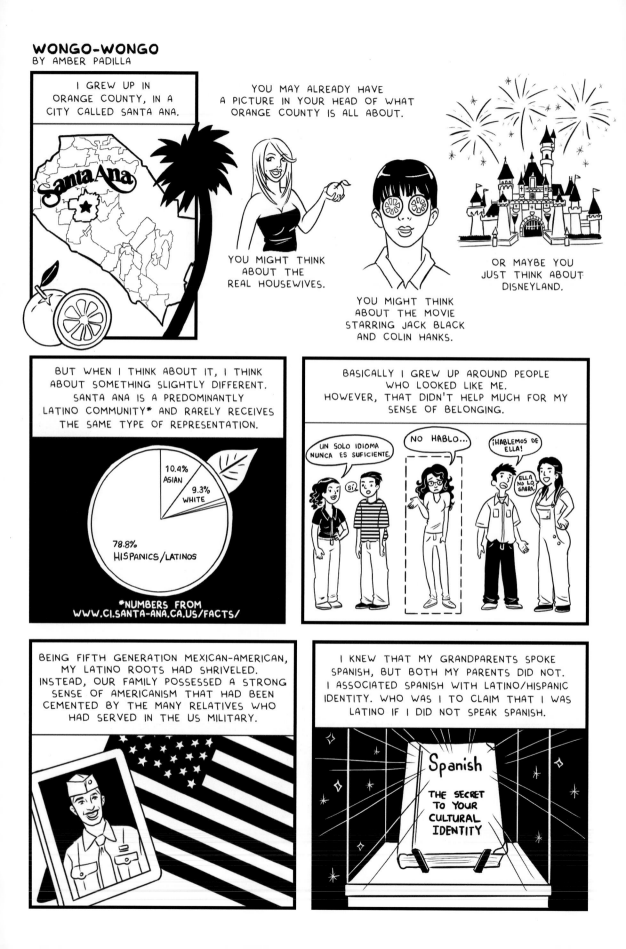

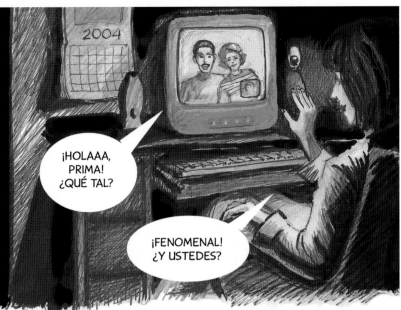

# LA CHARLA

## BY LILA QUINTERO WEAVER

I EMIGRATED FROM BUENOS AIRES WHEN I WAS FIVE & GREW UP IN ALABAMA, WHERE I STILL LIVE. I GOT TO KNOW MY COUSIN SUSANA & HER HUSBAND, ROBERTO, OVER THE INTNERNET. EVERY TIME WE HELD ONE OF OUR CHATS, THE 5,000+ MILES THAT SEPARATE US NARROWED A BIT. THESE CHATS GOT TO BE REGULAR WEEKEND VISITS THAT CULMINATED IN MY FIRST OF SEVERAL TRIPS TO ARGENTINA.

¡HOLAAA, PRIMA! ¿QUÉ TAL?

¡FENOMENAL! ¿Y USTEDES?

AFTER TRADING FAMILY NEWS, WE'D OFTEN TAKE UP CURRENT EVENTS. THAT WAS WHEN MY UNCONSCIOUS CONTRADICTIONS WOULD SURFACE, ESPECIALLY IN HOW I FRAMED MY BICULTURAL EXISTENCE.

ROBERTO IS THE ONE WHO CALLED ME OUT.

LILA, WHY DO YOU REFER TO ARGENTINOS AS "USTEDES" AND TO NORTEAMERICANOS AS "ELLOS"?

DOES THIS MEAN YOU DON'T BELONG TO *EITHER* COUNTRY?

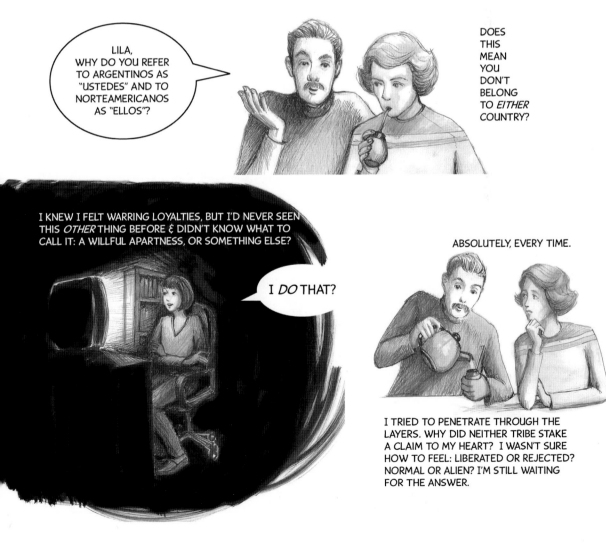

I KNEW I FELT WARRING LOYALTIES, BUT I'D NEVER SEEN THIS *OTHER* THING BEFORE & DIDN'T KNOW WHAT TO CALL IT: A WILLFUL APARTNESS, OR SOMETHING ELSE?

I *DO* THAT?

ABSOLUTELY, EVERY TIME.

I TRIED TO PENETRATE THROUGH THE LAYERS. WHY DID NEITHER TRIBE STAKE A CLAIM TO MY HEART? I WASN'T SURE HOW TO FEEL: LIBERATED OR REJECTED? NORMAL OR ALIEN? I'M STILL WAITING FOR THE ANSWER.

# "_____-AMERICAN"
## BY LOSO PÉREZ

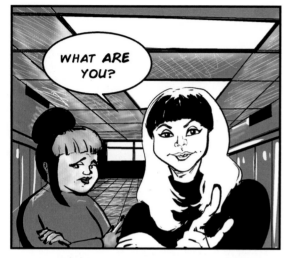

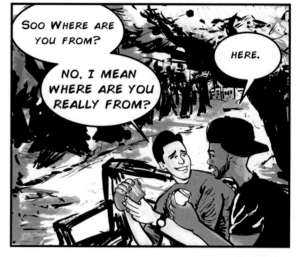

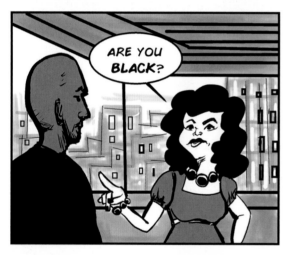

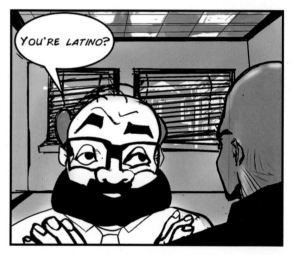

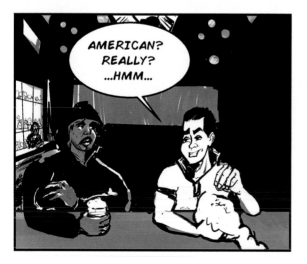

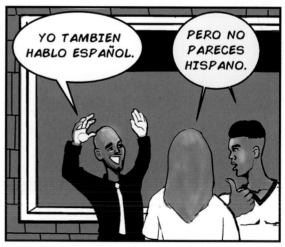

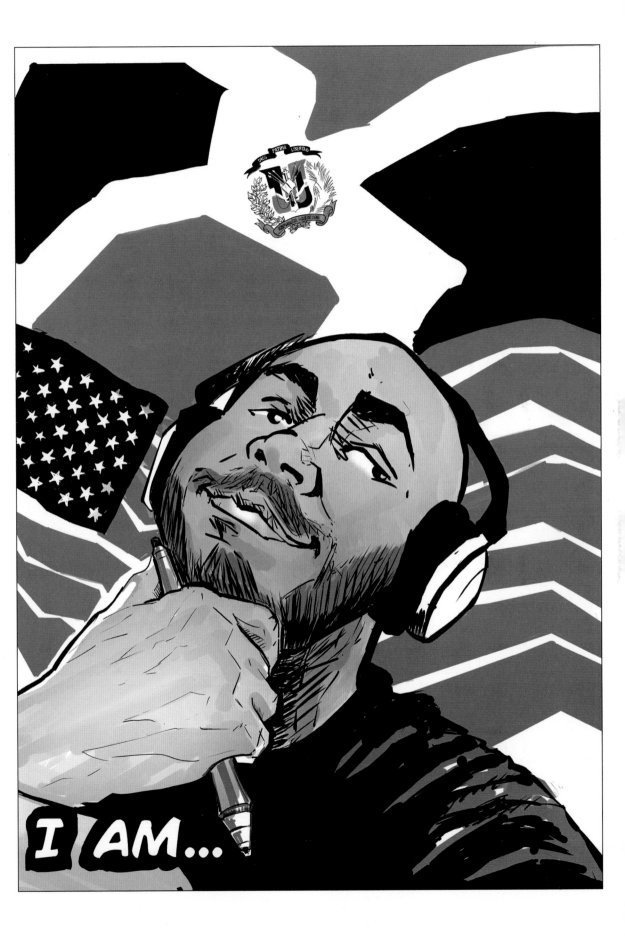

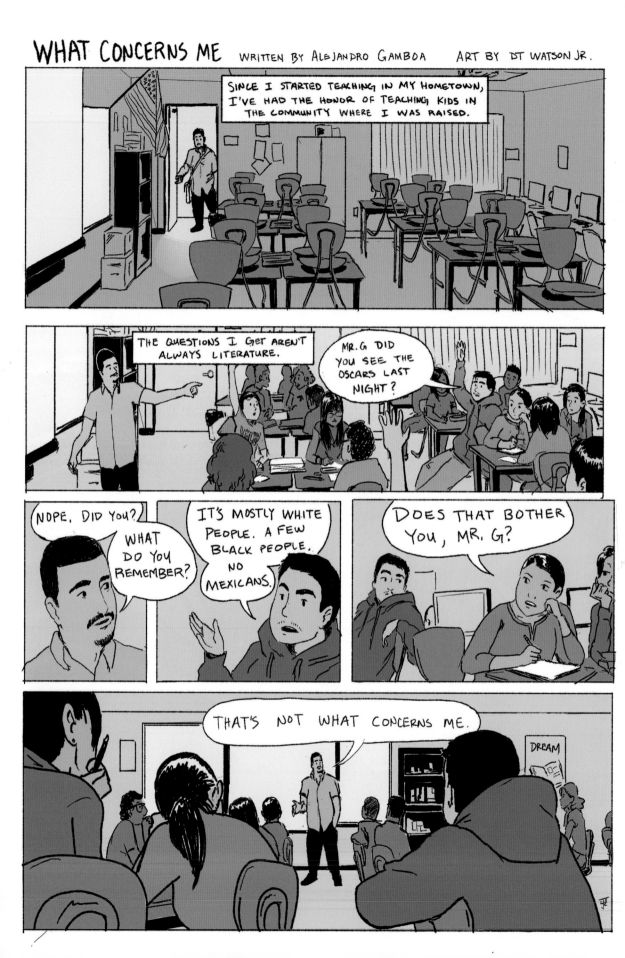

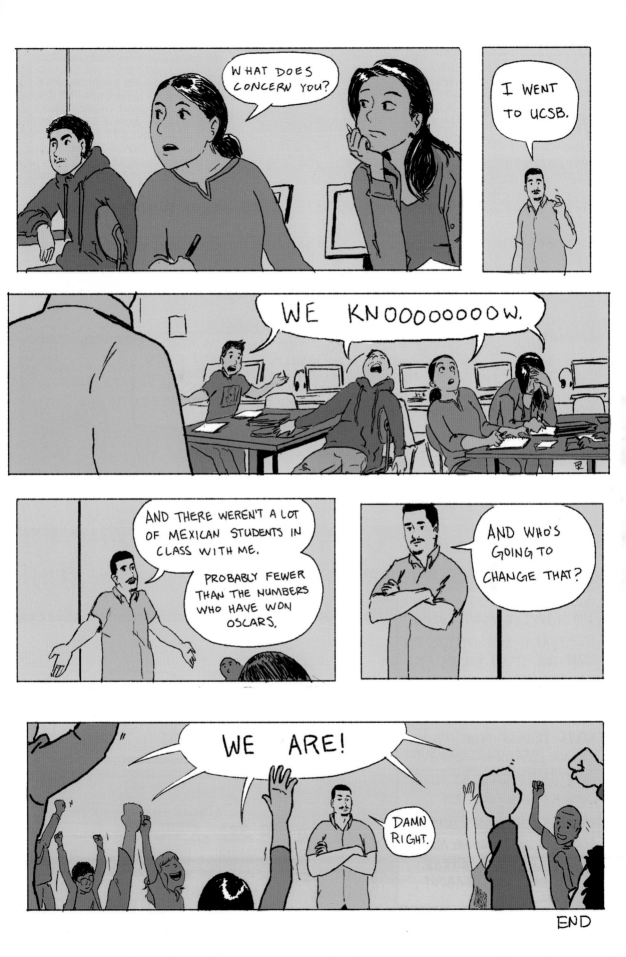

END

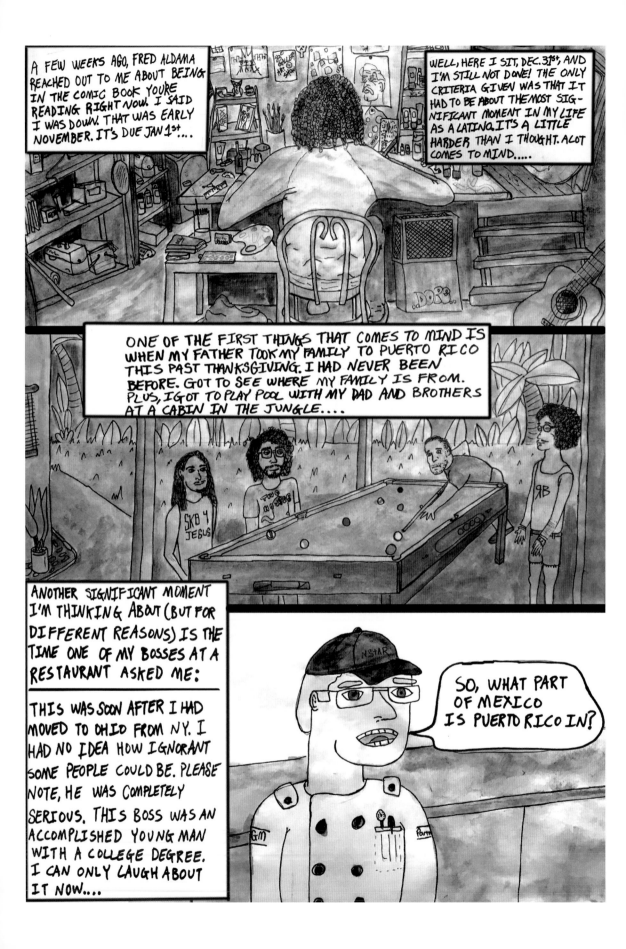

I GREW UP IN THE BRONX. WHEN I WAS 14 or 15, I GOT JUMPED BY SOME KIDS AROUND THE CORNER FROM MY BLOCK. THEY GOT ME GOOD. I LOOKED FOR HELP FROM TWO LATIN KINGS WHO WATCHED FROM ACROSS THE STREET. THEY JUST MINDED THEIR OWN BUSINESS. I LIMPED HOME AND CRIED WHEN I TOLD MY MOM THOSE KIDS STOLE OUR DINNER....

I DIGRESS, IF I REALLY HAD TO PICK A DEFINITIVE MOMENT IN MY LIFE AS A LATINO, IT WOULD PROLLY BE WHEN I MET DR. PALOMA MARTINEZ-CRUZ, A LATINO/A STUDIES PROFESSOR FROM OSU. I WAS INTIMIDATED. I FOUND MYSELF SITTING ACROSS FROM A WOMAN WHO HAS WRITTEN AND TRANSLATED BOOKS. I HAVE TROUBLE SPEAKING BASIC SPANISH. I TOLD HER I FELT LIKE A "BAD" PUERTO RICAN. HER RESPONSE WAS EMPOWERING:

A LOT OF YOUNG LATINOS SAY SIMILAR THINGS. YOU SHOULDN'T FEEL ASHAMED. YOU ARE LATINO! THAT'S THAT. THIS IS YOUR STORY. EMBRACE IT!

NOW, I SIT HERE LESS THAN 6 HOURS FROM MY DEADLINE AND I REALIZE A FEW THINGS: ONE, I NEED TO STOP PUTTING THINGS OFF TIL THE LAST MINUTE. TWO, WHO CARES HOW MUCH SPANISH I CAN SPEAK? (ALTHOUGH I HAVE BEEN PRACTICING #DUOLINGO). MY BLOOD AND GUTS ARE PUERTO RICAN SO I AM PUERTO RICAN. NO ONE CAN TAKE THAT FROM ME. I JUST NEED TO KEEP ON KEEPING ON AND BE PROUD OF WHO I AM. I HOPE ALL MY HERMANOS Y HERMANAS CAN DO THE SAME!

"NO TIME FOR TITLES" aeh '16

# DANGEROUS TRUTHS . . . CLEARING NEW IDENTITY SPACES

Frederick Luis Aldama (with John I. Jennings), "It Could've Been . . ."

Jaime Crespo, "White Shoulders"

Breena Nuñez Peralta, "They Call Me Morena . . . for a Reason"

Roberta Gregory, "California Girl"

Vicko Alvarez, "El Entender"

José Cabrera, "el cabrón"

Serenity Serseción, "Latinx"

Ivan Velez Jr., "Que Significa?"

John Jota Leaños (with Dustin "DusT" García), "Kaleidoscopic Latinx Indigeneities"

Zeke Peña, "A Nomad's Heart"

William Anthony Nericcio (with Guillermo Nericcio García), "A Mexican-American Semiotic Odyssey or Streets of Laredo Ex-Pat"

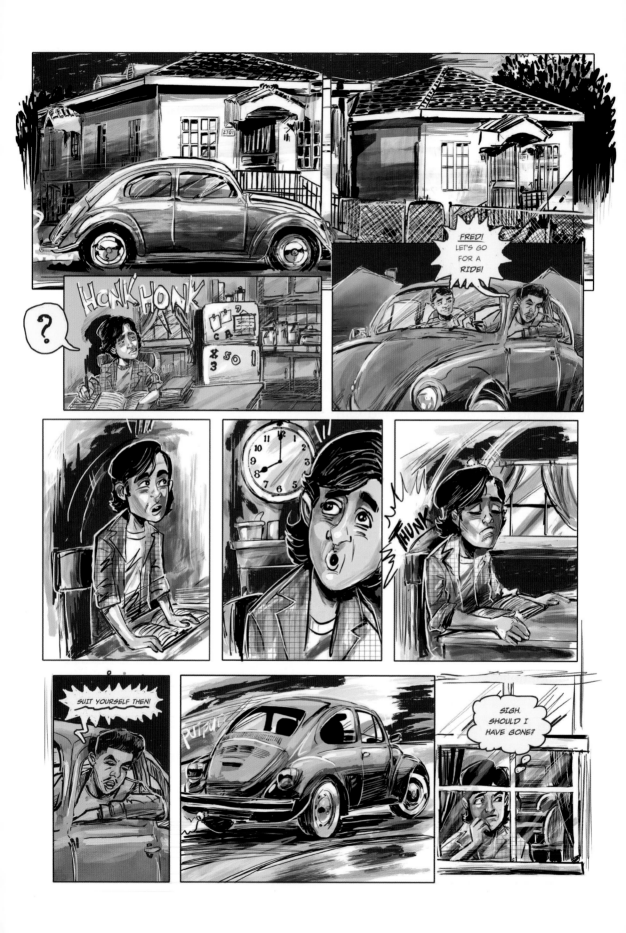

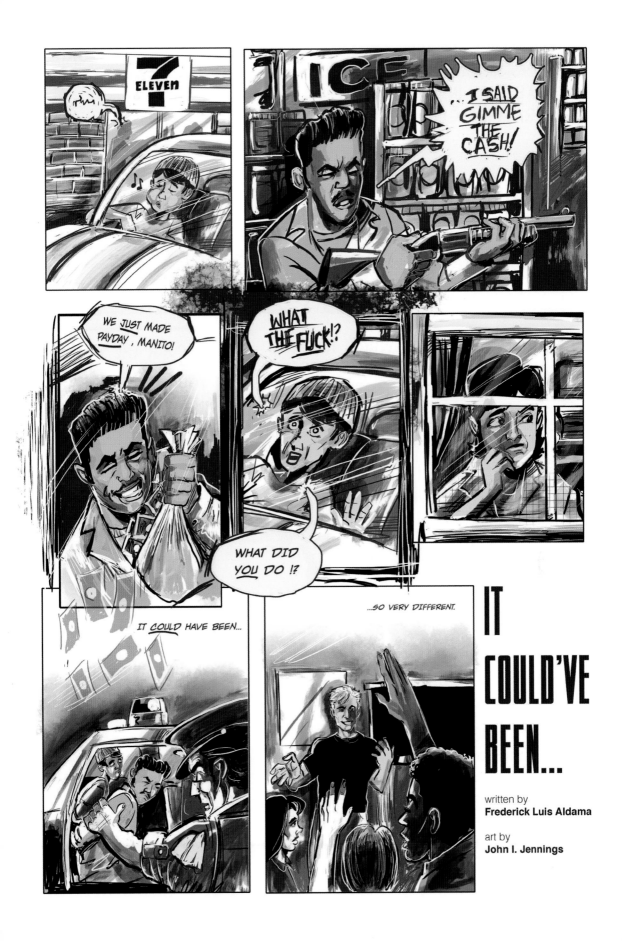

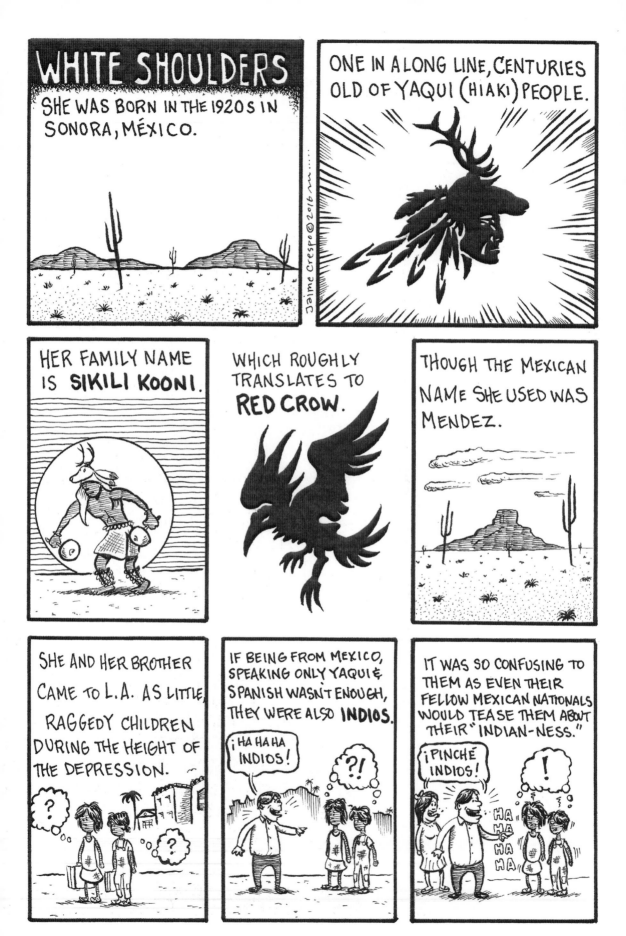

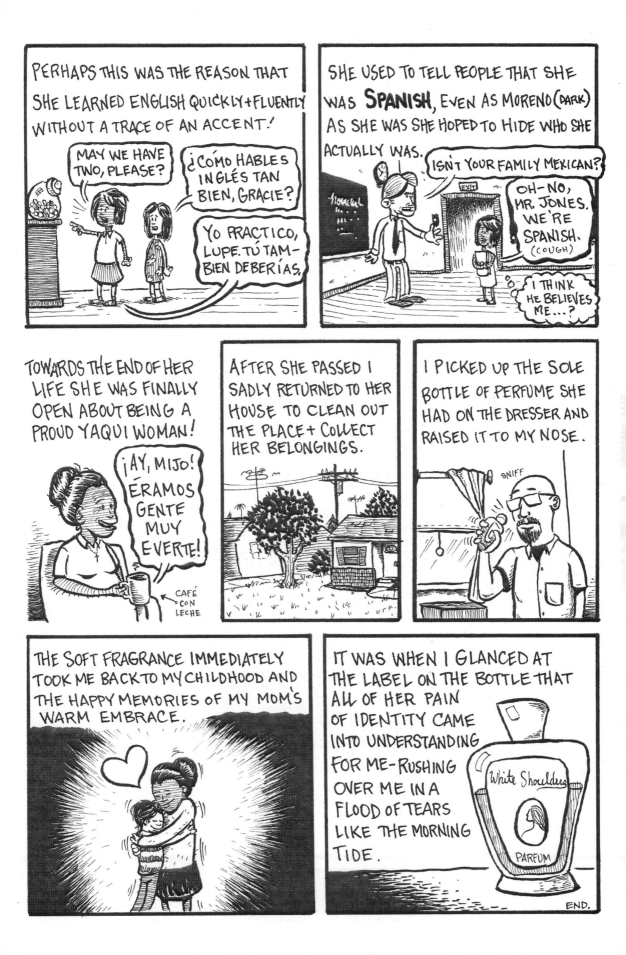

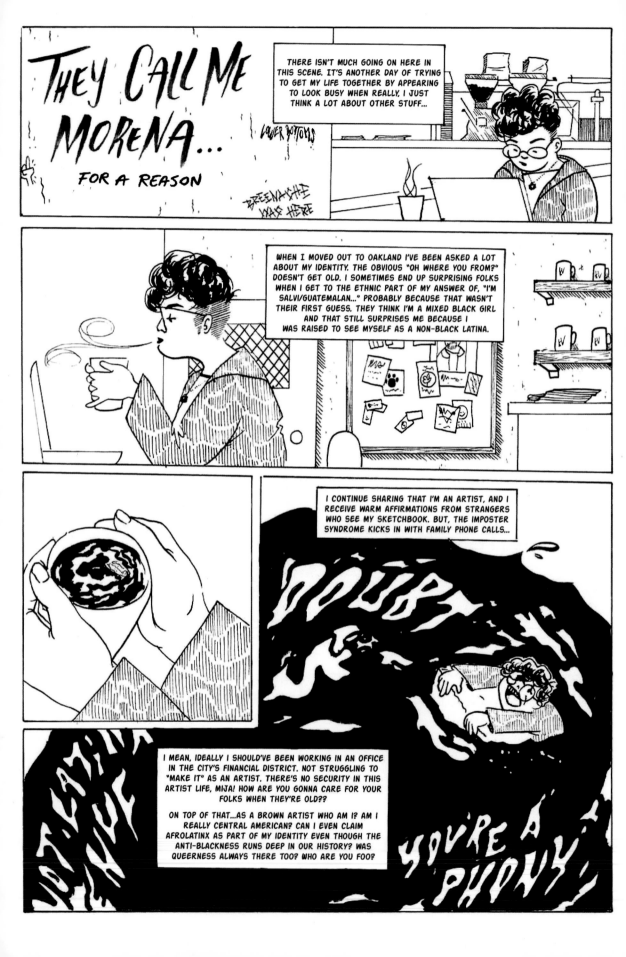

# THEY CALL ME MORENA...

## FOR A REASON

LOWER BOTTOMS

BREENASHE WAS HERE

THERE ISN'T MUCH GOING ON HERE IN THIS SCENE. IT'S ANOTHER DAY OF TRYING TO GET MY LIFE TOGETHER BY APPEARING TO LOOK BUSY WHEN REALLY, I JUST THINK A LOT ABOUT OTHER STUFF...

WHEN I MOVED OUT TO OAKLAND I'VE BEEN ASKED A LOT ABOUT MY IDENTITY. THE OBVIOUS "OH WHERE YOU FROM?" DOESN'T GET OLD. I SOMETIMES END UP SURPRISING FOLKS WHEN I GET TO THE ETHNIC PART OF MY ANSWER OF, "I'M SALVI/GUATEMALAN..." PROBABLY BECAUSE THAT WASN'T THEIR FIRST GUESS. THEY THINK I'M A MIXED BLACK GIRL AND THAT STILL SURPRISES ME BECAUSE I WAS RAISED TO SEE MYSELF AS A NON-BLACK LATINA.

I CONTINUE SHARING THAT I'M AN ARTIST, AND I RECEIVE WARM AFFIRMATIONS FROM STRANGERS WHO SEE MY SKETCHBOOK. BUT, THE IMPOSTER SYNDROME KICKS IN WITH FAMILY PHONE CALLS...

DOUBT

YOU'RE A PHONY!

I MEAN, IDEALLY I SHOULD'VE BEEN WORKING IN AN OFFICE IN THE CITY'S FINANCIAL DISTRICT. NOT STRUGGLING TO "MAKE IT" AS AN ARTIST. THERE'S NO SECURITY IN THIS ARTIST LIFE, MIJA! HOW ARE YOU GONNA CARE FOR YOUR FOLKS WHEN THEY'RE OLD??

ON TOP OF THAT...AS A BROWN ARTIST WHO AM I? AM I REALLY CENTRAL AMERICAN? CAN I EVEN CLAIM AFROLATINX AS PART OF MY IDENTITY EVEN THOUGH THE ANTI-BLACKNESS RUNS DEEP IN OUR HISTORY? WAS QUEERNESS ALWAYS THERE TOO? WHO ARE YOU FOO?

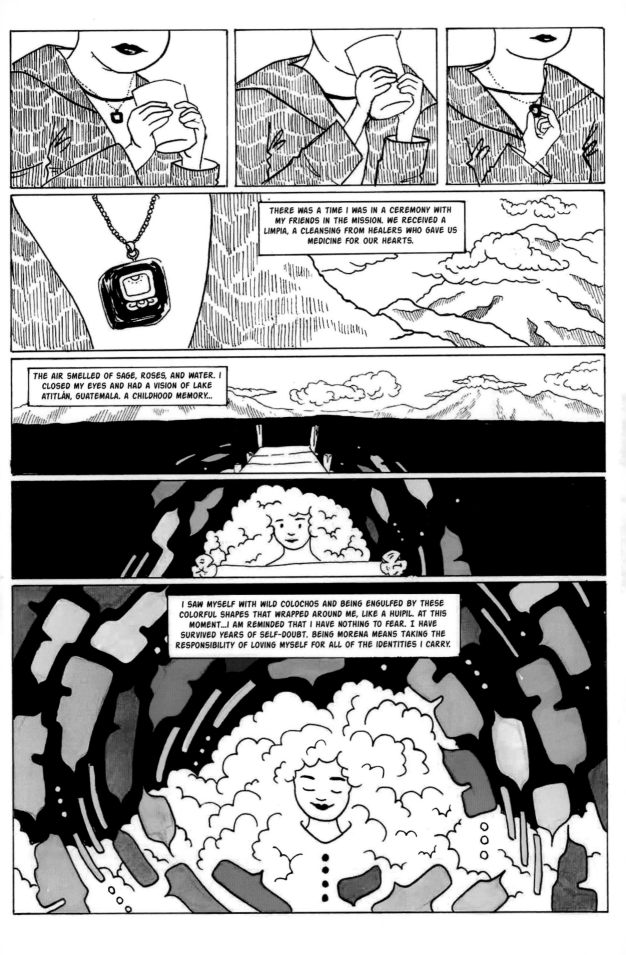

THERE WAS A TIME I WAS IN A CEREMONY WITH MY FRIENDS IN THE MISSION. WE RECEIVED A LIMPIA, A CLEANSING FROM HEALERS WHO GAVE US MEDICINE FOR OUR HEARTS.

THE AIR SMELLED OF SAGE, ROSES, AND WATER. I CLOSED MY EYES AND HAD A VISION OF LAKE ATITLÁN, GUATEMALA. A CHILDHOOD MEMORY...

I SAW MYSELF WITH WILD COLOCHOS AND BEING ENGULFED BY THESE COLORFUL SHAPES THAT WRAPPED AROUND ME, LIKE A HUIPIL. AT THIS MOMENT...I AM REMINDED THAT I HAVE NOTHING TO FEAR. I HAVE SURVIVED YEARS OF SELF-DOUBT. BEING MORENA MEANS TAKING THE RESPONSIBILITY OF LOVING MYSELF FOR ALL OF THE IDENTITIES I CARRY.

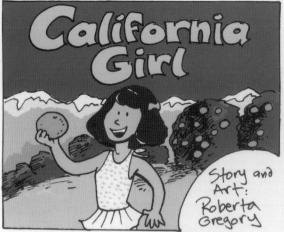

# California Girl

Story and Art: Roberta Gregory

I grew up in Wilmington, California from the mid '50s to the early '60s. It's the harbor district of Los Angeles.

It had a Main Street (literally!) brick storefronts, a little city park, a quaint little library and quiet, residential streets with exotic names: Mauretania, Papeete, Avalon.

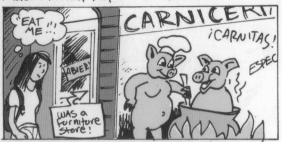

It has since become very Hispanic. I went back to look at the old neighborhood recently and felt almost like I was somewhere in Mexico.

My Grandparents on my Mother's side of the family were from Mexico.

On my father's side, the relatives seemed like average white Americans.

When I was little, my Mother and Grandmother spoke Spanish to each other. Probably because it was mostly "grownup talk."

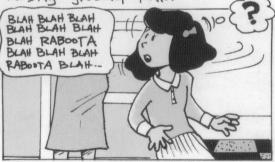

I never knew what they were saying unless I heard a NAME mentioned.

And even THAT was confusing. Spanish-speaking people seem fond of nick-names. Grandpa Leo was called "Polo."

"Visiting the relatives" when I was REAL little often seemed to involve a scary ancient-looking bedridden little woman who only spoke Spanish.

Now they've learned that young children are at a "window" where they pick up languages easily. If I'd been able to learn Spanish back then, perhaps I might be fluent today.

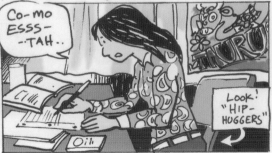

Maybe! I took Spanish in High School, but never got very good at it!

I recall being at a pool at a private club that my Uncle (on my father's side) belonged to, and this little girl asked:

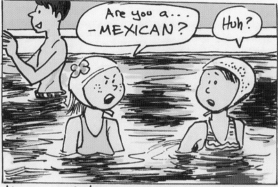

It sounded like something really BAD the way she said it!

I didn't think about my Mother's side of the family. All I could picture was a silly-looking cartoon chihuahua in a sombrero, so I said:

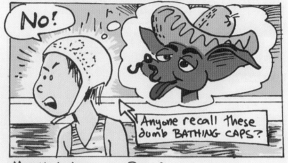

Anyone recall these dumb BATHING CAPS?

MUCH later, I found out that Mexicans weren't allowed to go into "White" pools in the 1950s!

Actually, "Mexican" DID seem to be sort of a bad word back then! Fast food chains selling Mexican food never had that word in their names! It was always...

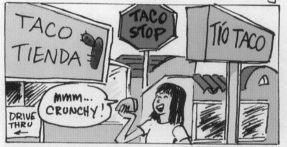

TACO TIENDA

TACO STOP

TÍO TACO

DRIVE THRU →

MMM... CRUNCHY!

"TACO-this" or, "TACO-THAT." They still seem to be called "Taco-something" these days, so maybe "Mexican" IS a bad word!

I think the same may have been true for the really old-time Chinese restaurants! When I was a kid, they ALL seemed to be called "CHOP SUEY!" Do you EVER see that name used anywhere these days?

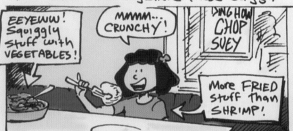

EEYEWW! Squiggly stuff with VEGETABLES!

MMM... CRUNCHY!

DING HOW CHOP SUEY

More FRIED stuff than SHRIMP!

As a child, I wasn't very adventurous. When we went out for "chop suey", all I would eat was fried shrimp and rice!

Our neighborhood was kind of international. Besides Spanish-speaking people there were "Middle-Eastern" and "Indians."

Plus this little German boy the other boys picked on. He didn't speak much. He may have been "slow" OR his English wasn't good. AND "the War" hadn't been over for very long, either!

The folks down the block were Filipino, and had LOTS of spooky CHIHUAHUAS! I was always scared to go over to their house because the dogs would bark and JUMP up at me... RIGHT at child's-eye-level!

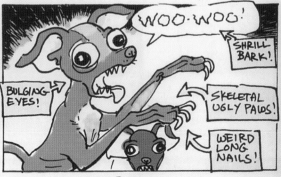

WOO·WOO!

SHRILL BARK!

BULGING EYES!

SKELETAL UGLY PAWS!

WEIRD LONG NAILS!

The people NEXT DOOR got some, too!

There were also "regular Americans," too. There was a "retarded" girl who lived around the corner who I was scared of. And, this other girl my age I didn't like to have over, ever since....

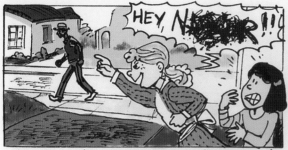

..the day she ran outside yelling racist stuff at a black man walking past our house. (There were NOT any black neighbors.)

My best friend was this blonde, very pale girl who went to Christian school instead of the Public School I went to. Her family seemed very exotic to me!

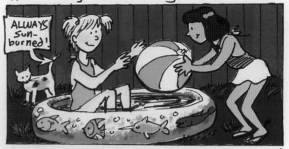

They were from Baltimore and they talked sort of funny. And, they shopped for food at the Navy Base Commissary instead of the Ranch Market, like WE did!

They'd talk about "the Japs" sometimes, so I used to think that "the War" was still going on. Her Aunt, who worked at the fish cannery, lived with them.

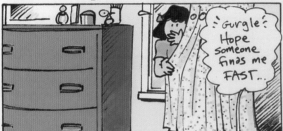

Her room always smelled like stale old fish and cigarette smoke. I hid in her room once while playing hide-and-seek and it almost made me throw up!

I used to stay overnight at their house and it was ALWAYS very interesting. I didn't like to take a bath over there.

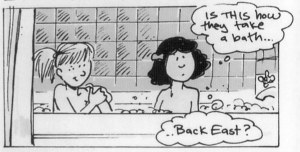

The family ALL used the SAME bathtub-full of water and it got dirtier and DIRTIER! I assume NOW that it may have been some sort of Navy thing.

Even though she went to Christian School, I don't recall her family being very religious. They seemed to smoke and drink as much (if not MORE!) as anyone ELSE did back in the 1950s.

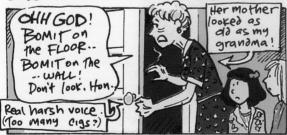

One night when I stayed over, her Aunt came home drunk and vomited all over the bathroom! (I never actually SAW it. I just HEARD all about it...)

That seemed VERY exotic to me! I had no idea people DID things like that... at least not in MY family...

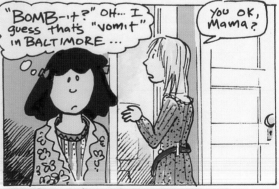

My friend "had to" get married when she was 16 and I lost track of her.

In 1962, we took a car trip to visit my aunt in Louisiana. We went through Arizona and New Mexico and saw, among other things, Carlsbad Caverns, the Grand Canyon and the Taos Pueblos.

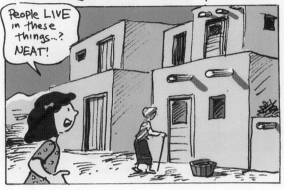

People LIVE in these things...? NEAT!

We went through Texas, which seemed like miles and miles of NOTHING, and visited someone (I don't recall who) in a small town in the middle of NOWHERE!

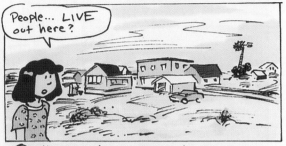

People... LIVE out here?

On the way back we went through Oklahoma and almost got in the way of a TORNADO! The motel had a cellar and there were COWBOYS in it with us!

We visited friends out in the country in Tennessee. It was very, VERY green! PLUS, I saw birds like Cardinals and Blue Jays... which I'd seen in my "BIRD BOOKS" but NEVER in California!

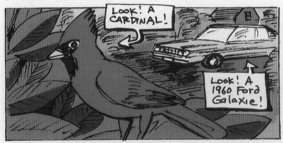

LOOK! A CARDINAL!

Look! A 1960 Ford Galaxie!

These were birds that only people "Back East" ever got to see!

Growing up, I'd always heard about "Back East." It never sounded like any place you'd want to live. But, a lot of it looked like pictures in my books which showed "regular, small-town America."

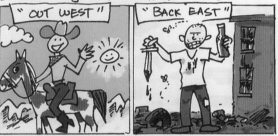

"OUT WEST"

"BACK EAST"

These places seemed far more exotic to me than dull, ordinary old California! (Which was VERY exotic to the folks "Back East.")

In the South, I vaguely recall Vicksburg and a Southern mansion. We stopped for sno-cones, too! But, my MOST vivid memory was the first gas station we came to once we reached MISSISSIPPI!

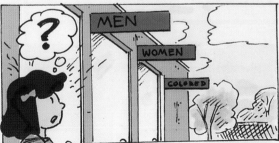

?

MEN

WOMEN

COLORED

I still recall the rust-streaked white metal walls and the blue-and-white signs saying "MEN", "WOMEN" and "COLORED!"

I was so SHOCKED! From the point-of-view of an eight-year-old, of course! All I could think was:

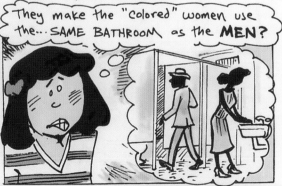

They make the "colored" women use the... SAME BATHROOM as the MEN?

Things were VERY strange "Back East." And even STRANGER "Down South!"

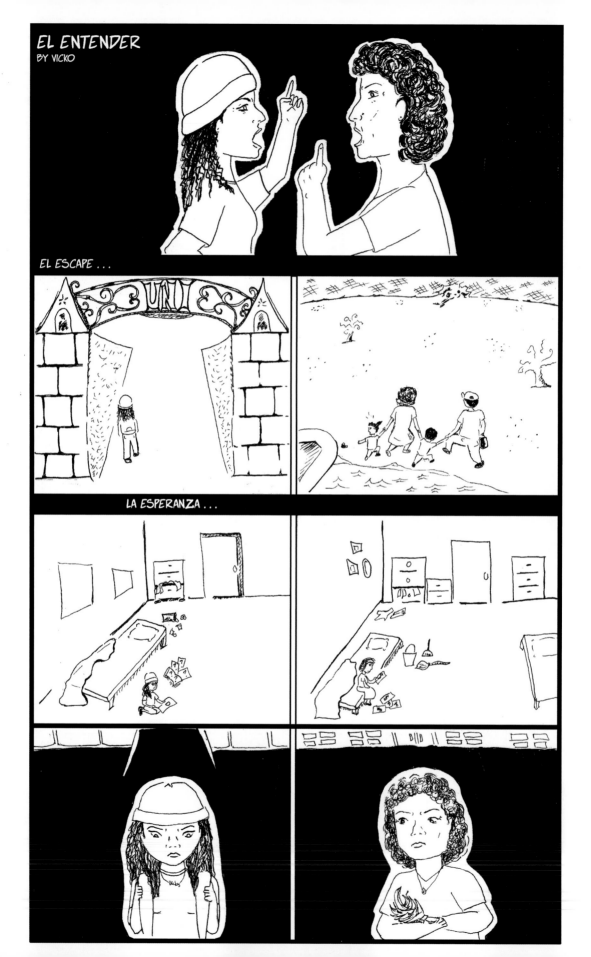

EL AGUANTE . . .

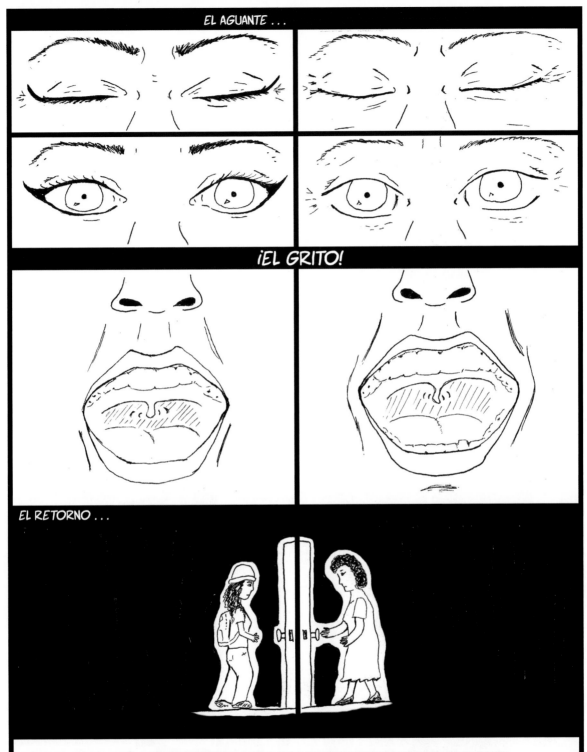

¡EL GRITO!

EL RETORNO . . .

I'M NOT SURE WHEN I FIRST REALIZED I WAS NOT MUCH DIFFERENT FROM MY MOTHER.
BUT IT HAD SOMETHING TO DO WITH THOSE THINGS THAT DRIVE ONE MAD. I DO KNOW
THAT IT HAS BEEN THE MOST SIGNIFICANT REALIZATION OF MY ENTIRE 28 YEARS OF LIFE
IN THE U.S.

NO SE CUANDO ME DI CUENTA DE QUE NO ERA TAN DIFERENTE A MI MADRE. PERO TENÍA
ALGO QUE VER CON ESAS COSAS QUE ENLOQUECEN. SIN EMBARGO, HA SIDO LA
REALIZACIÓN MÁS SIGNIFICANTE DE MIS 28 AÑOS DE LA VIDA EN LOS E.E.UU.

# el Cabrón

by José Cabrera

In this new year, I want to get some shit off my chest. I remember a conversation I had with my father. It wasn't actually a dialogue but rather a tongue lashing of biblical proportions and I was doing the lashing.

This son-of-a-bitch had it coming to him. He had the audacity to leave a message on my answering machine threatening me if I didn't tell him where his son Alex (my brother) was at. I was 29 at the time and I wasn't gonna let a motha fucka like him try to intimidate me!

All those years of abuse and torture had finally come to a peak when I heard his voice threatening me. It triggered something I had been holding on to for so long. It was time to get it off my chest...

"¡Mira mama guevo, sea la última vez que tu me deje un mensaje como ese!" (Look cocksucker, don't ever leave a message like that again.)

Father?! Coño, you were never my father. You never gave me anything! Everything I have I've gotten through hard work. My education, my job, EVERYTHING! All you ever were and still are is an abuser.

I can leave any message I want! I'm your father and I deserve respect!

I never abused your mother. NEVER!

What are you calling me a liar?! I remember all the times you beat the crap out of her!

You don't know what you're talking about! You were too young to remember.

Ah you see ¡degraciado! That's what you were counting on-that I was too young to remember. Ok let me give you a detail that only you and I remember. The black phone you smashed across mom's face because you said she was using it to call her boyfriends!

YOU REMEMBER NOW, MOTHA FUCKA?!

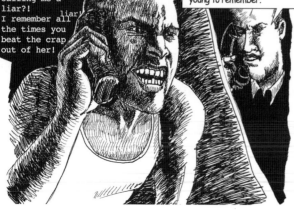

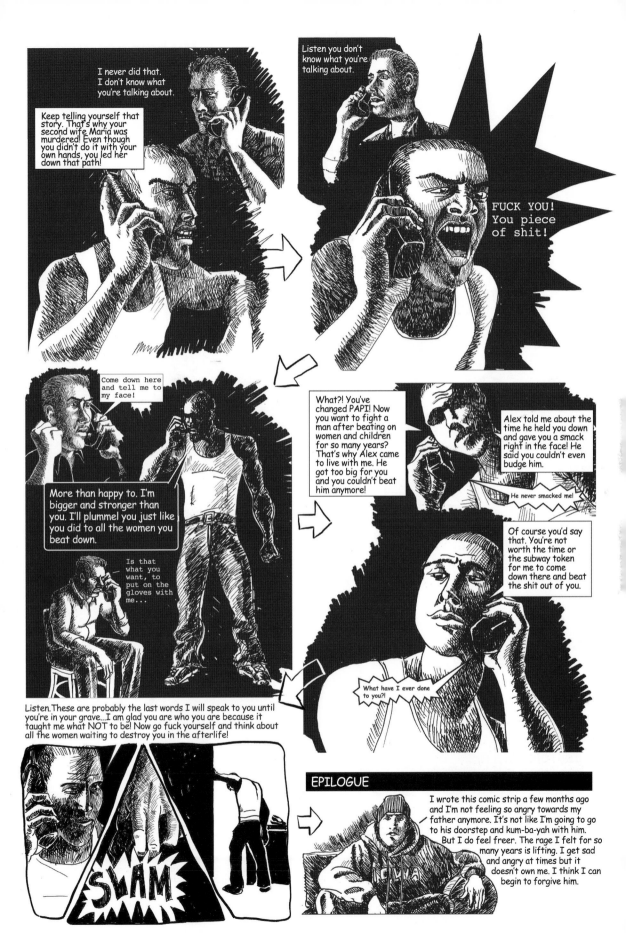

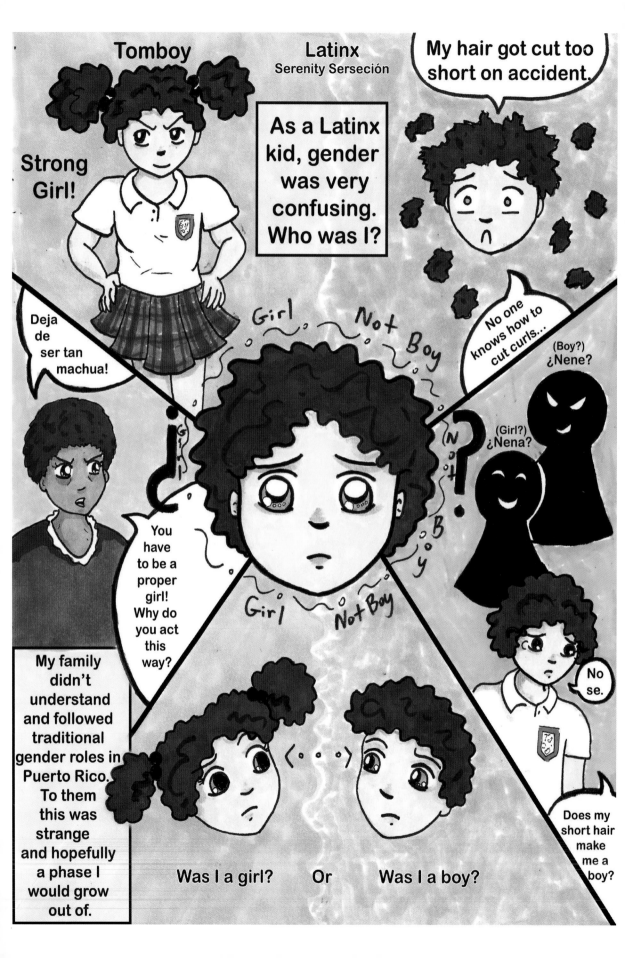

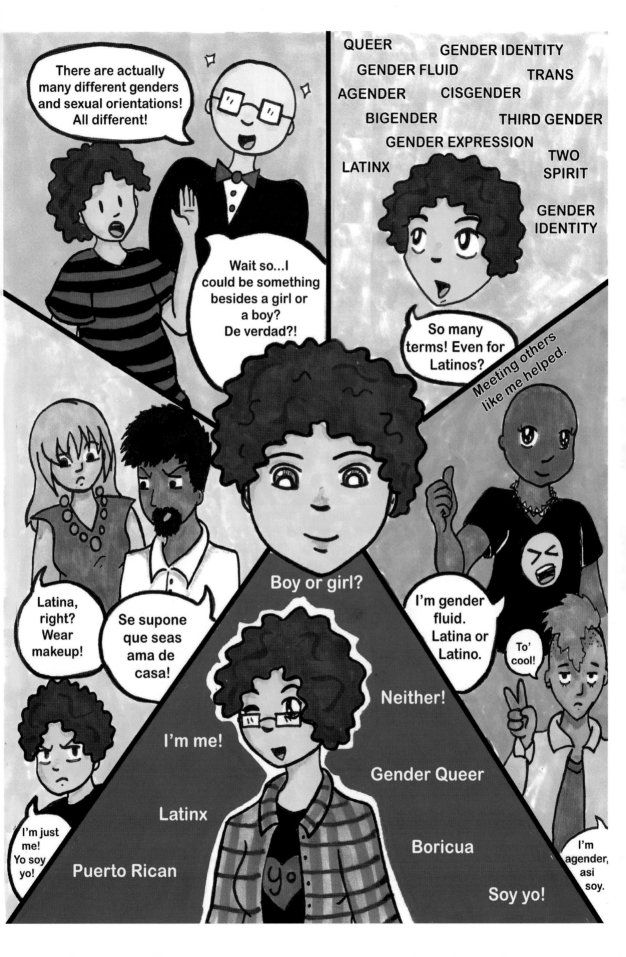

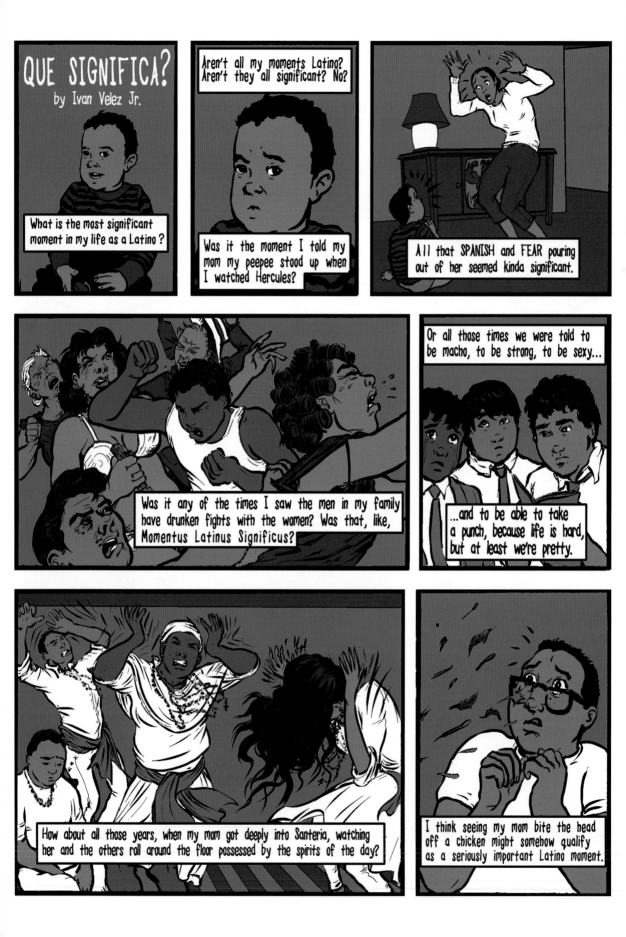

Or are my Latino moments judged on significance or worthiness by the gaze of others?

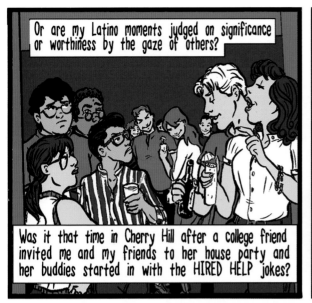

Was it that time in Cherry Hill after a college friend invited me and my friends to her house party and her buddies started in with the HIRED HELP jokes?

Or is it a career moment? Like that year when a multicultural comic book company hired me to write for them (Bless them)...

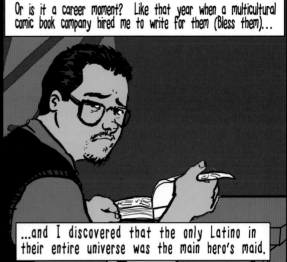

...and I discovered that the only Latino in their entire universe was the main hero's maid.

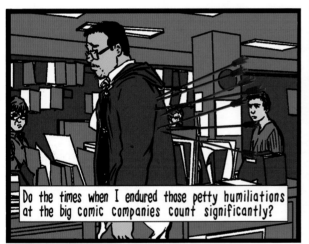

Do the times when I endured those petty humiliations at the big comic companies count significantly?

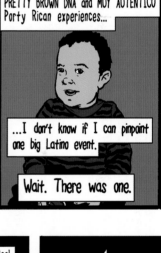

Was it because I was openly gay or openly Latino? With them you never know.

And this is what bugs me. For all my PRETTY BROWN DNA and MUY AUTENTICO Porty Rican experiences...

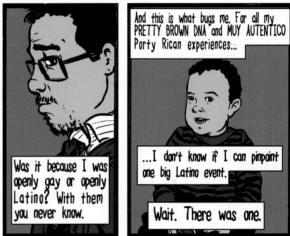

...I don't know if I can pinpoint one big Latino event.

Wait. There was one.

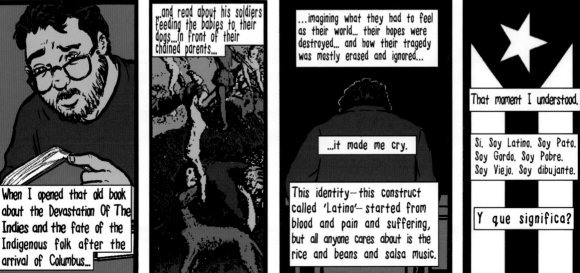

When I opened that old book about the Devastation Of The Indies and the fate of the Indigenous folk after the arrival of Columbus...

...and read about his soldiers feeding the babies to their dogs...in front of their chained parents...

...imagining what they had to feel as their world... their hopes were destroyed... and how their tragedy was mostly erased and ignored...

...it made me cry.

This identity—this construct called 'Latino'—started from blood and pain and suffering, but all anyone cares about is the rice and beans and salsa music.

That moment I understood.

Si. Soy Latino. Soy Pato. Soy Gordo. Soy Pobre. Soy Viejo. Soy dibujante.

Y que significa?

## "Beauty in the Struggle"

Written and Designed by John Jota Leaños
Drawn by DusT Garcia

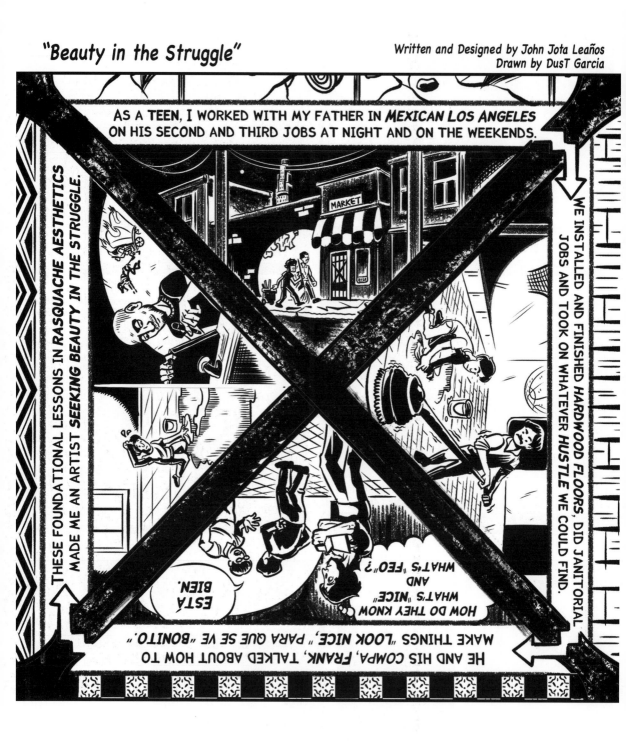

## "Official Indian"

Written and Designed by John Jota Leaños
Drawn by DusT Garcia

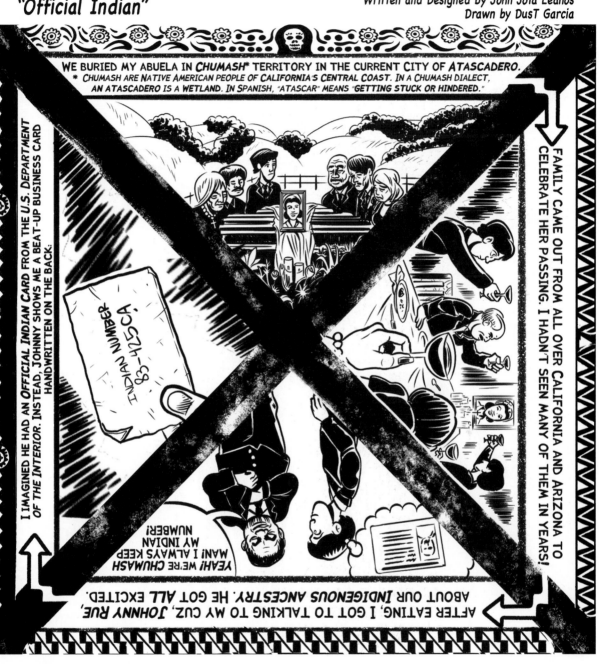

WE BURIED MY ABUELA IN *CHUMASH** TERRITORY IN THE CURRENT CITY OF *ATASCADERO.*
* CHUMASH ARE NATIVE AMERICAN PEOPLE OF CALIFORNIA'S CENTRAL COAST. IN A CHUMASH DIALECT, AN ATASCADERO IS A WETLAND. IN SPANISH, "ATASCAR" MEANS "GETTING STUCK OR HINDERED."

FAMILY CAME OUT FROM ALL OVER CALIFORNIA AND ARIZONA TO CELEBRATE HER PASSING. I HADN'T SEEN MANY OF THEM IN YEARS!

AFTER EATING, I GOT TO TALKING TO MY CUZ, *JOHNNY RUE,* ABOUT OUR *INDIGENOUS ANCESTRY.* HE GOT ALL EXCITED.

YEAH! WE'RE CHUMASH MAN! I ALWAYS KEEP MY INDIAN NUMBER!

I IMAGINED HE HAD AN *OFFICIAL INDIAN CARD* FROM THE *U.S. DEPARTMENT OF THE INTERIOR.* INSTEAD, JOHNNY SHOWS ME A BEAT-UP BUSINESS CARD HANDWRITTEN ON THE BACK:

INDIAN NUMBER 83-425CA

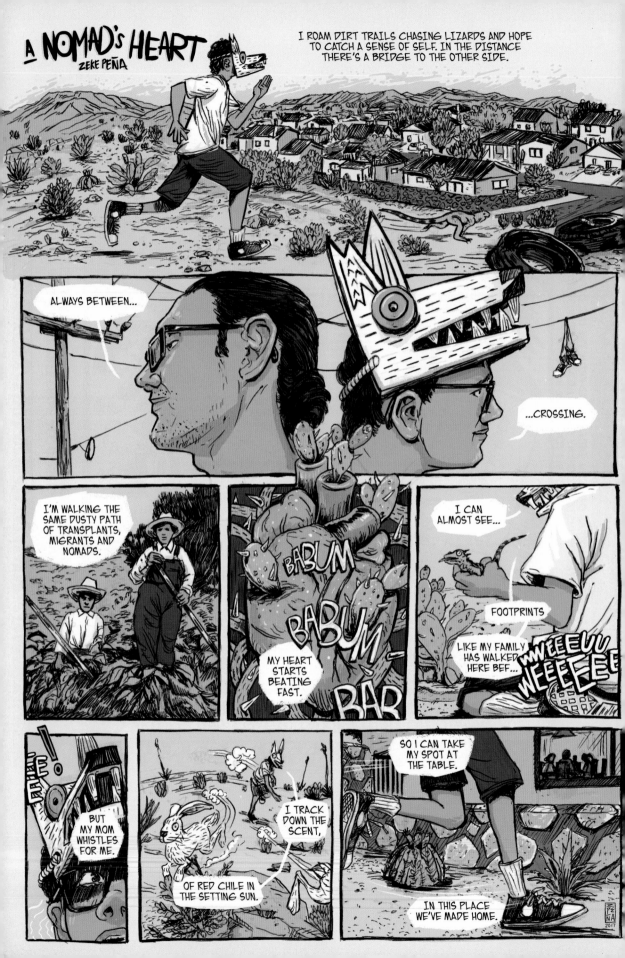

**Guillermo Nericcio García y William Anthony Nericcio**

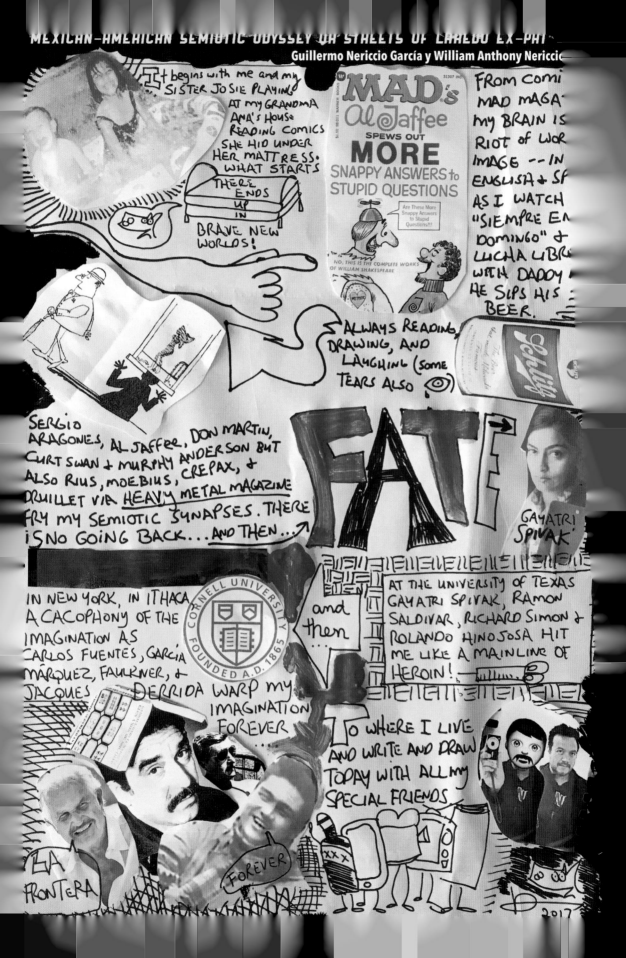

It begins with me and my sister Josie playing at my grandma Ana's house reading comics she hid under her mattress. What starts THERE ENDS UP IN BRAVE NEW WORLDS!

MAD's Al Jaffee SPEWS OUT MORE SNAPPY ANSWERS to STUPID QUESTIONS

Are These More Snappy Answers to Stupid Questions?!

NO, THIS IS THE COMPLETE WORKS OF WILLIAM SHAKESPEARE

From comi MAD MAGA my BRAIN IS RIOT of WOR IMAGE -- IN ENGLISH & SF AS I WATCH "SIEMPRE EN DOMINGO" & LUCHA LIBRE WITH DADDY HE SIPS HIS BEER.

ALWAYS READING, DRAWING, AND LAUGHING (SOME TEARS ALSO

SERGIO ARAGONES, AL JAFFEE, DON MARTIN, CURT SWAN + MURPHY ANDERSON BUT ALSO RIUS, MOEBIUS, CREPAX, & DRUILLET VIA HEAVY METAL MAGAZINE FRY MY SEMIOTIC SYNAPSES. THERE IS NO GOING BACK... AND THEN...

FATE

GAYATRI SPIVAK

IN NEW YORK, IN ITHACA A CACOPHONY OF THE IMAGINATION AS CARLOS FUENTES, GARCIA MÁRQUEZ, FAULKNER, & JACQUES DERRIDA WARP MY IMAGINATION FOREVER...

CORNELL UNIVERSITY · FOUNDED A.D. 1865

and then...

AT THE UNIVERSITY OF TEXAS GAYATRI SPIVAK, RAMON SALDIVAR, RICHARD SIMON & ROLANDO HINOJOSA HIT ME LIKE A MAINLINE OF HEROIN!

TO WHERE I LIVE AND WRITE AND DRAW TODAY WITH ALL MY SPECIAL FRIENDS

LA FRONTERA

FOREVER

2017

# NEW MYTHOS

Liz Mayorga, "Brainstorming Session"

Jenny Gonzalez-Blitz, "The Witch's Curse"

Ilan Stavans (with Roberto Weil), "Rite of Passage"

Dustin "DusT" García, "Saved"

Daniel Parada, "A Cacaopera Tale"

Myra Lara, "Fork-Tongued & Tongue-Tied"

Raúl González, "New Citizen Conqueror"

Kelly Fernandez, "The Ciguapa"

Jaime "Xaime" Hernandez, "La Blanca"

Eric Esquivel (with Michael Macropoulos), "El ChupaSoyMilk"

Jason "J-Gonzo" González, "My Life as a Pocho"

Frederico "Rico" Cuatlacuatl, "Kauitl Nomad"

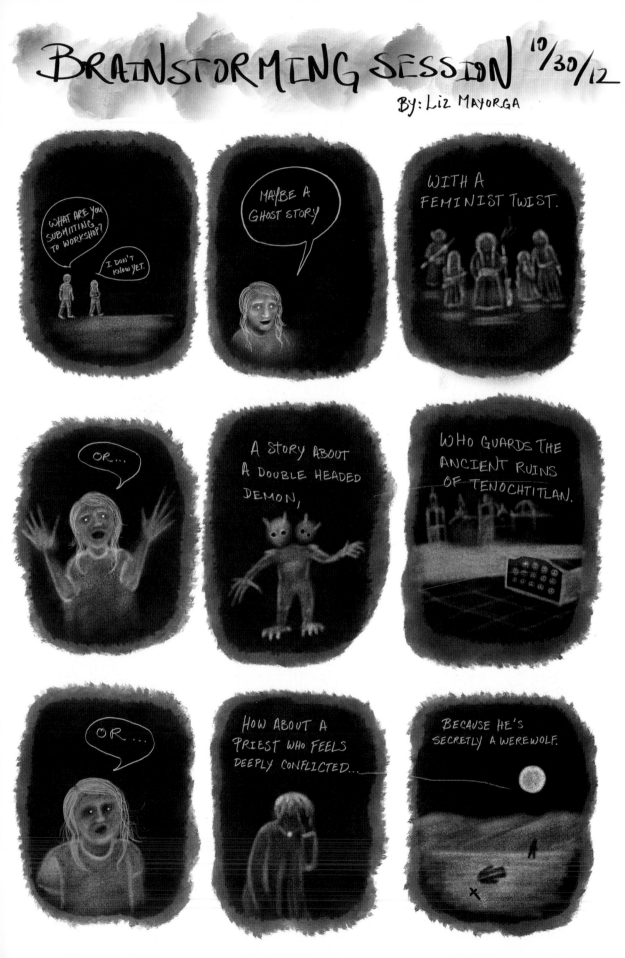

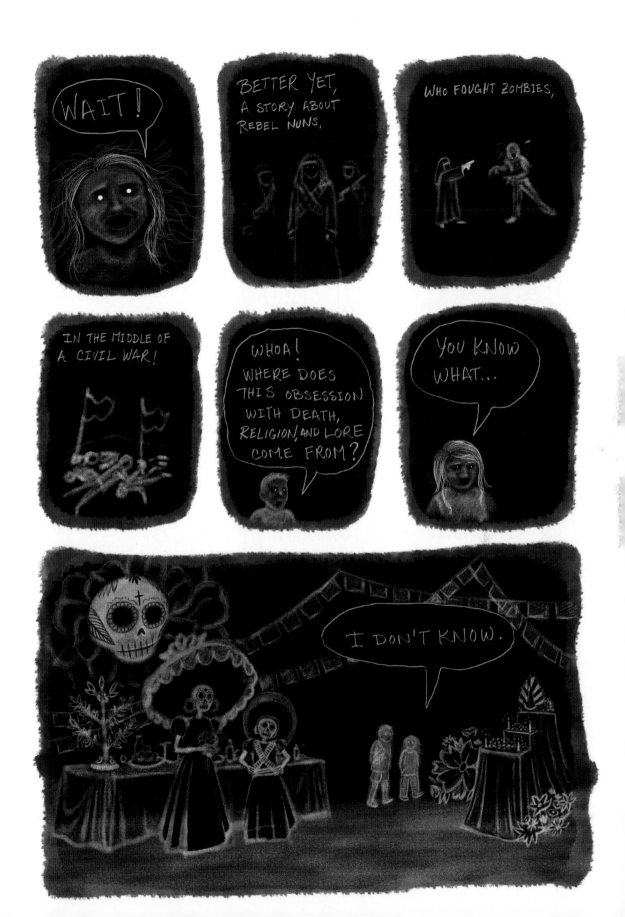

# The Witch's Curse

J. Gonzalez-Blitz

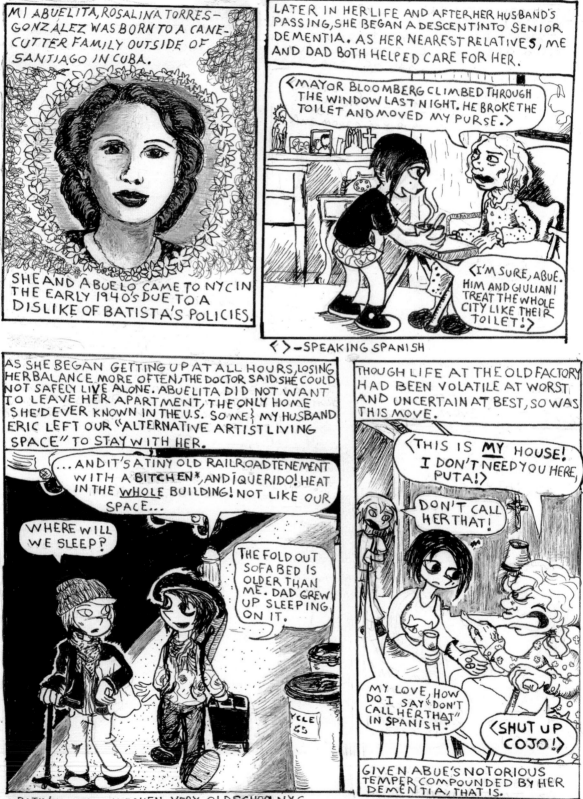

MI ABUELITA, ROSALINA TORRES-GONZALEZ WAS BORN TO A CANE-CUTTER FAMILY OUTSIDE OF SANTIAGO IN CUBA.

SHE AND ABUELO CAME TO NYC IN THE EARLY 1940's DUE TO A DISLIKE OF BATISTA'S POLICIES.

LATER IN HER LIFE AND AFTER HER HUSBAND'S PASSING, SHE BEGAN A DESCENT INTO SENIOR DEMENTIA. AS HER NEAREST RELATIVES, ME AND DAD BOTH HELPED CARE FOR HER.

<MAYOR BLOOMBERG CLIMBED THROUGH THE WINDOW LAST NIGHT. HE BROKE THE TOILET AND MOVED MY PURSE.>

<I'M SURE, ABUE. HIM AND GIULIANI TREAT THE WHOLE CITY LIKE THEIR TOILET!>

< > —SPEAKING SPANISH

AS SHE BEGAN GETTING UP AT ALL HOURS, LOSING HER BALANCE MORE OFTEN, THE DOCTOR SAID SHE COULD NOT SAFELY LIVE ALONE. ABUELITA DID NOT WANT TO LEAVE HER APARTMENT, THE ONLY HOME SHE'D EVER KNOWN IN THE U.S. SO ME & MY HUSBAND ERIC LEFT OUR "ALTERNATIVE ARTIST LIVING SPACE" TO STAY WITH HER.

...AND IT'S A TINY OLD RAILROAD TENEMENT WITH A BITCHEN*, AND ¡QUERIDO! HEAT IN THE WHOLE BUILDING! NOT LIKE OUR SPACE...

WHERE WILL WE SLEEP?

THE FOLD OUT SOFA BED IS OLDER THAN ME. DAD GREW UP SLEEPING ON IT.

CYCLE 5

THOUGH LIFE AT THE OLD FACTORY HAD BEEN VOLATILE AT WORST AND UNCERTAIN AT BEST, SO WAS THIS MOVE.

<THIS IS **MY** HOUSE! I DON'T NEED YOU HERE, PUTA!>

DON'T CALL HER THAT!

MY LOVE, HOW DO I SAY "DON'T CALL HER THAT" IN SPANISH?

<SHUT UP COJO!>

GIVEN ABUE'S NOTORIOUS TEMPER COMPOUNDED BY HER DEMENTIA, THAT IS.

*BATH/SHOWER IN KITCHEN. VERY OLD SCHOOL NYC

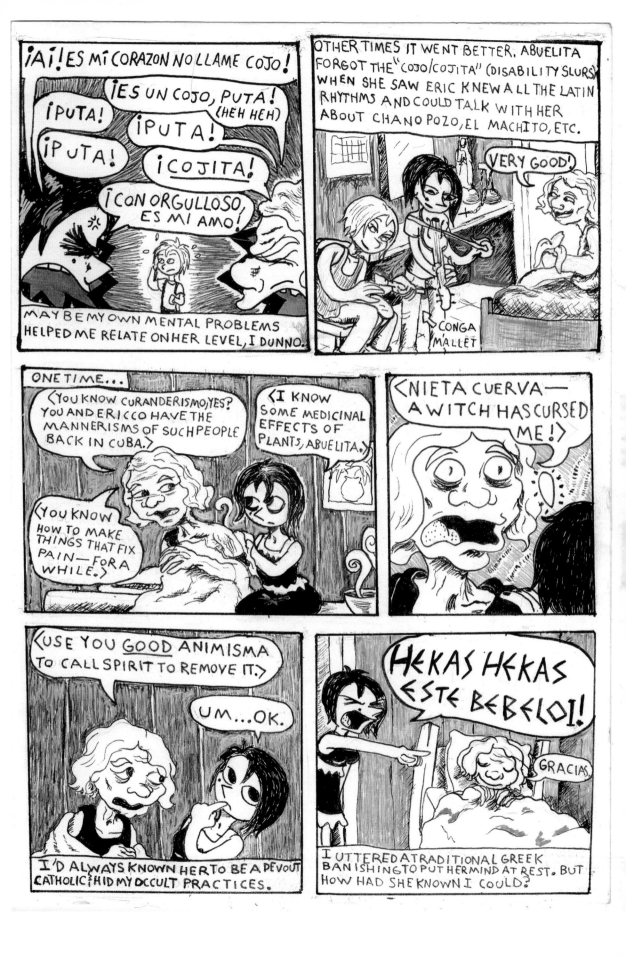

# Rite of Passage

Story by ILAN STAVANS

Illustrations by ROBERTO WEIL

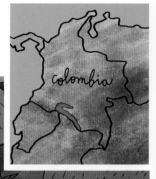

colombia

I once participated in a shamanic ceremony with an indigenous tribe from the PUTUMAYO DISTRICT. It was with the Kamëntsá people, who live in the Sibundoy Valley. Some of them spoke the native Kamsá language.

Growing up in Mexico, I nurtured a deep fascination with indigenous civilization. But I was always an observer. Until this experience.

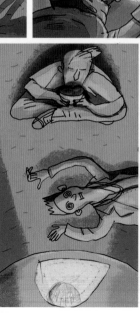

In a hallucinatory state, I imagined I could penetrate the texture of things.

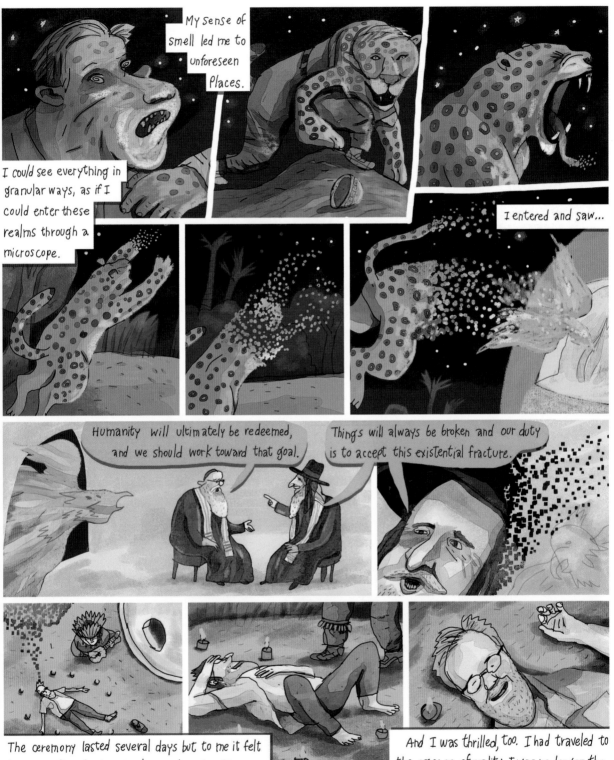

# SAVED BY DYS

AT HOME, BEING *LATINO* CAME SECOND TO BEING AN *AMERICAN*.

MY MOTHER'S *NICARAGÜENSE* FAMILY BUILT AN ABUNDANT BUSINESS AND LIVED COMFORTABLY.

MY FATHER'S FAMILY ESCAPED FROM CASTRO'S *CUBA* WITH *NOTHING*.

*CHRISTIANITY* HAD BROUGHT THEM TOGETHER.

SETTING THE STAGE OF THE *THEATRE* OF MY *FAMILY*.

A *COMEDY* OF *LOVE*.

*BLINDED* BY A *WHITE* LIGHT OF *CERTAINTY*.

...BUT BEHIND THE *BLACK* CURTAIN...

...CAST A *SHADOW* OF SILENT *TRAGEDY*.

I WALKED THROUGH THE VALLEY OF THE *SHADOW* OF *DEATH*.

FEARING ALL *EVIL*.

A *BURDEN* WRAPPED AS A *GIFT* OF *MERCY* BY AN *ANGRY* GOD.

A GOD OF WHICH I COULD NOT *SEE*...

..NOR *HEAR*.

*AMERICAN* WAS SECONDARY TO BEING *CHRISTIAN*.

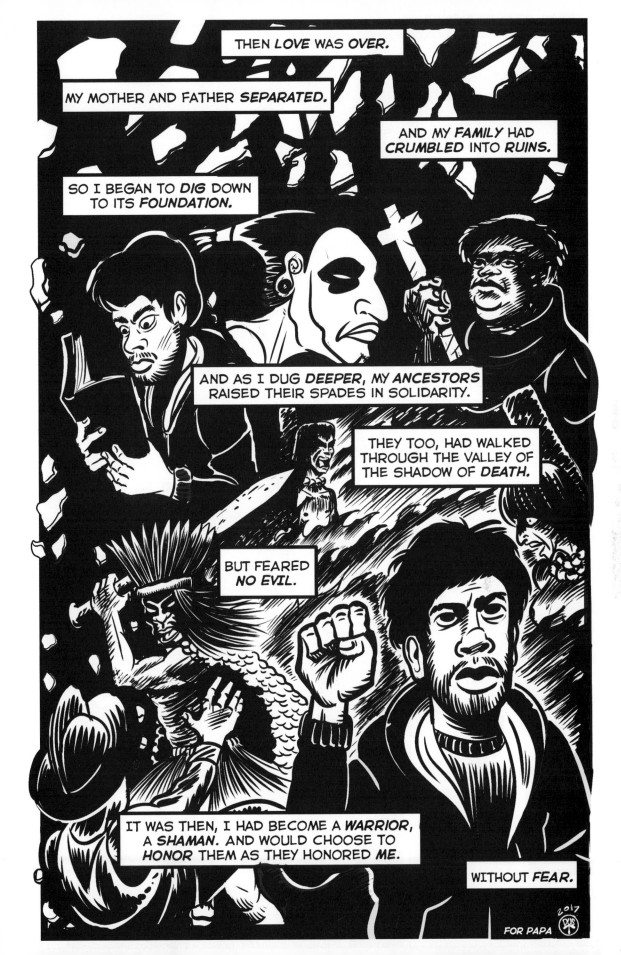

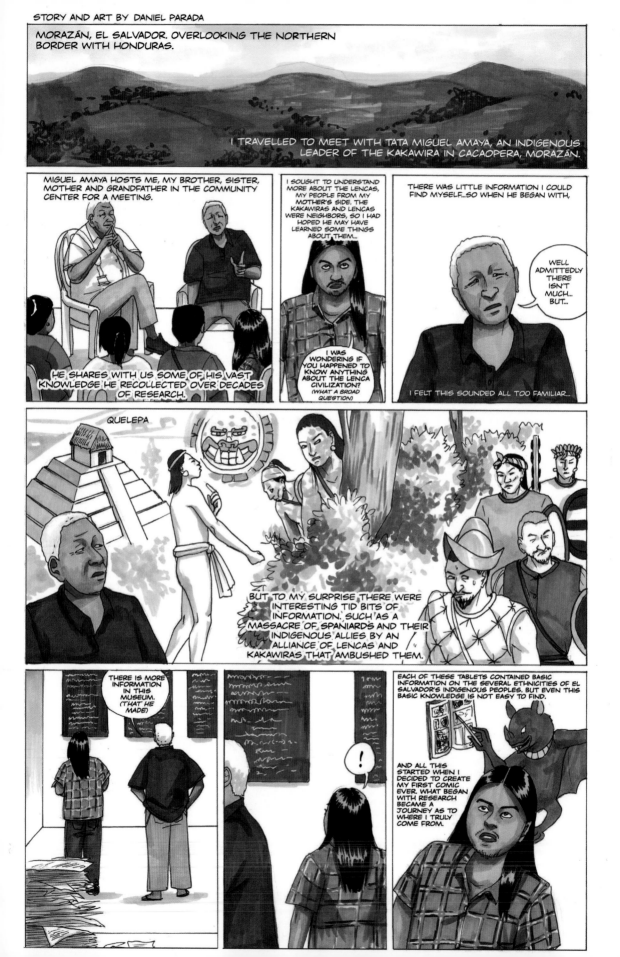

# FORK·TONGUED & TONGUE·TIED

MYRA LARA

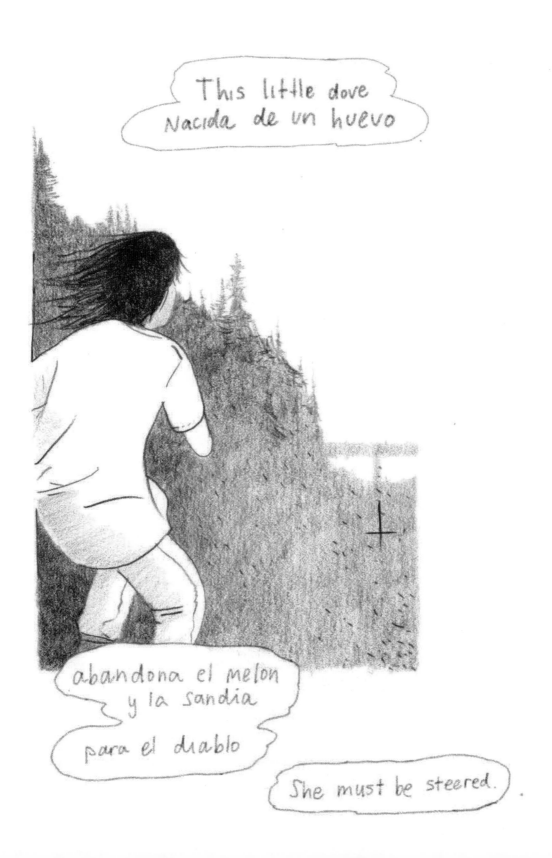

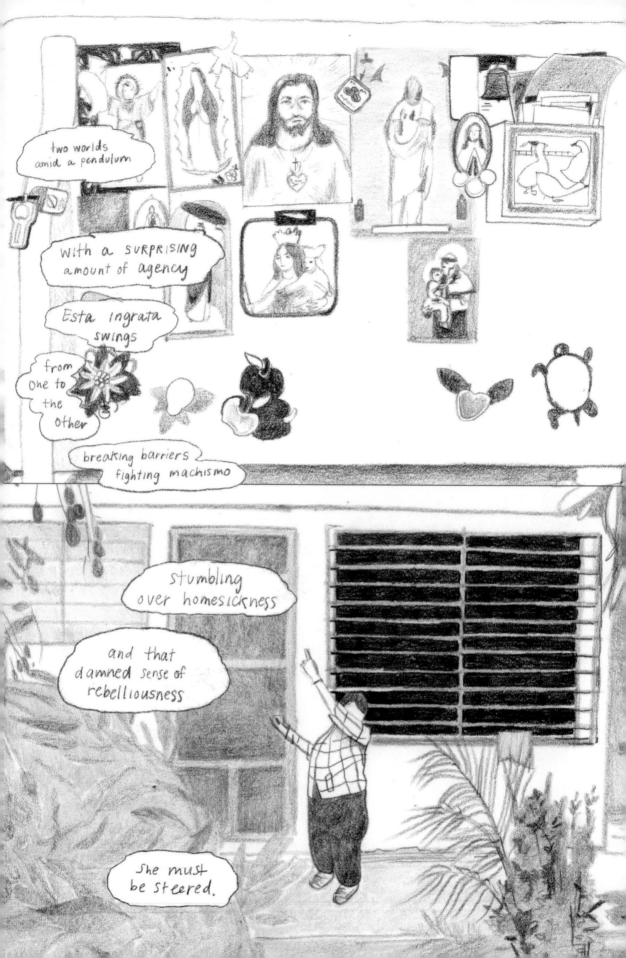

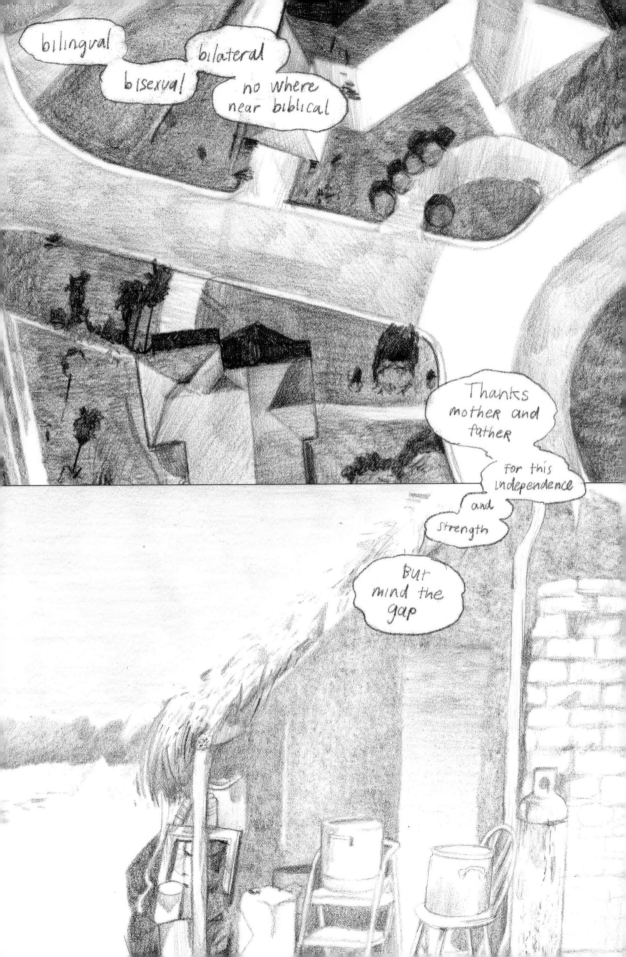

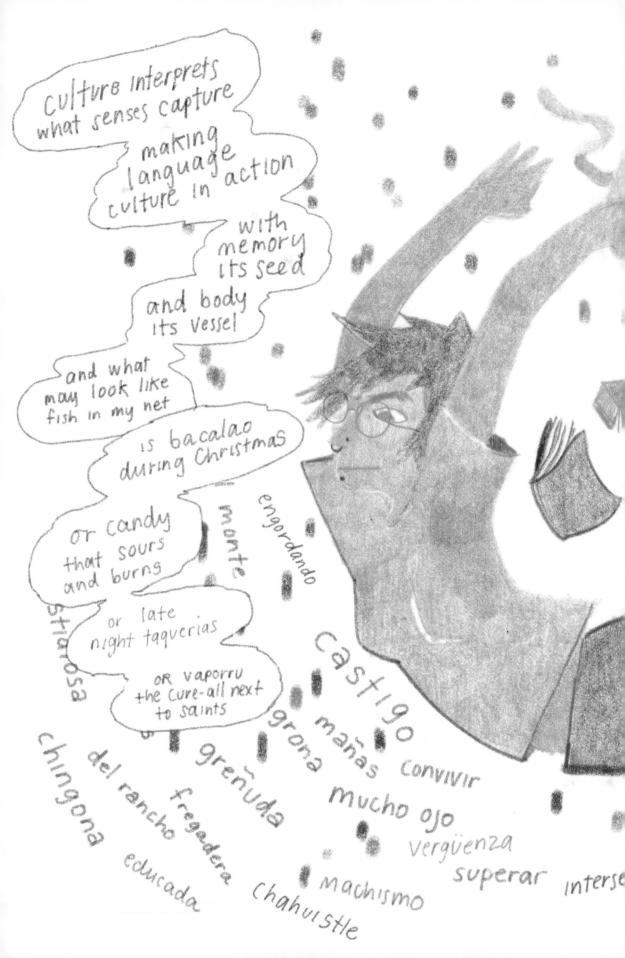

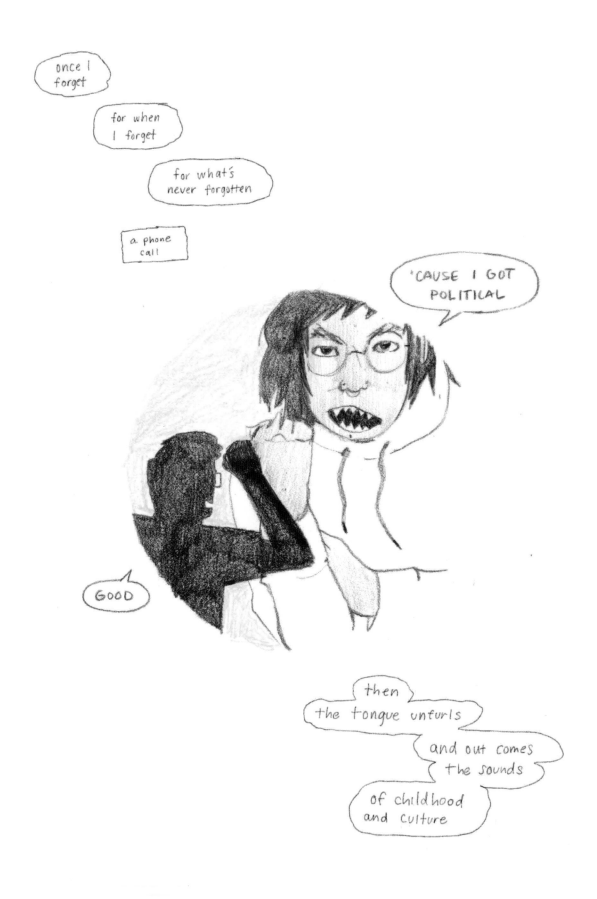

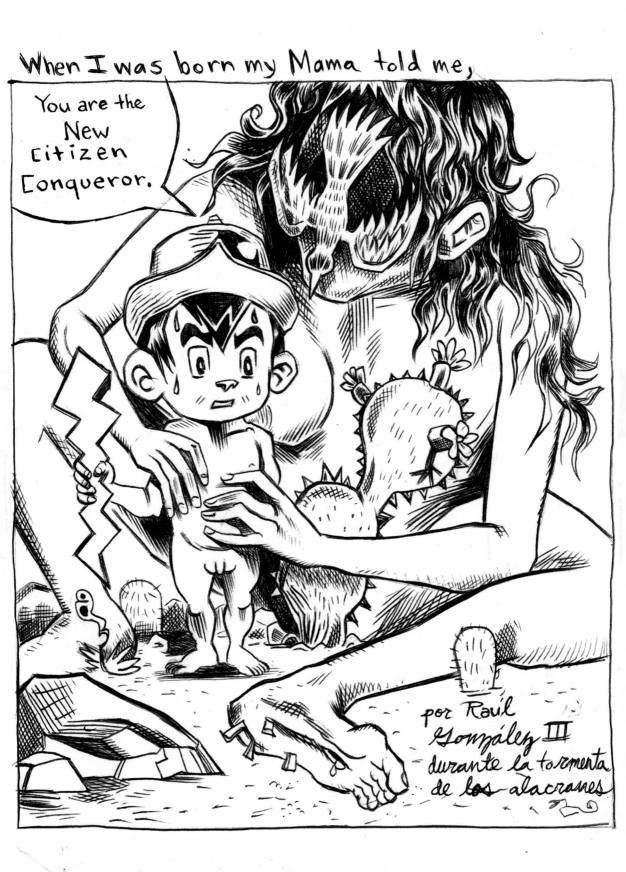

# THE CIGUAPA BY KELLY FERNANDEZ

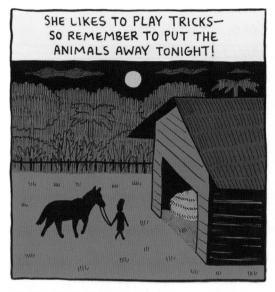

SHE LIKES TO PLAY TRICKS—SO REMEMBER TO PUT THE ANIMALS AWAY TONIGHT!

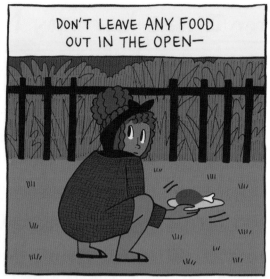

DON'T LEAVE ANY FOOD OUT IN THE OPEN—

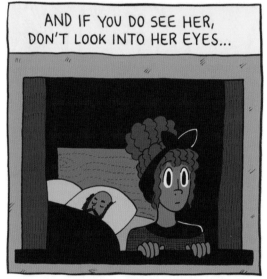

AND IF YOU DO SEE HER, DON'T LOOK INTO HER EYES...

MNNN

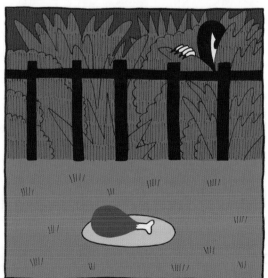

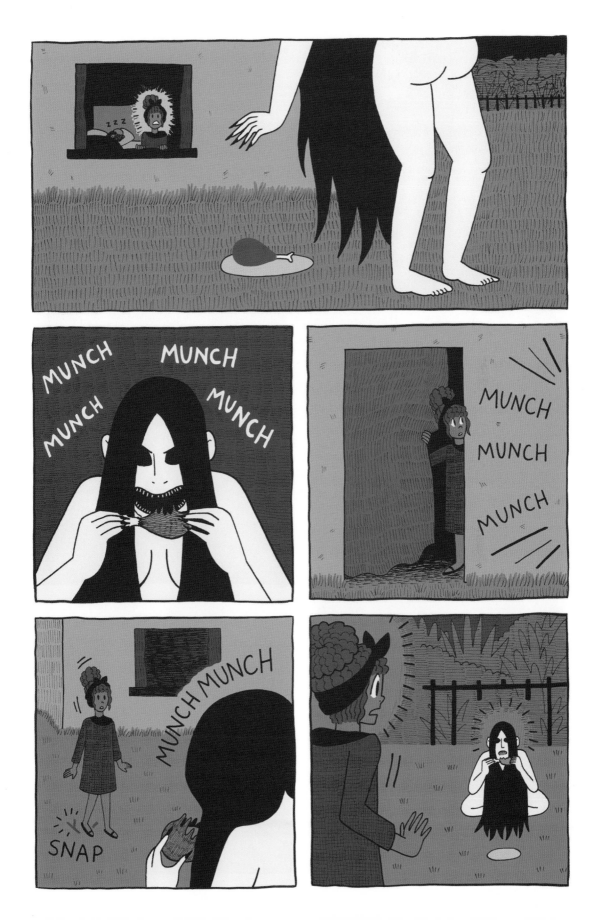

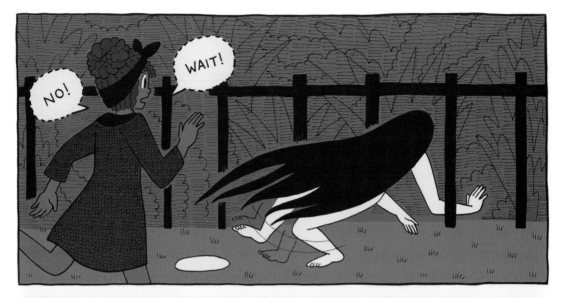

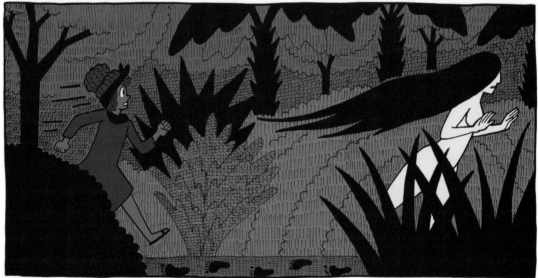

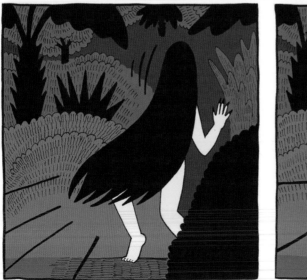

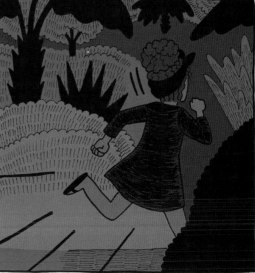

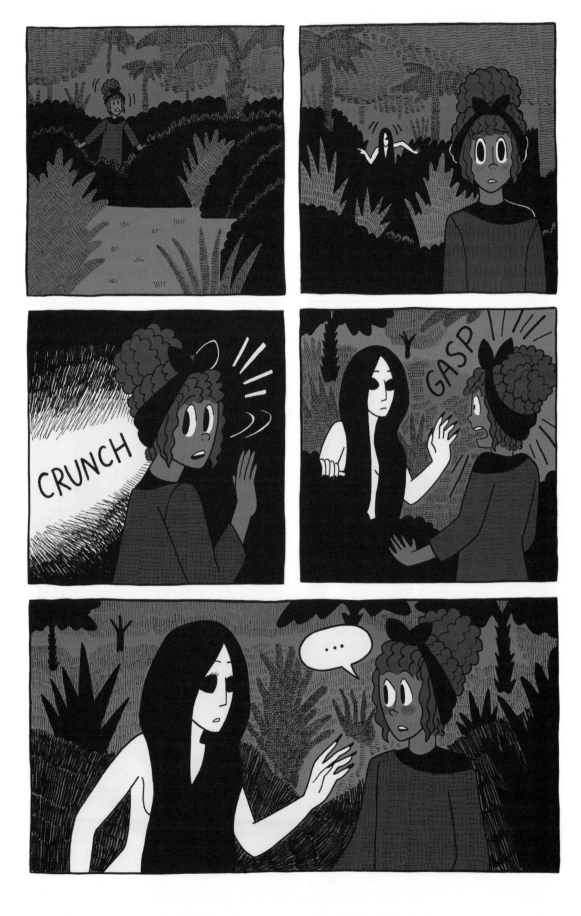

La Blanca
A TRUE STORY

XAIME 99

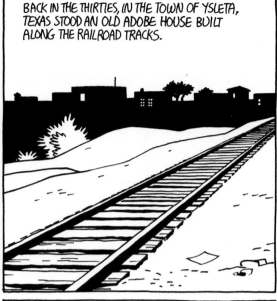

BACK IN THE THIRTIES, IN THE TOWN OF YSLETA, TEXAS STOOD AN OLD ADOBE HOUSE BUILT ALONG THE RAILROAD TRACKS.

FOR MANY YEARS STRANGE THINGS HAPPENED IN AND AROUND THE HOUSE. THE WALLS FREQUENTLY ECHOED WITH THE SOUND OF HUMAN TAPPING.

ONE MORNING ONE OF THE INHABITANTS OF THE HOUSE WOKE TO FIND HER BED TURNED TO FACE THE OPPOSITE SIDE OF THE ROOM. THERE WAS NO SIGN THAT ANYONE ELSE HAD ENTERED.

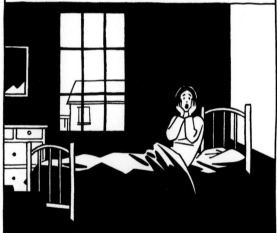

ONE DAY SOME KIDS PLAYING IN FRONT OF THE HOUSE HEARD A BELL-RINGING SOUND UNDER THE GROUND. IT SEEMED TO LEAD THEM TO THE RAILROAD TRACKS. THEY FOLLOWED THE SOUND ALONG THE TRACKS TILL IT DISAPPEARED.

ALL OF THESE ODD OCCURRENCES WERE BLAMED ON A NEIGHBORHOOD GHOST THEY CALLED LA BLANCA, A BRIGHTLY LIT FIGURE OF A WOMAN HIDING HER FACE UNDER A SHAWL. THE CLICK OF HER HEELS COULD BE HEARD AS SHE WALKED.

1

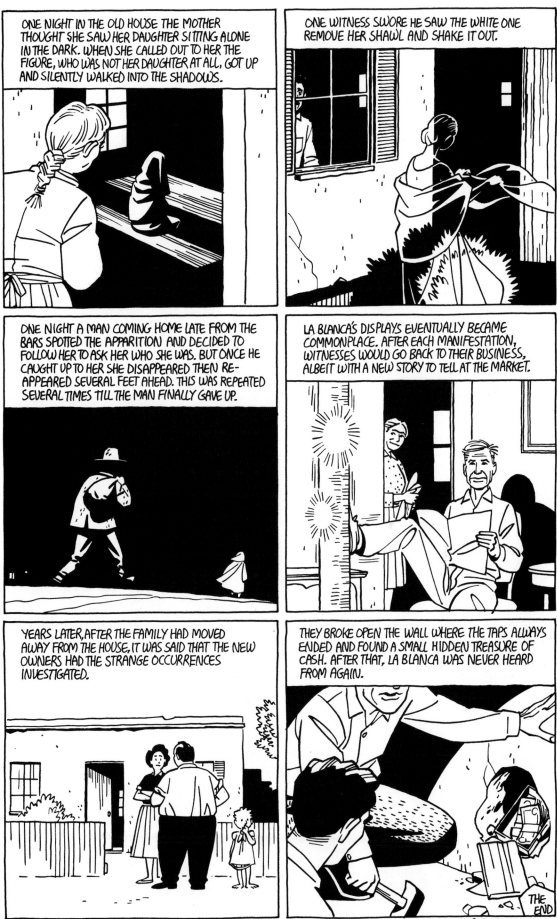

ONE NIGHT IN THE OLD HOUSE THE MOTHER THOUGHT SHE SAW HER DAUGHTER SITTING ALONE IN THE DARK. WHEN SHE CALLED OUT TO HER THE FIGURE, WHO WAS NOT HER DAUGHTER AT ALL, GOT UP AND SILENTLY WALKED INTO THE SHADOWS.

ONE WITNESS SWORE HE SAW THE WHITE ONE REMOVE HER SHAWL AND SHAKE IT OUT.

ONE NIGHT A MAN COMING HOME LATE FROM THE BARS SPOTTED THE APPARITION AND DECIDED TO FOLLOW HER TO ASK HER WHO SHE WAS. BUT ONCE HE CAUGHT UP TO HER SHE DISAPPEARED THEN RE-APPEARED SEVERAL FEET AHEAD. THIS WAS REPEATED SEVERAL TIMES TILL THE MAN FINALLY GAVE UP.

LA BLANCA'S DISPLAYS EVENTUALLY BECAME COMMONPLACE. AFTER EACH MANIFESTATION, WITNESSES WOULD GO BACK TO THEIR BUSINESS, ALBEIT WITH A NEW STORY TO TELL AT THE MARKET.

YEARS LATER, AFTER THE FAMILY HAD MOVED AWAY FROM THE HOUSE, IT WAS SAID THAT THE NEW OWNERS HAD THE STRANGE OCCURRENCES INVESTIGATED.

THEY BROKE OPEN THE WALL WHERE THE TAPS ALWAYS ENDED AND FOUND A SMALL HIDDEN TREASURE OF CASH. AFTER THAT, LA BLANCA WAS NEVER HEARD FROM AGAIN.

THE END

A TIP OF THE HAT TO MOM HERNANDEZ FOR A GREAT TALE...

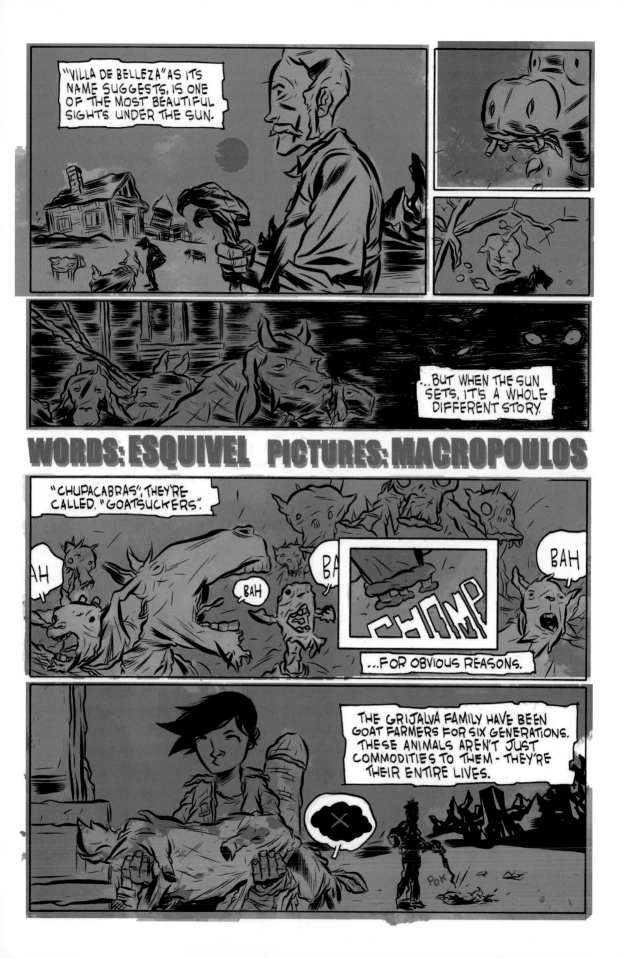

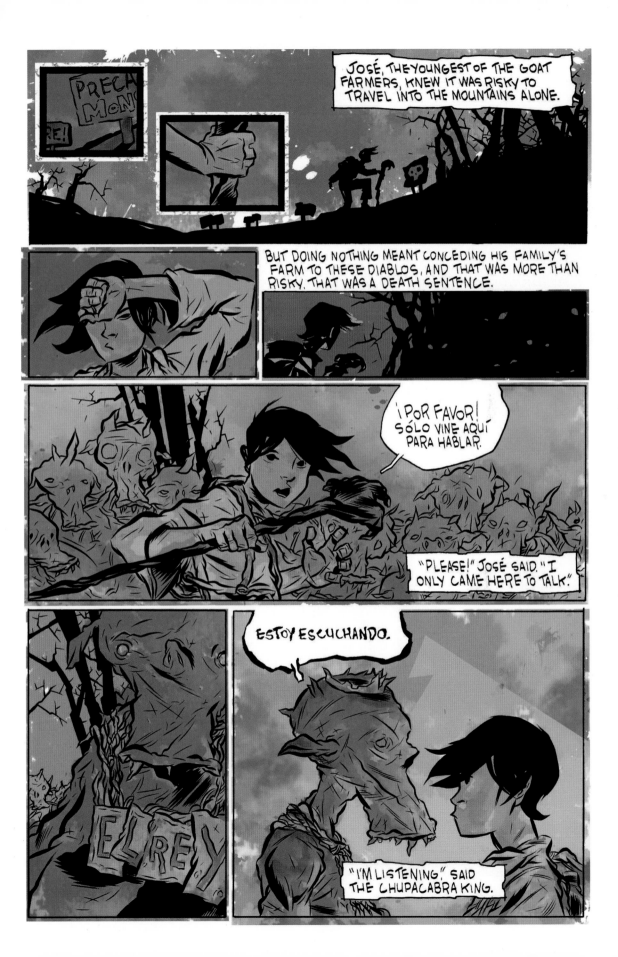

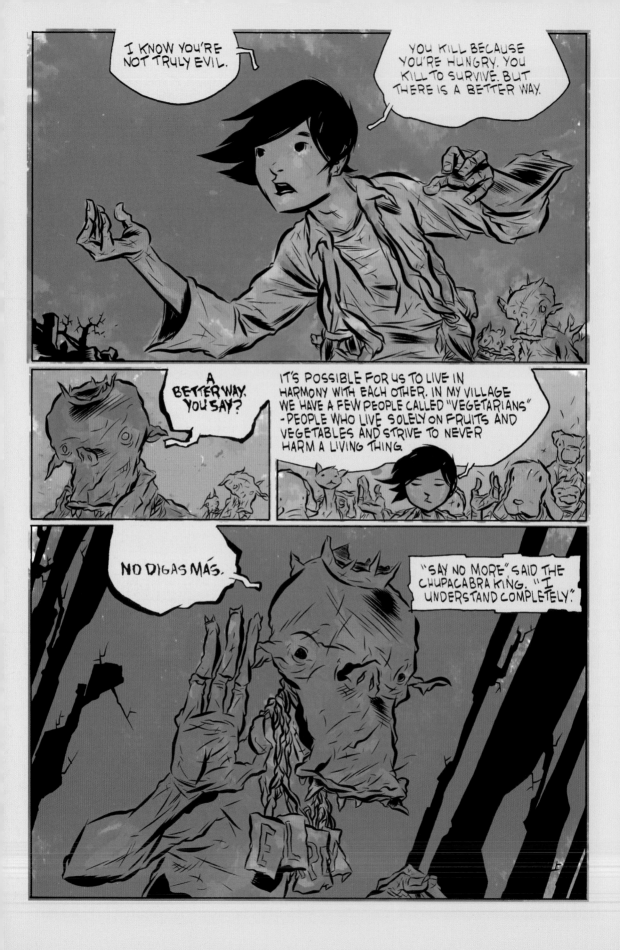

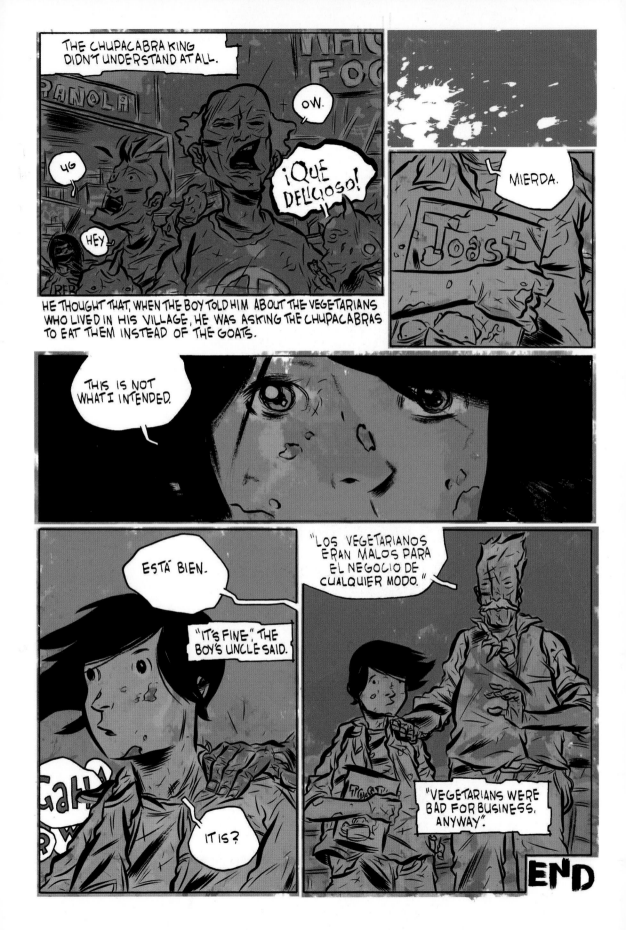

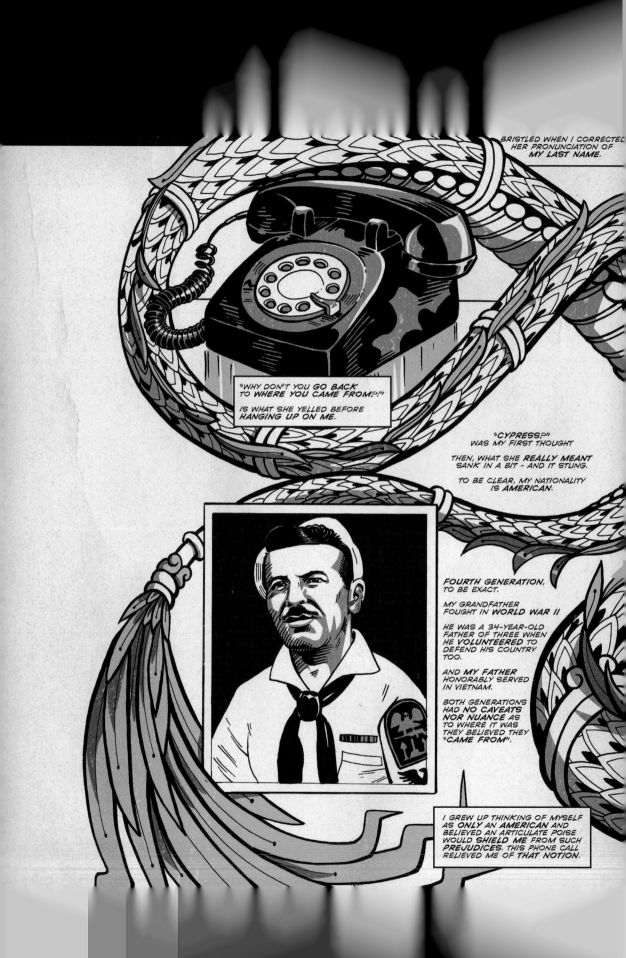

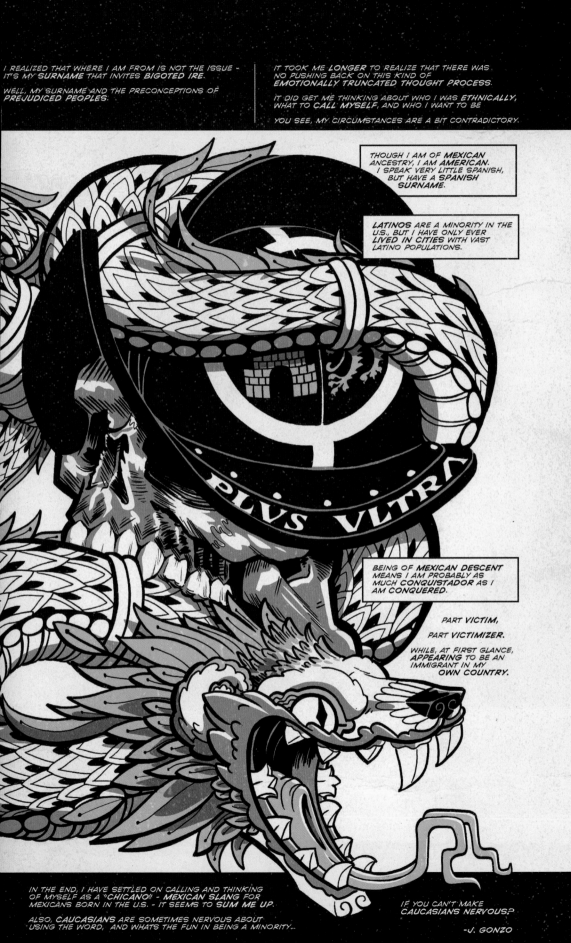

I REALIZED THAT WHERE I AM FROM IS NOT THE ISSUE - IT'S MY *SURNAME* THAT INVITES *BIGOTED IRE*.

WELL, MY SURNAME AND THE PRECONCEPTIONS OF *PREJUDICED PEOPLES*.

IT TOOK ME *LONGER* TO REALIZE THAT THERE WAS NO PUSHING BACK ON THIS KIND OF *EMOTIONALLY TRUNCATED THOUGHT PROCESS*.

IT DID GET ME THINKING ABOUT WHO I WAS *ETHNICALLY*, WHAT TO *CALL MYSELF*, AND WHO I WANT TO BE

YOU SEE, MY CIRCUMSTANCES ARE A BIT CONTRADICTORY.

THOUGH I AM OF *MEXICAN* ANCESTRY, I AM AMERICAN. I SPEAK VERY LITTLE SPANISH, BUT HAVE A *SPANISH* SURNAME.

*LATINOS* ARE A MINORITY IN THE U.S., BUT I HAVE ONLY EVER *LIVED IN CITIES* WITH VAST LATINO POPULATIONS.

BEING OF *MEXICAN DESCENT* MEANS I AM PROBABLY AS MUCH *CONQUISTADOR* AS I AM *CONQUERED*.

PART *VICTIM*,

PART *VICTIMIZER*.

WHILE, AT FIRST GLANCE, *APPEARING* TO BE AN IMMIGRANT IN MY OWN COUNTRY.

IN THE END, I HAVE SETTLED ON CALLING AND THINKING OF MYSELF AS A "*CHICANO*" - *MEXICAN SLANG* FOR MEXICANS BORN IN THE U.S. - IT SEEMS TO *SUM ME UP*.

ALSO, *CAUCASIANS* ARE SOMETIMES NERVOUS ABOUT USING THE WORD, AND WHATS THE FUN IN BEING A MINORITY...

IF YOU CAN'T MAKE *CAUCASIANS* NERVOUS?

-J. GONZO

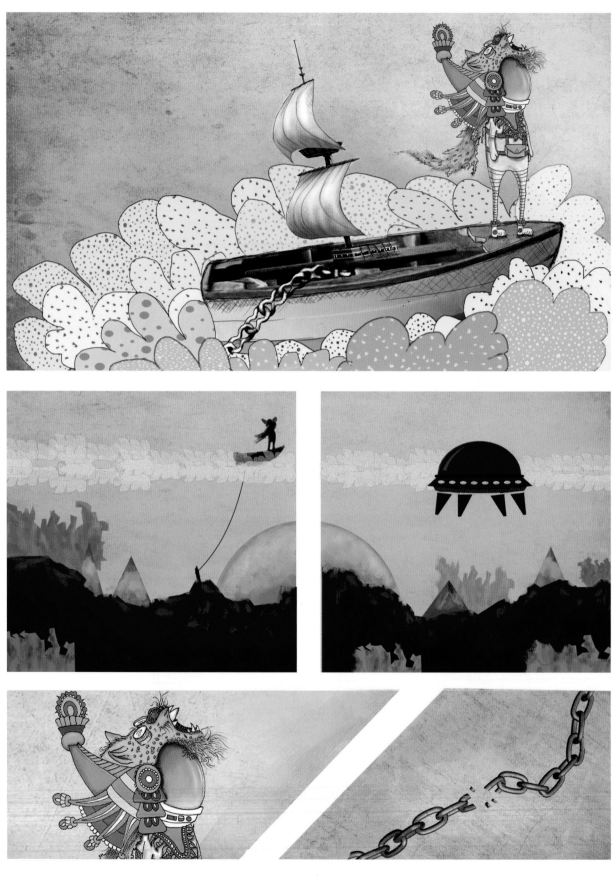

# BETWIXT & BETWEEN

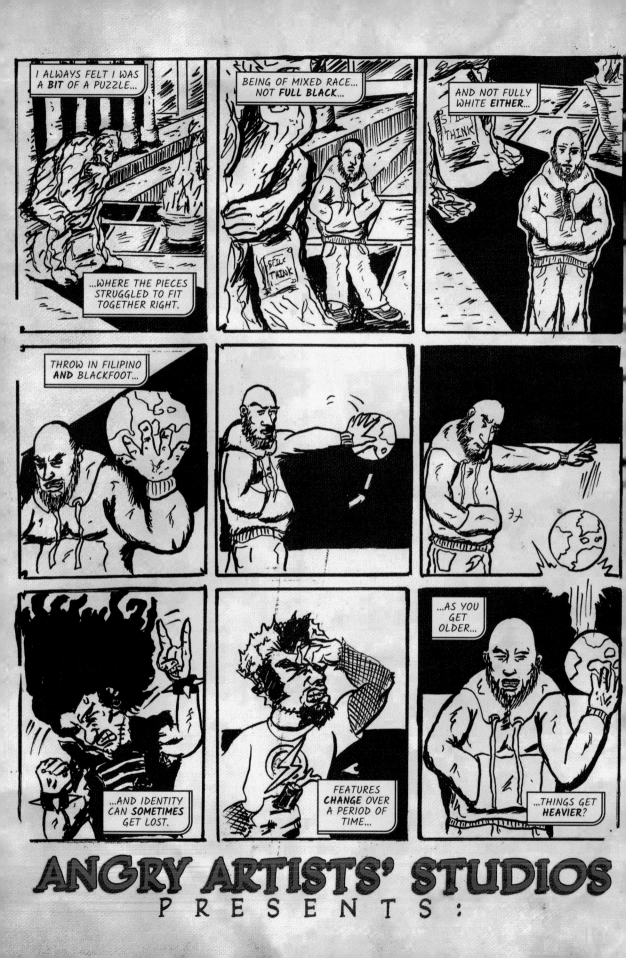

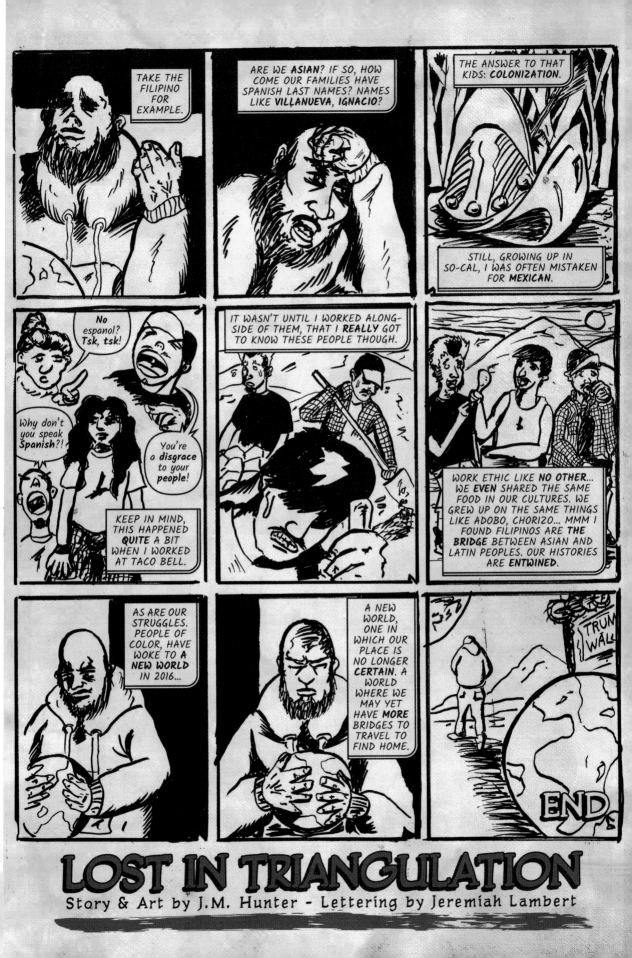

# LOST IN TRIANGULATION
Story & Art by J.M. Hunter - Lettering by Jeremiah Lambert

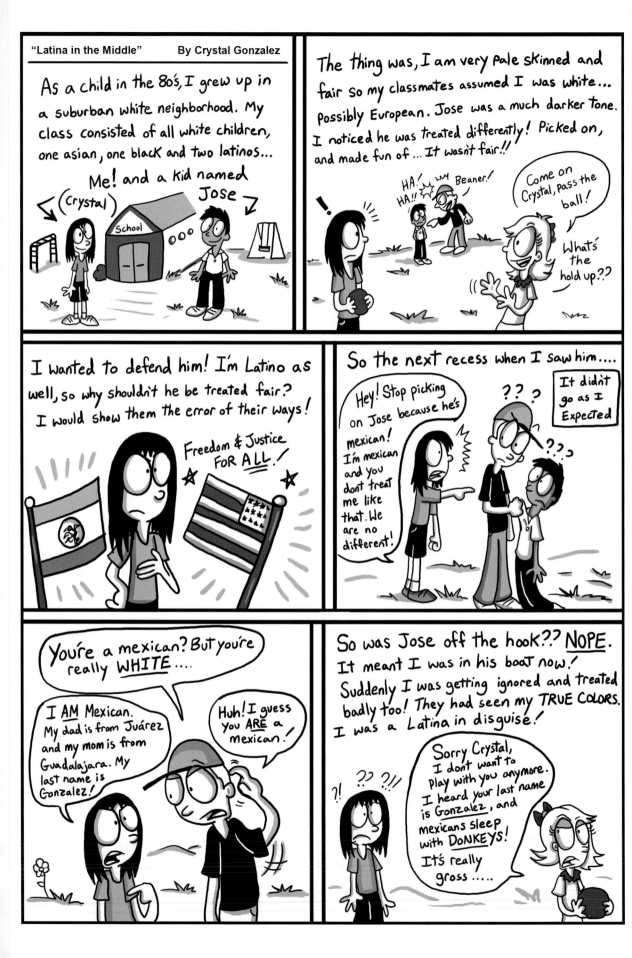

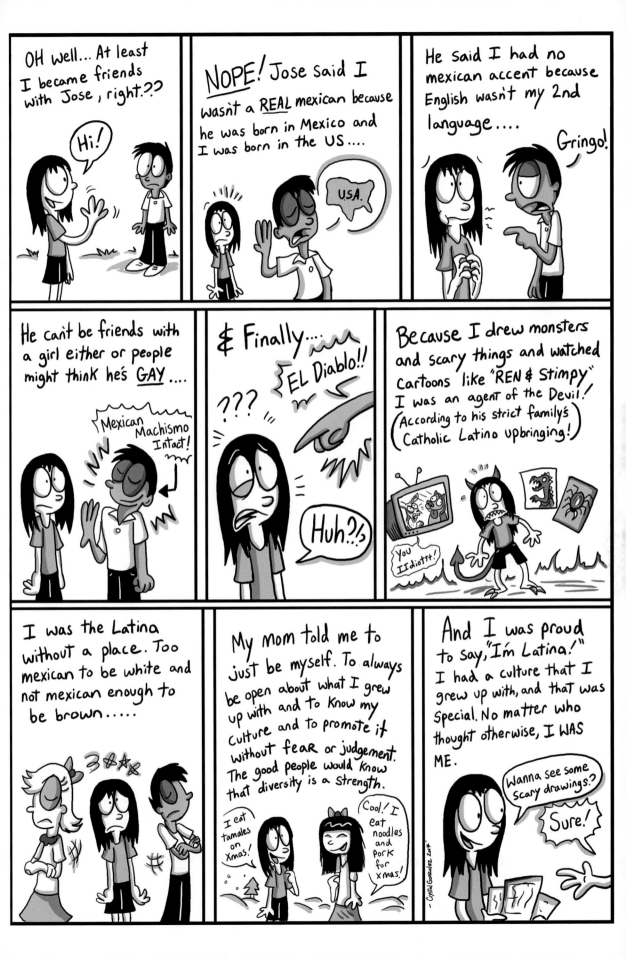

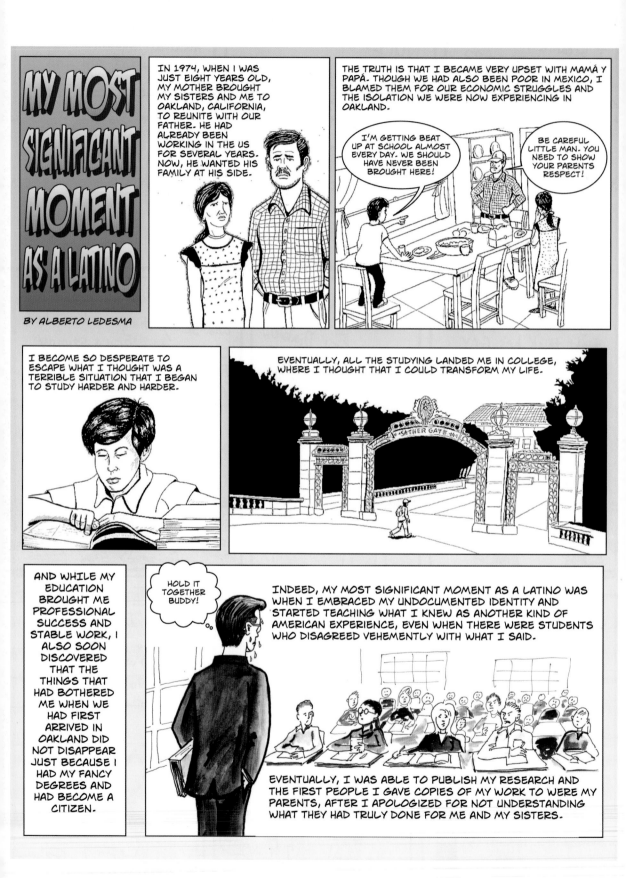

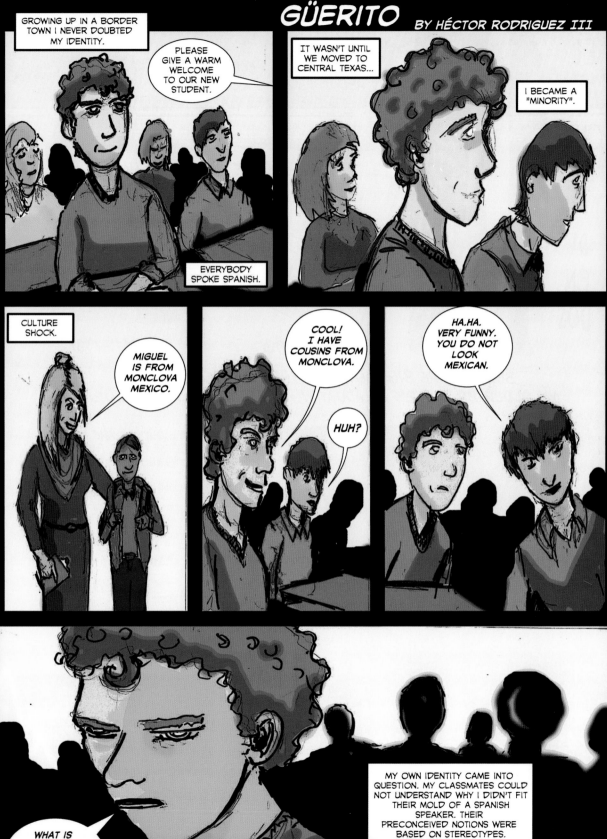

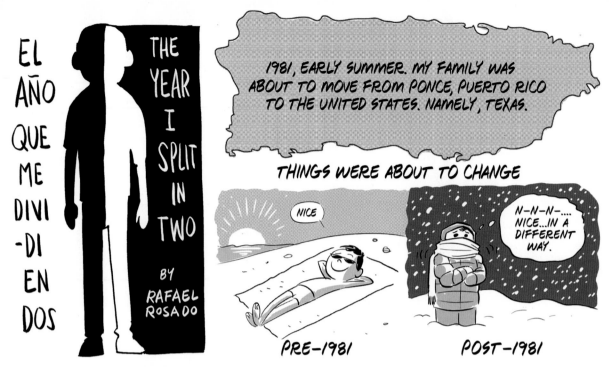

# EL AÑO QUE ME DIVI-DI EN DOS

# THE YEAR I SPLIT IN TWO

### BY RAFAEL ROSADO

1981, EARLY SUMMER. MY FAMILY WAS ABOUT TO MOVE FROM PONCE, PUERTO RICO TO THE UNITED STATES. NAMELY, TEXAS.

THINGS WERE ABOUT TO CHANGE

NICE

N-N-N-.... NICE...IN A DIFFERENT WAY.

PRE-1981

POST-1981

BEFORE THE BIG MOVE, WE SPENT A WEEK WITH MY OLDER BROTHER'S GRADUATING CLASS IN ORLANDO, FLORIDA.

WE WENT TO THE MAGIC KINGDOM, OF COURSE....

WE HUNG OUT AT THE HOTEL, HIT SOME OTHER PARKS... ...IT'S ALL A BLUR.

THINGS STILL SEEMED SOMEWHAT NORMAL.

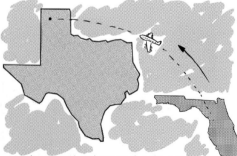

HALFWAY THROUGH THE WEEK, MY PARENTS AND MY LITTLE BROTHER FLEW TO TEXAS AHEAD OF US.

MY OLDER BROTHER AND I STAYED BACK IN FLORIDA FOR A FEW MORE DAYS.

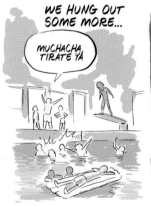

WE HUNG OUT SOME MORE...

MUCHACHA TIRATE YA

HAD A GOOD TIME...

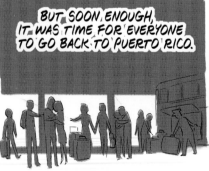

BUT SOON ENOUGH, IT WAS TIME FOR EVERYONE TO GO BACK TO PUERTO RICO.

...EVERYONE BUT US.

## MY OLDER BROTHER AND I STAYED BEHIND WHILE THE REST OF THE GANG WENT BACK TO PONCE

← **PAST**   **FUTURE** →

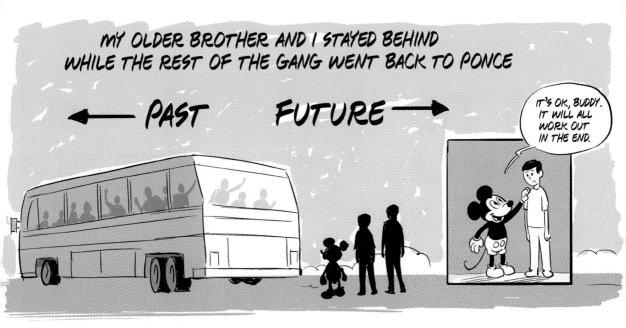

I'VE LIVED IN THE STATES OVER TWO THIRDS OF MY LIFE NOW, I MARRIED A LOVELY MIDWESTERN GIRL, AND HAD TWO BEAUTIFUL DAUGHTERS.

BUT ON THOSE COLD, SUNLESS, OHIO DAYS, THE BORICUA INSIDE ME LONGS FOR THOSE WARM AND SUNNY DAYS BACK IN THE ISLAND.

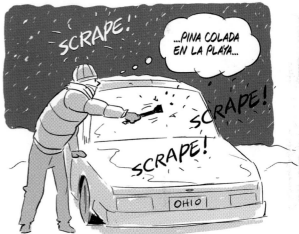

P.S.—WHEN MY BROTHER AND I FINALLY ARRIVED IN TEXAS, WE NOTICED A BUNCH OF GUITAR CASES IN BAGGAGE CLAIM. THE BAND JOURNEY WAS PLAYING A PRIVATE SHOW FOR SOME OIL MILLIONAIRE.

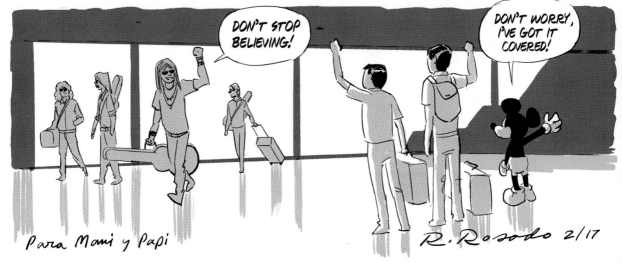

Para Mami y Papi

R. Rosado 2/17

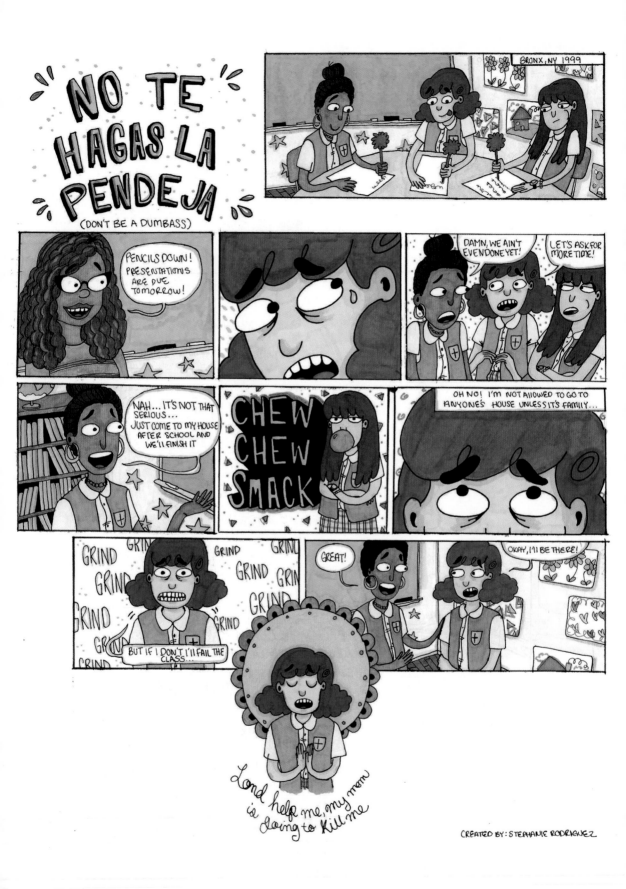

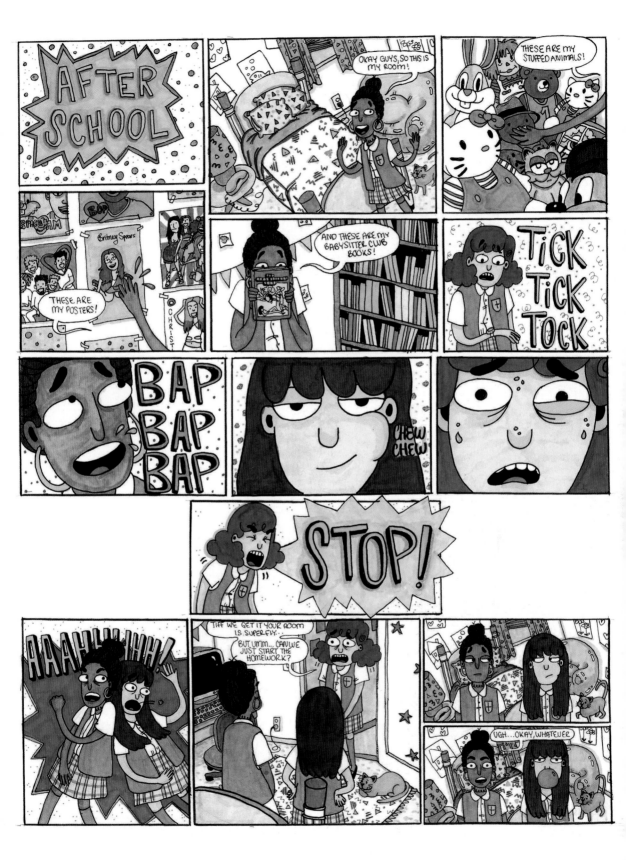

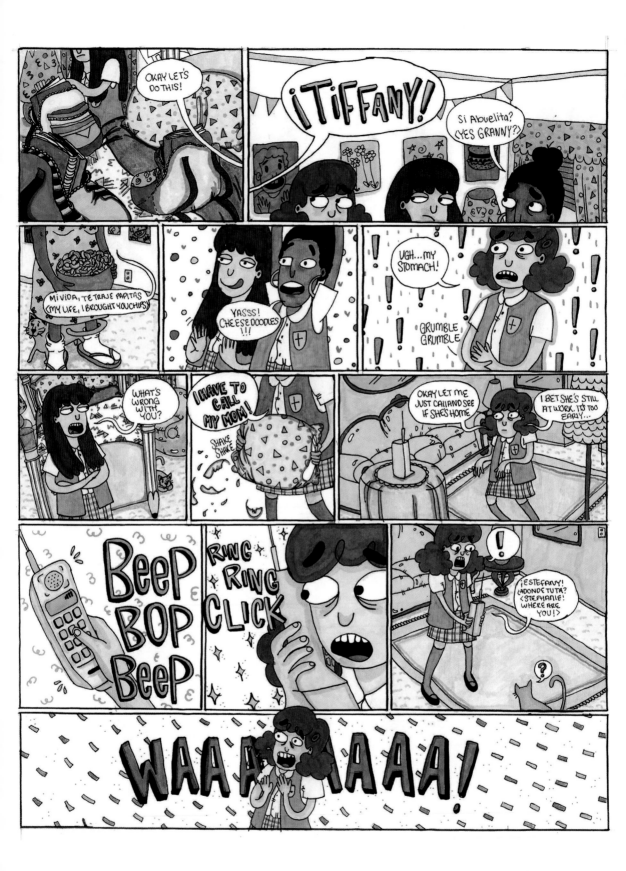

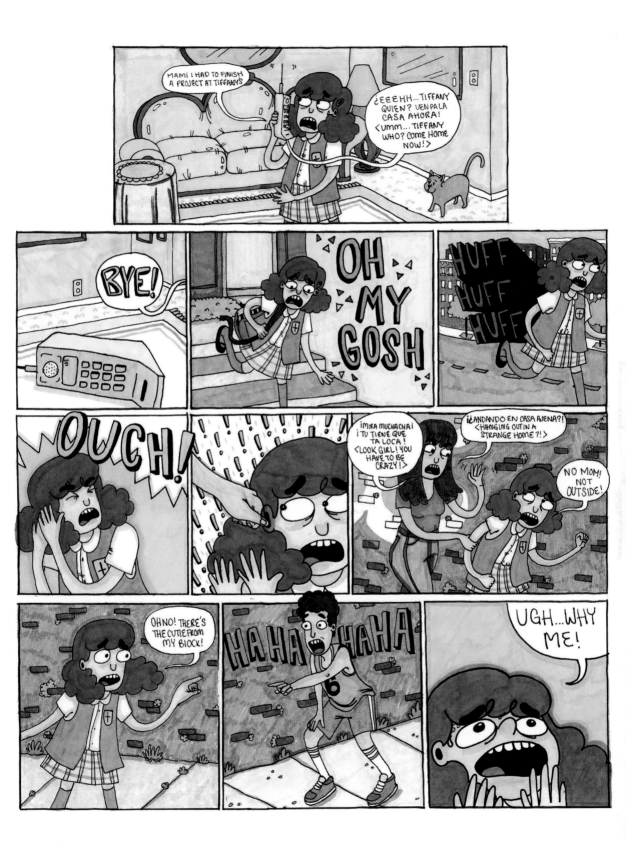

# BENDING TIME, SPACE, AND FORMS

Candy Briones, "The Mayan Prophesy"

Eric J. García, "Chopping Down the Cottonwood"

Alejandro Juvera (with Jeremiah Lambert), "Where the Heart Is"

Andrés Vera Martínez, "Down on the Riverbed"

Mapache Studios' Fernando de Peña and Rodrigo Vargas, "A Little Canción about My People"

Fernando Balderas Rodriguez, "Aztec of the City: Behind the Beginning"

Israel Francisco Haros Lopez, "Re-Membering"

# "The Mayan Prophecy"

## By Candy Briones

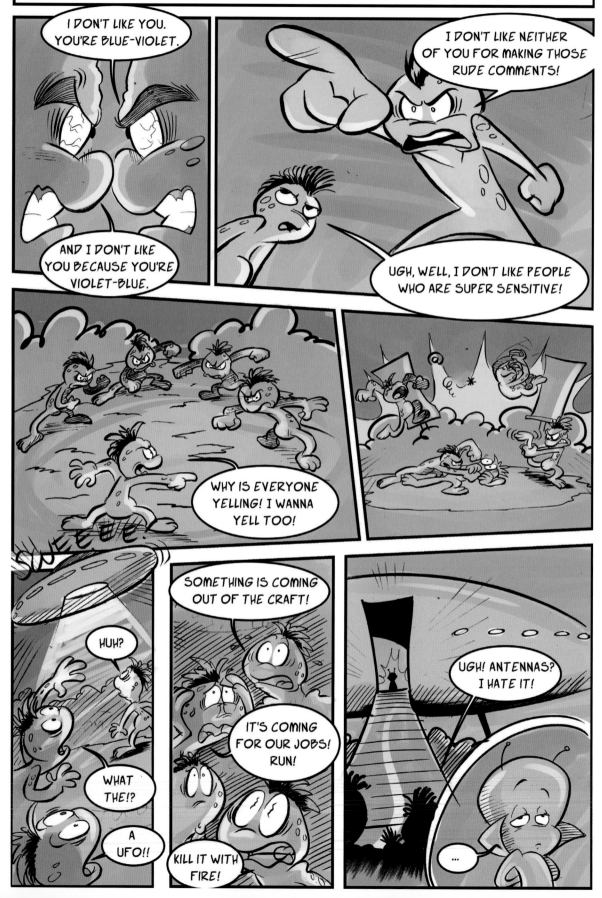

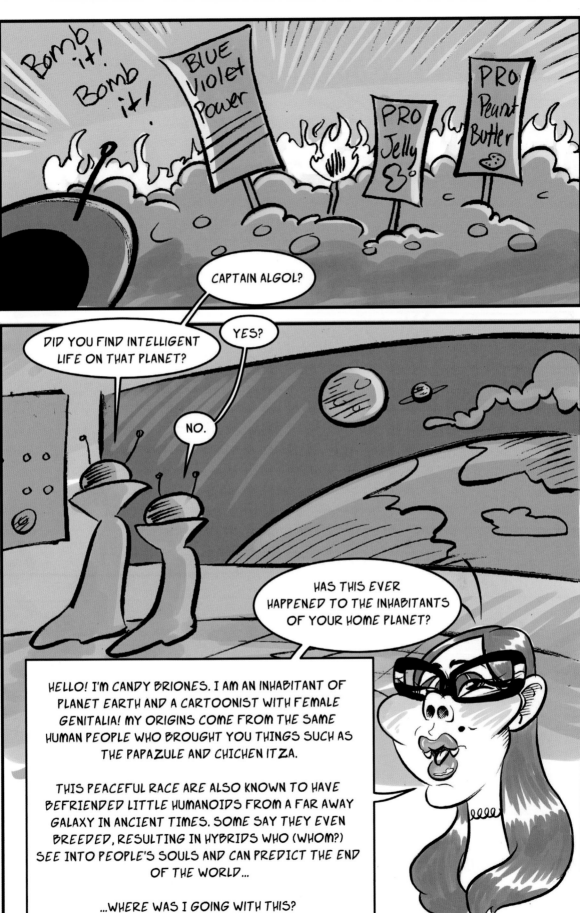

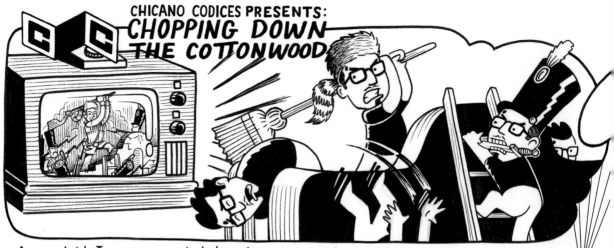

**CHICANO CODICES PRESENTS:**
## CHOPPING DOWN THE COTTONWOOD

As a child I was corrupted by the propaganda on T.V. which nurtured my fascination with warfare and manipulated my understanding of history.

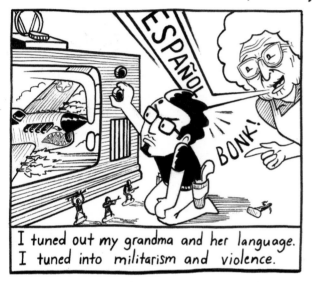

I tuned out my grandma and her language. I tuned into militarism and violence.

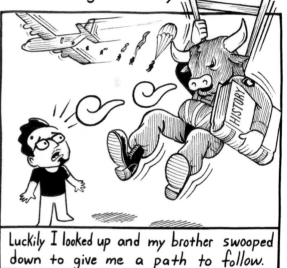

Luckily I looked up and my brother swooped down to give me a path to follow.

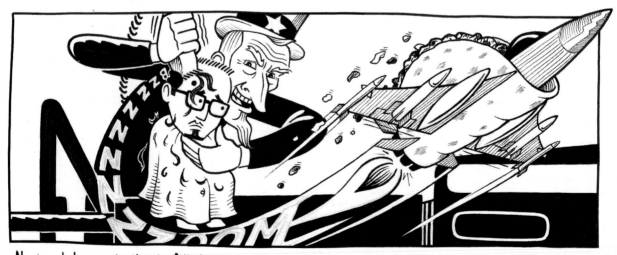

Nurtured by a childhood filled with G.I. Joe toys, Rambo movies, and an atomic bomb museum, I inevitably enlisted in the military.

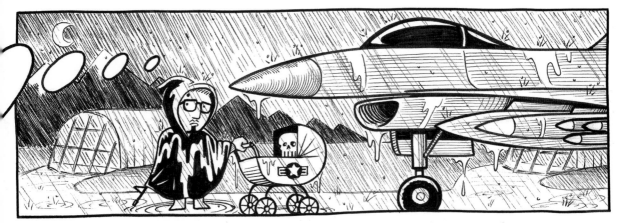

But guarding jets for the Air Force was nothing like defending the Alamo. Stationed in Italy, the only thing I feared was falling asleep on post.

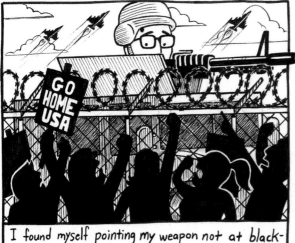

I found myself pointing my weapon not at black-hatted "bad guys" but at peaceful protestors.

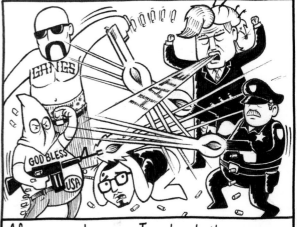

After my enlistment I realized that my war was not overseas but right here at home.

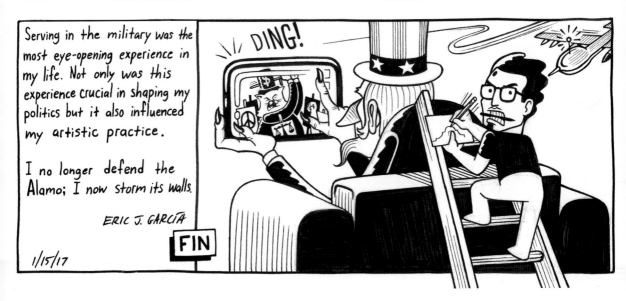

Serving in the military was the most eye-opening experience in my life. Not only was this experience crucial in shaping my politics but it also influenced my artistic practice.

I no longer defend the Alamo; I now storm its walls.

ERIC J. GARCÍA

FIN

1/15/17

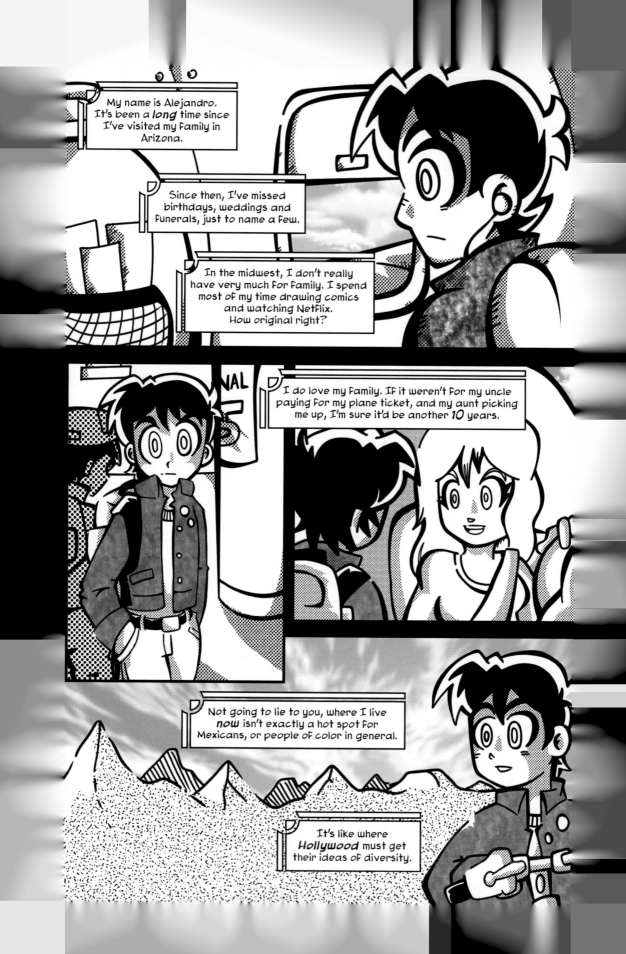

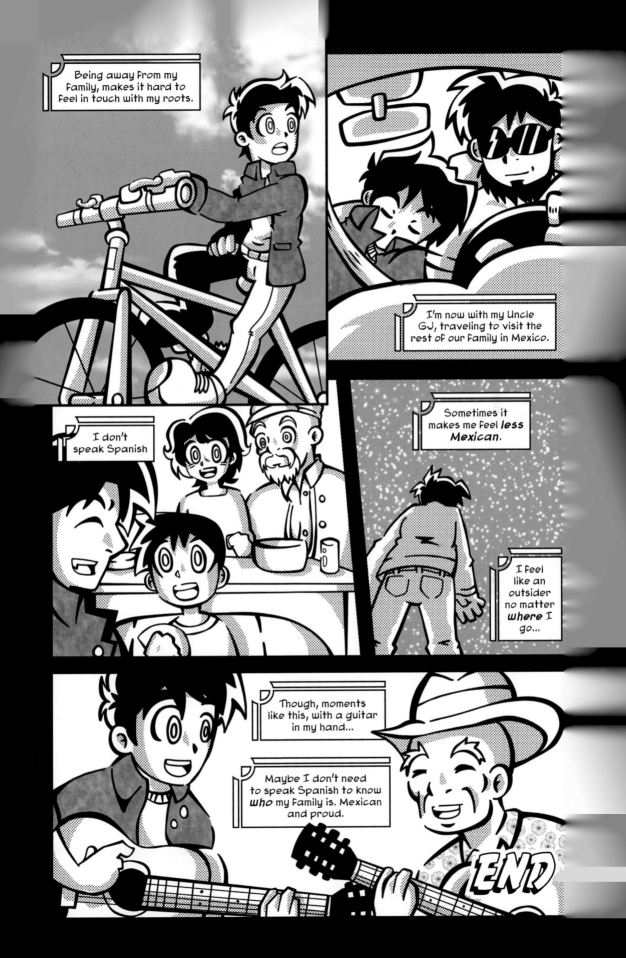

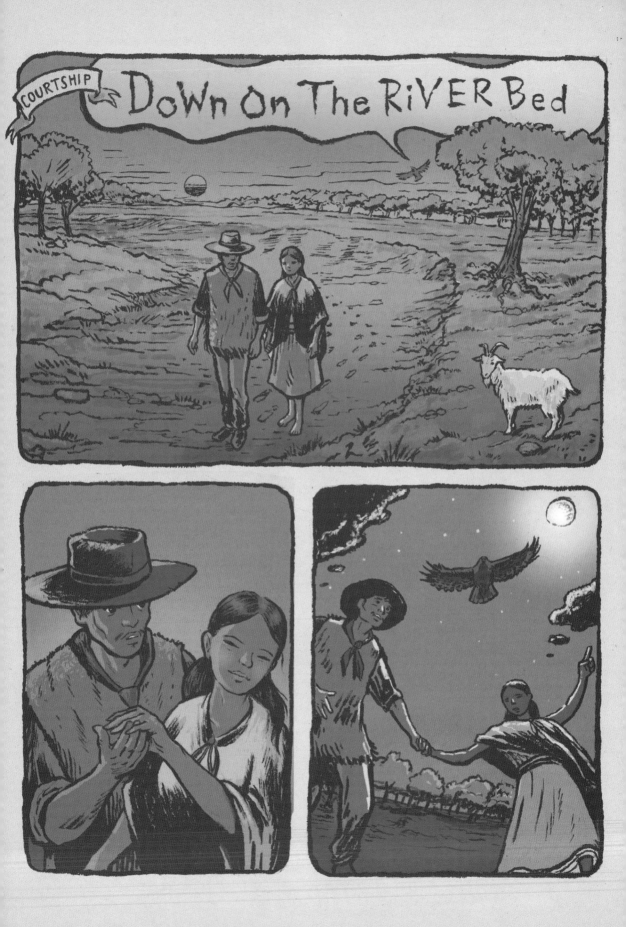

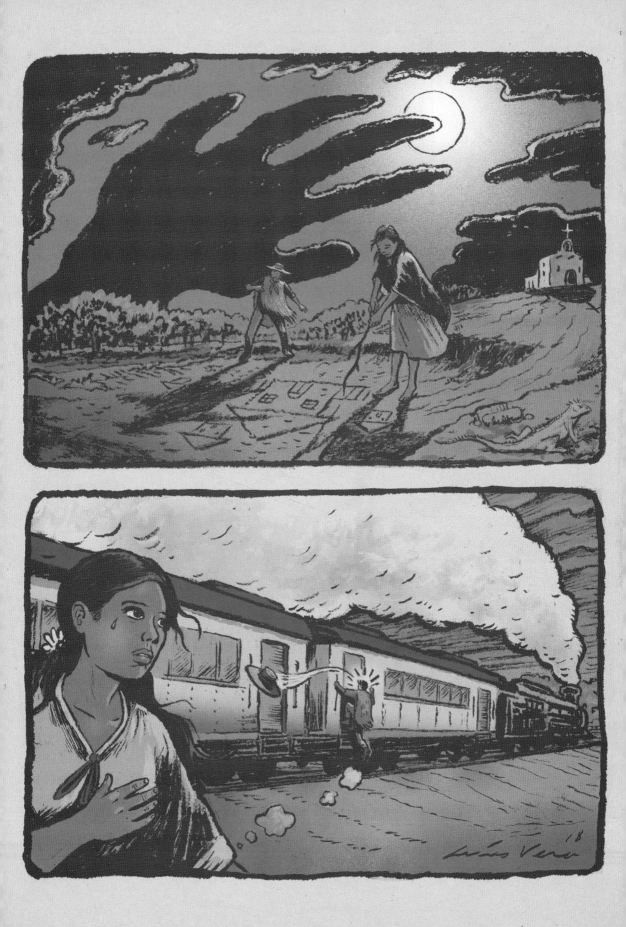

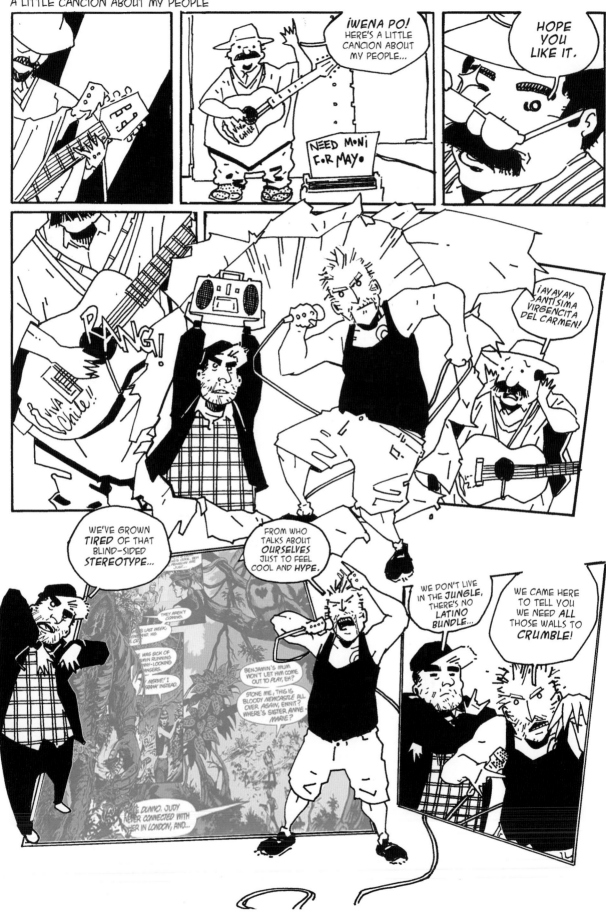

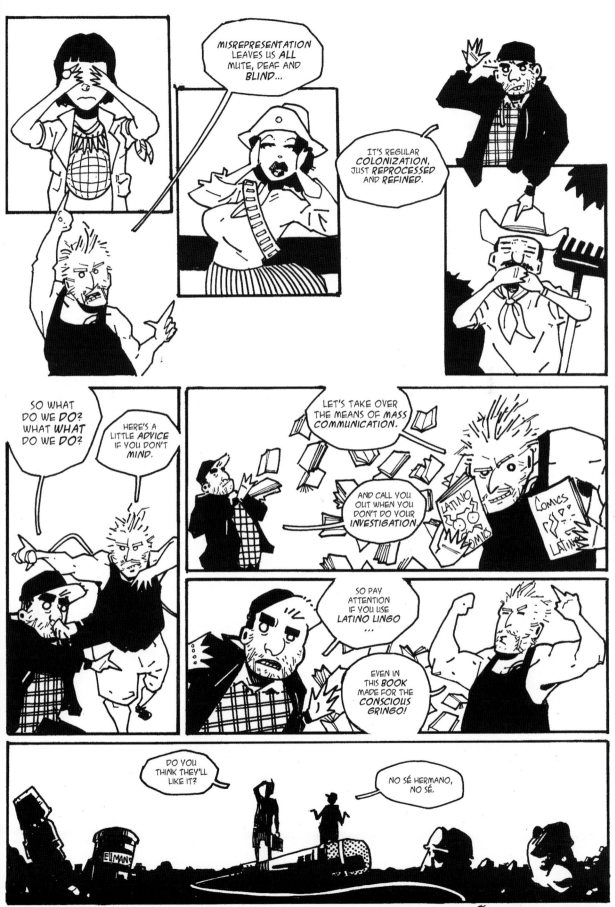

FERNANDO DE PEÑA+RODRIGO VARGAS '16

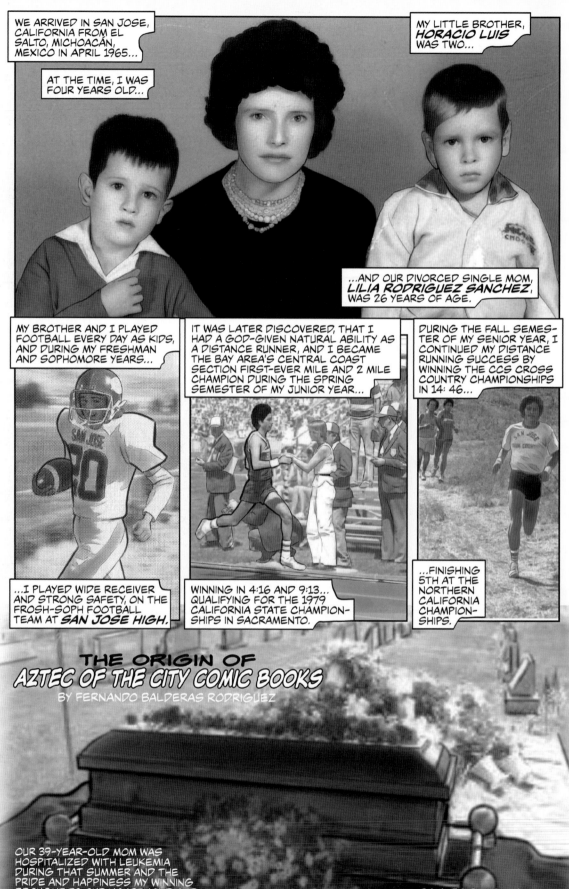

WE ARRIVED IN SAN JOSE, CALIFORNIA FROM EL SALTO, MICHOACÁN, MEXICO IN APRIL 1965...

AT THE TIME, I WAS FOUR YEARS OLD...

MY LITTLE BROTHER, *HORACIO LUIS* WAS TWO...

...AND OUR DIVORCED SINGLE MOM, *LILIA RODRIGUEZ SANCHEZ*, WAS 26 YEARS OF AGE.

MY BROTHER AND I PLAYED FOOTBALL EVERY DAY AS KIDS, AND DURING MY FRESHMAN AND SOPHOMORE YEARS...

...I PLAYED WIDE RECEIVER AND STRONG SAFETY, ON THE FROSH-SOPH FOOTBALL TEAM AT *SAN JOSE HIGH.*

IT WAS LATER DISCOVERED, THAT I HAD A GOD-GIVEN NATURAL ABILITY AS A DISTANCE RUNNER, AND I BECAME THE BAY AREA'S CENTRAL COAST SECTION FIRST-EVER MILE AND 2 MILE CHAMPION DURING THE SPRING SEMESTER OF MY JUNIOR YEAR...

WINNING IN 4:16 AND 9:13... QUALIFYING FOR THE 1979 CALIFORNIA STATE CHAMPIONSHIPS IN SACRAMENTO.

DURING THE FALL SEMESTER OF MY SENIOR YEAR, I CONTINUED MY DISTANCE RUNNING SUCCESS BY WINNING THE CCS CROSS COUNTRY CHAMPIONSHIPS IN 14:46...

...FINISHING 5TH AT THE NORTHERN CALIFORNIA CHAMPIONSHIPS.

# THE ORIGIN OF
## *AZTEC OF THE CITY COMIC BOOKS*
### BY FERNANDO BALDERAS RODRIGUEZ

OUR 39-YEAR-OLD MOM WAS HOSPITALIZED WITH LEUKEMIA DURING THAT SUMMER AND THE PRIDE AND HAPPINESS MY WINNING BROUGHT TO OUR HOUSEHOLD, AND HER HEART, WAS CRUSHED WITH THE AGONY AND PAIN OF HER PASSING AWAY ON OCTOBER 1, 1979...

I COMPETED LOCALLY AT *SAN JOSE CITY COLLEGE* IN CROSS COUNTRY THE FOLLOWING YEAR...THEN DROPPED OUT OF SCHOOL AND QUIT RUNNING IN 1981 AT 19 YEARS OF AGE...

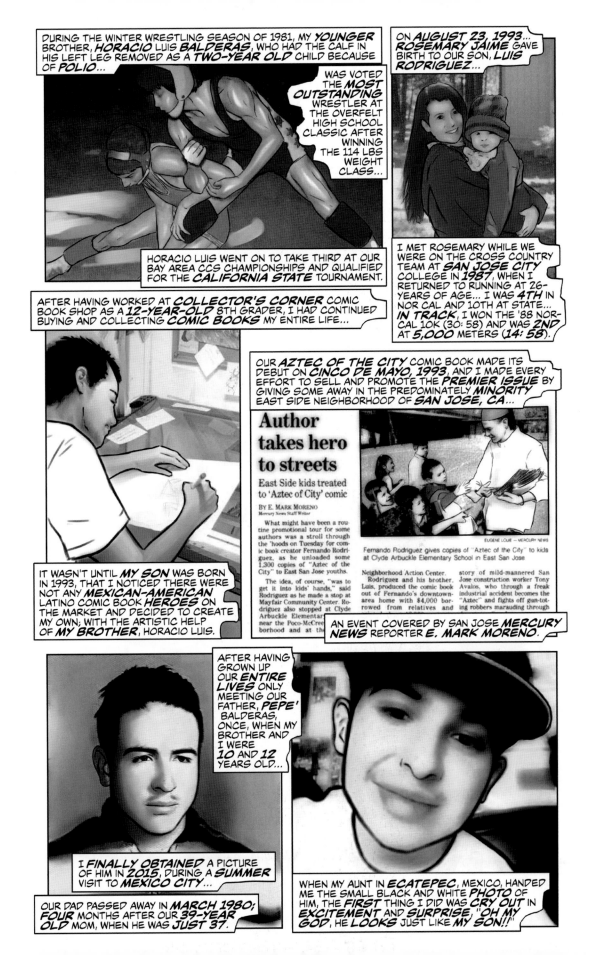

DURING THE WINTER WRESTLING SEASON OF 1981, MY *YOUNGER* BROTHER, *HORACIO* LUIS *BALDERAS*, WHO HAD THE CALF IN HIS LEFT LEG REMOVED AS A *TWO-YEAR OLD* CHILD BECAUSE OF *POLIO*...

WAS VOTED THE *MOST OUTSTANDING* WRESTLER AT THE OVERFELT HIGH SCHOOL CLASSIC AFTER WINNING THE 114 LBS WEIGHT CLASS...

HORACIO LUIS WENT ON TO TAKE THIRD AT OUR BAY AREA CCS CHAMPIONSHIPS AND QUALIFIED FOR THE *CALIFORNIA STATE* TOURNAMENT.

ON *AUGUST 23, 1993*... *ROSEMARY JAIME* GAVE BIRTH TO OUR SON, *LUIS RODRIGUEZ*...

I MET ROSEMARY WHILE WE WERE ON THE CROSS COUNTRY TEAM AT *SAN JOSE CITY* COLLEGE IN *1987*, WHEN I RETURNED TO RUNNING AT 26-YEARS OF AGE... I WAS *4TH* IN NOR CAL AND 10TH AT STATE... *IN TRACK*, I WON THE '88 NOR-CAL 10K (30:58) AND WAS *2ND* AT *5,000* METERS (14:58).

AFTER HAVING WORKED AT *COLLECTOR'S CORNER* COMIC BOOK SHOP AS A *12-YEAR-OLD* 8TH GRADER, I HAD CONTINUED BUYING AND COLLECTING *COMIC BOOKS* MY ENTIRE LIFE...

OUR *AZTEC OF THE CITY* COMIC BOOK MADE ITS DEBUT ON *CINCO DE MAYO, 1993*, AND I MADE EVERY EFFORT TO SELL AND PROMOTE THE *PREMIER ISSUE* BY GIVING SOME AWAY IN THE PREDOMINATELY *MINORITY* EAST SIDE NEIGHBORHOOD OF *SAN JOSE, CA*...

## Author takes hero to streets

### East Side kids treated to 'Aztec of City' comic

BY E. MARK MORENO
Mercury News Staff Writer

What might have been a routine promotional tour for some authors was a stroll through the 'hoods on Tuesday for comic book creator Fernando Rodriguez, as he unloaded some 1,300 copies of "Aztec of the City" to East San Jose youths.

The idea, of course, "was to get it into kids' hands," said Rodriguez as he made a stop at Mayfair Community Center. Luis, produced the comic book out of Fernando's downtown-area home with $4,000 borrowed from relatives and

Fernando Rodriguez gives copies of "Aztec of the City" to kids at Clyde Arbuckle Elementary School in East San Jose

EUGENE LOUIE — MERCURY NEWS

Neighborhood Action Center.

Rodriguez and his brother, Luis, produced the comic book out of Fernando's downtown-area home with $4,000 borrowed from relatives and also stopped at Clyde Arbuckle Elementary near the Poco-McCree borhood and at the

story of mild-mannered San Jose construction worker Tony Avalos, who through a freak industrial accident becomes the "Aztec" and fights off gun-toting robbers marauding through

IT WASN'T UNTIL *MY SON* WAS BORN IN 1993, THAT I NOTICED THERE WERE NOT ANY *MEXICAN-AMERICAN* LATINO COMIC BOOK *HEROES* ON THE MARKET AND DECIDED TO CREATE MY OWN; WITH THE ARTISTIC HELP OF *MY BROTHER*, HORACIO LUIS.

AN EVENT COVERED BY SAN JOSE *MERCURY NEWS* REPORTER *E. MARK MORENO*.

AFTER HAVING GROWN UP OUR *ENTIRE LIVES* ONLY MEETING OUR FATHER, *PEPE'* BALDERAS, ONCE, WHEN MY BROTHER AND I WERE *10* AND *12* YEARS OLD...

I *FINALLY OBTAINED* A PICTURE OF HIM IN *2015*, DURING A *SUMMER* VISIT TO *MEXICO CITY*...

OUR DAD PASSED AWAY IN *MARCH 1980*; *FOUR* MONTHS AFTER OUR *39-YEAR OLD* MOM, WHEN HE WAS *JUST 37*.

WHEN MY AUNT IN *ECATEPEC*, MEXICO, HANDED ME THE SMALL BLACK AND WHITE *PHOTO* OF HIM, THE *FIRST* THING I DID WAS *CRY OUT* IN *EXCITEMENT* AND *SURPRISE*, "OH MY GOD, HE *LOOKS* JUST LIKE *MY SON!!*"

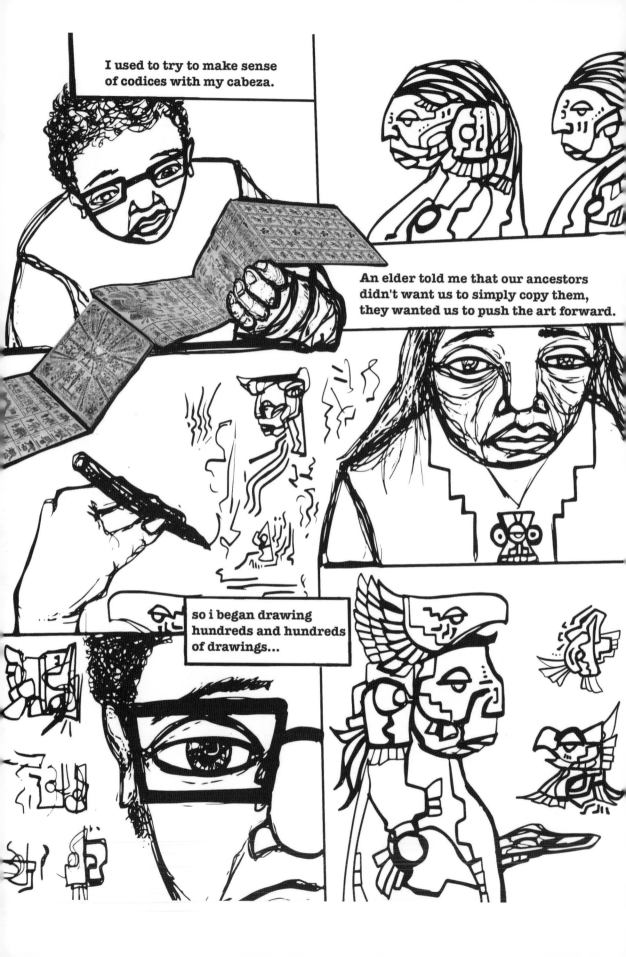

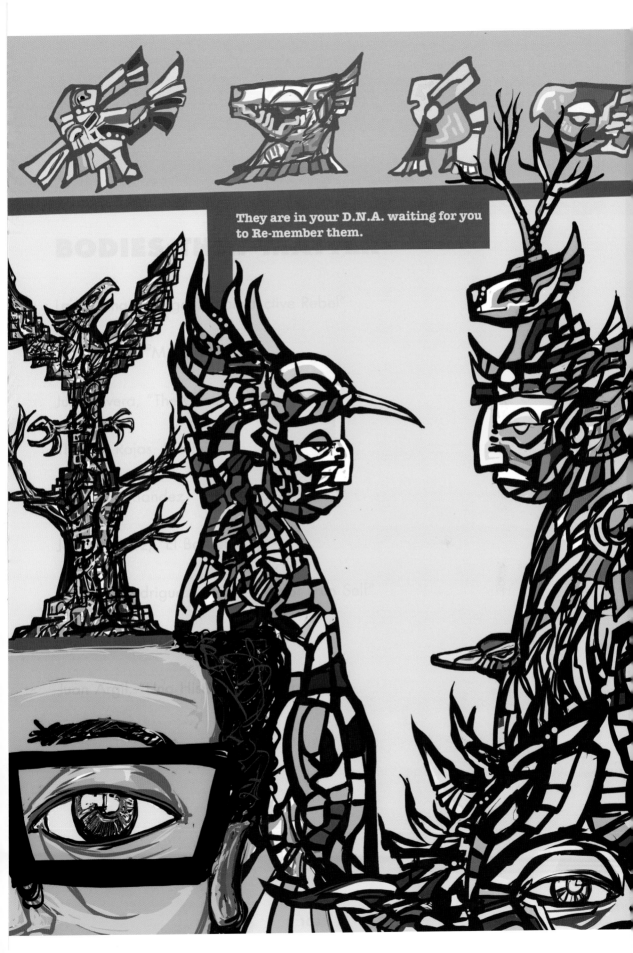

They are in your D.N.A. waiting for you to Re-member them.

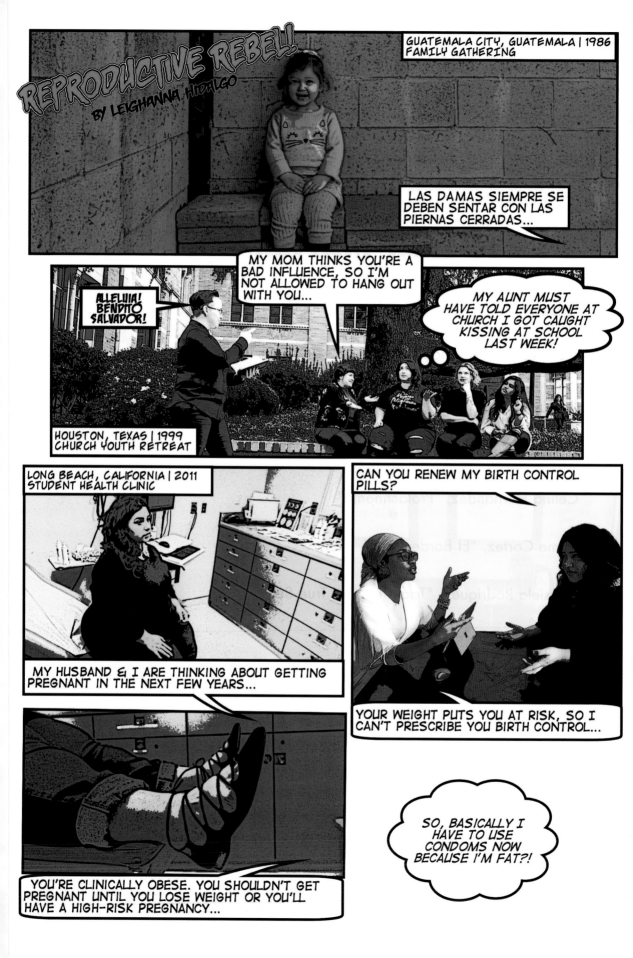

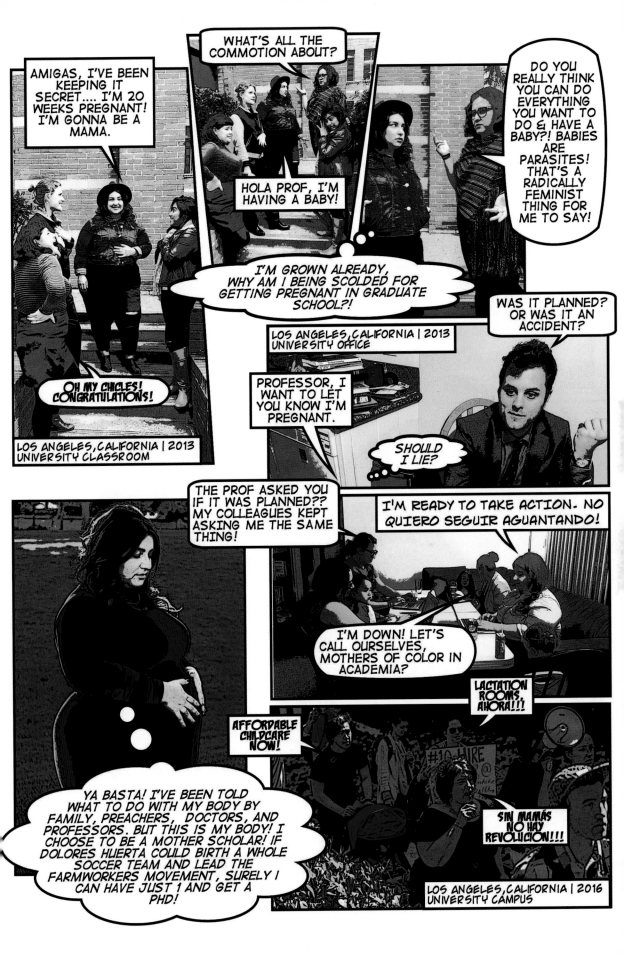

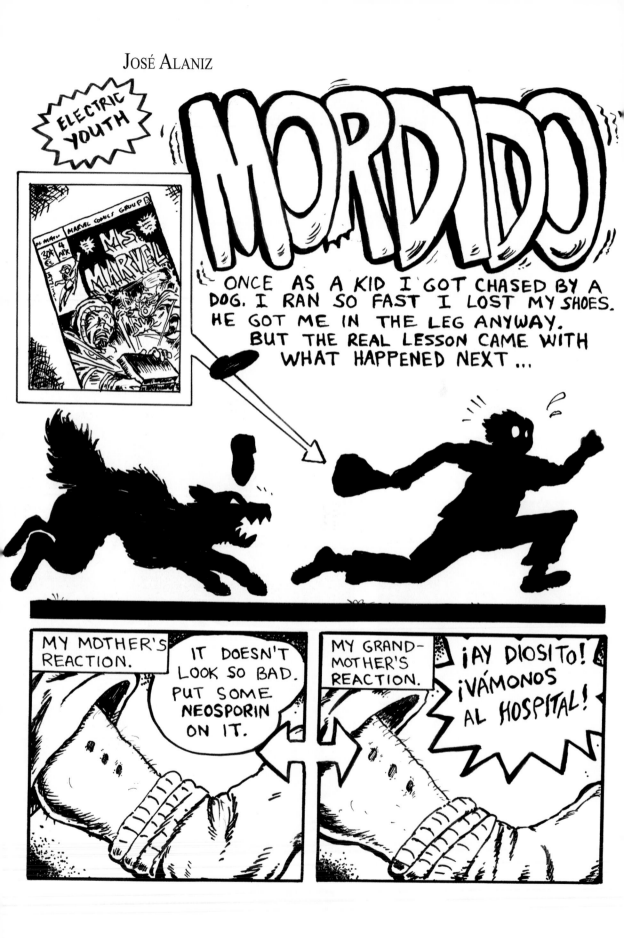

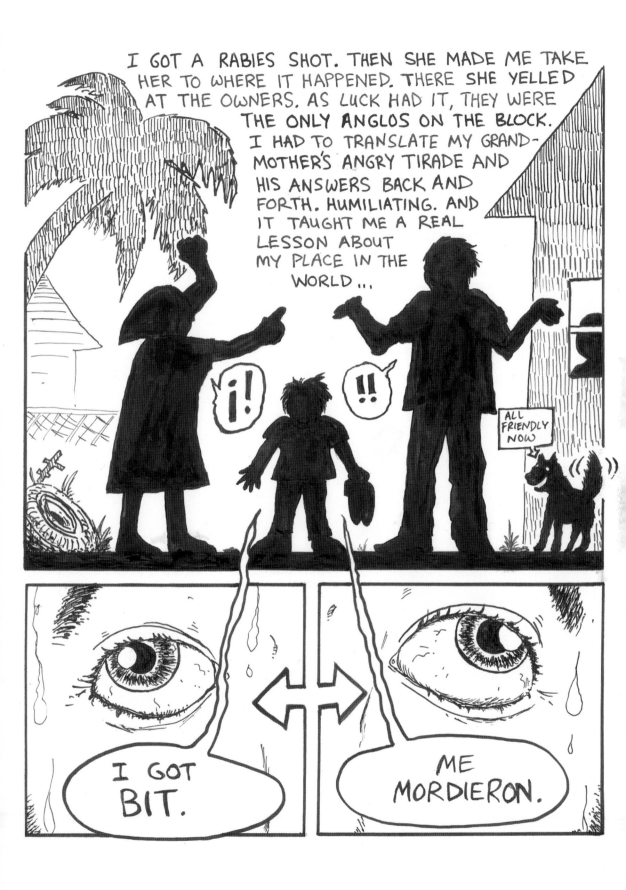

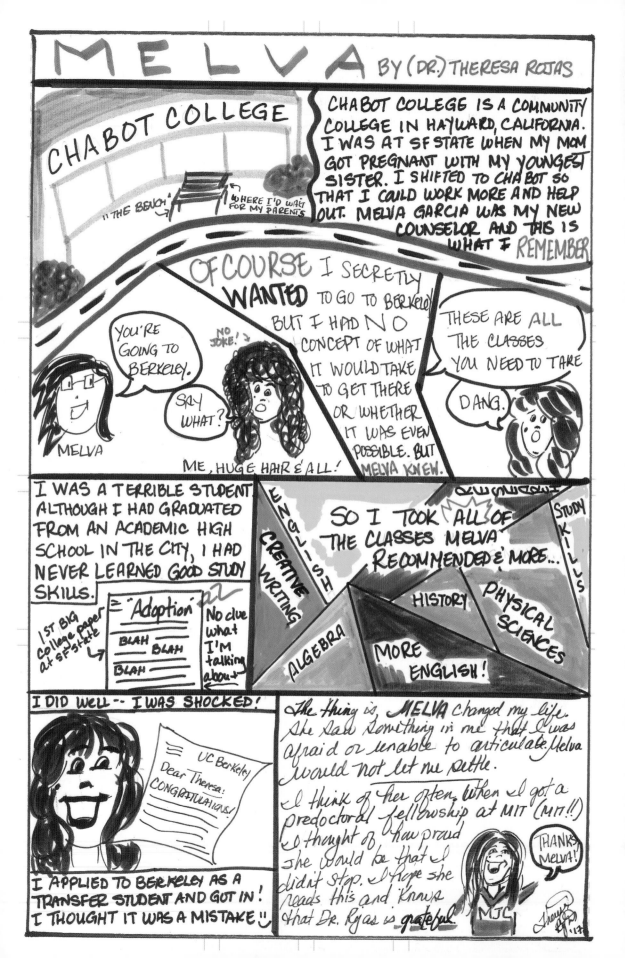

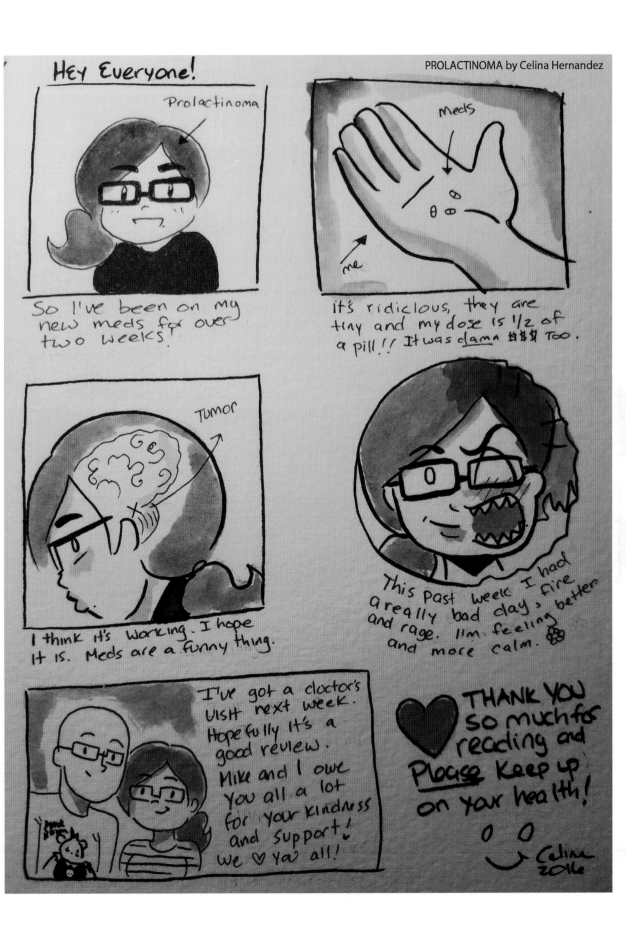

PROLACTINOMA by Celina Hernandez

# El Border Xing

Jaime Cortez, 2017

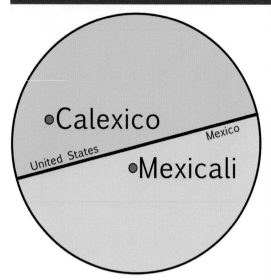

•Calexico

Mexico

United States

•Mexicali

A bit cutesy, those inverted names for twinned cities that kiss so awkwardly across the border.

It is 1974.

Crossing into Mexico is frictionless. The border guard, who seems to have nothing to guard, waves us all in. Car after car coasts past-no questions asked. We stay for weeks.

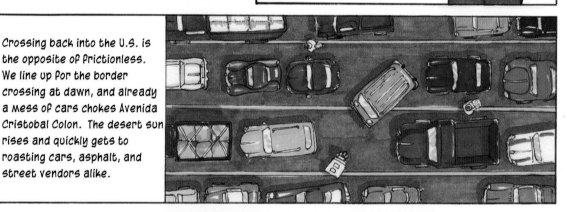

Crossing back into the U.S. is the opposite of frictionless. We line up for the border crossing at dawn, and already a mess of cars chokes Avenida Cristobal Colon. The desert sun rises and quickly gets to roasting cars, asphalt, and street vendors alike.

The vendors walk against the traffic, hawking their wares. Cintos. Sombreros. Serapes. Sandia con limon. The littlest vendors are just five or six, tired out already in the early morning sun.

Chicles

They seem kind of lucky to me. No hovering parents or teachers in sight. Every day a feast of independence. All the gum you can chew. That is my 3rd grade logic...

Dad overpays for the gum with a silver dollar. I do not yet know that he was once a little vendor on these streets.

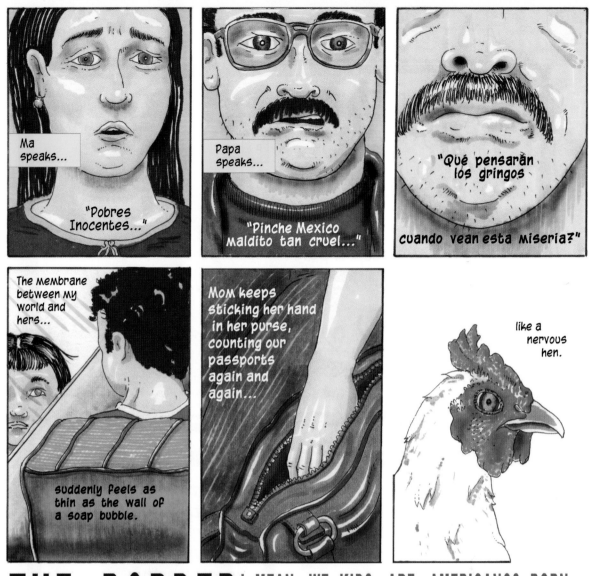

# THE BORDER IS STRANGE.

I MEAN, WE KIDS ARE AMERICANOS BORN. MAMA AND PAPA ARE AMERICANOS MADE. PERO AQUI EN LA FRONTERA, WE FEEL SO FRAGILE. LESS LIKE CITIZENS AND MORE LIKE TENTATIVE GUESTS WHO COULD BE SUMMARILY DIS-INVITED, SENT IN REVERSE, BACK TO THE MOTHERLAND, SO BELOVED AND CHINGADA. THE AIR IN OUR CAR IS COOL AND SMELLS OF FREON & SHAME. We breathe it all in…

# TAP INTO YOUR TRUE SELF
## BY GRASIELA RODRIGUEZ

Art has always been a part of my life.

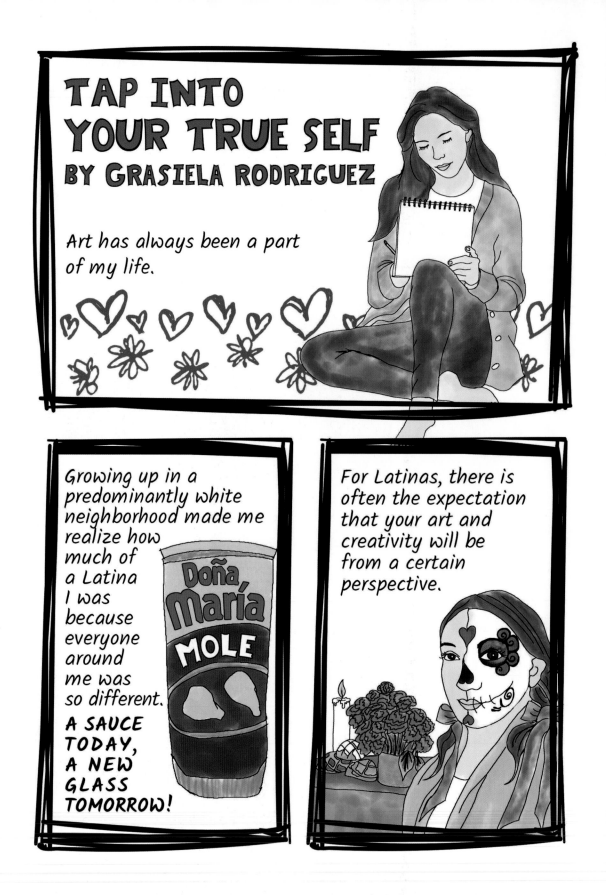

Growing up in a predominantly white neighborhood made me realize how much of a Latina I was because everyone around me was so different.

**A SAUCE TODAY, A NEW GLASS TOMORROW!**

Doña María MOLE

For Latinas, there is often the expectation that your art and creativity will be from a certain perspective.

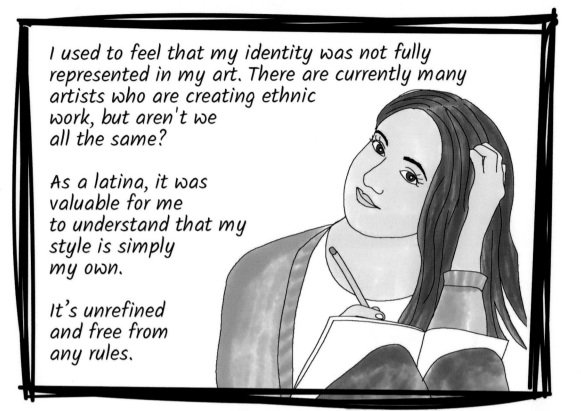

I used to feel that my identity was not fully represented in my art. There are currently many artists who are creating ethnic work, but aren't we all the same?

As a latina, it was valuable for me to understand that my style is simply my own.

It's unrefined and free from any rules.

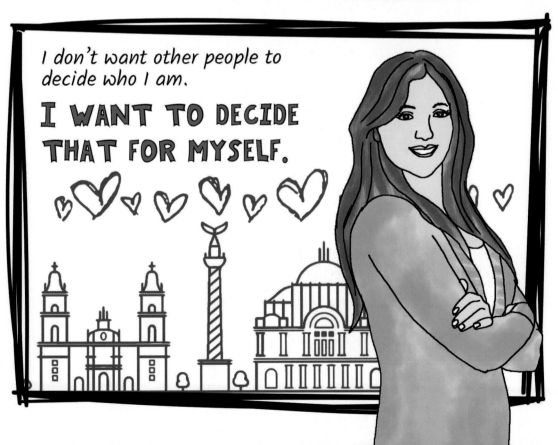

I don't want other people to decide who I am.

**I WANT TO DECIDE THAT FOR MYSELF.**

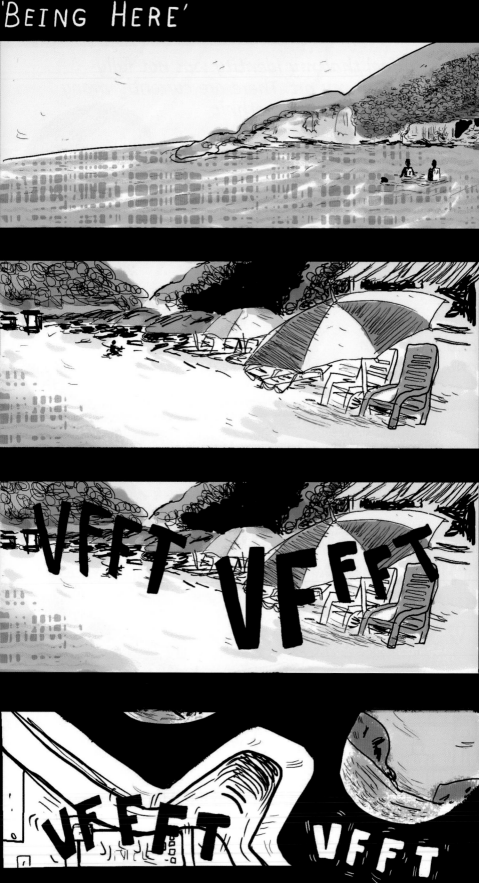

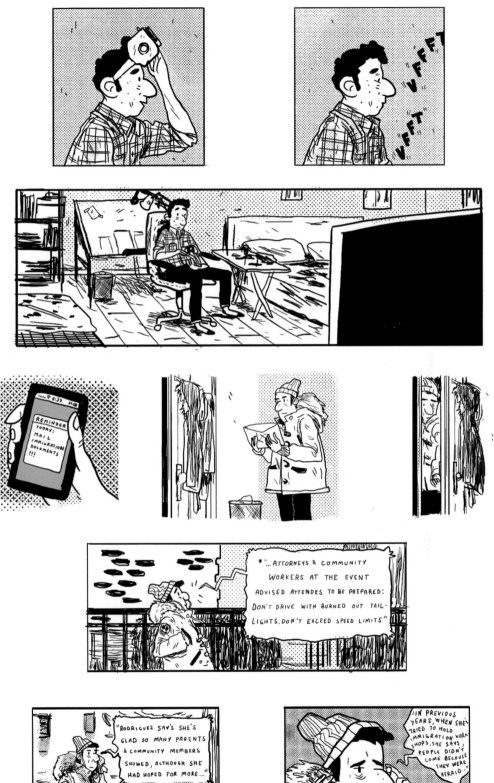
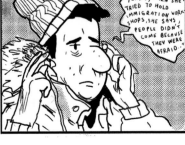

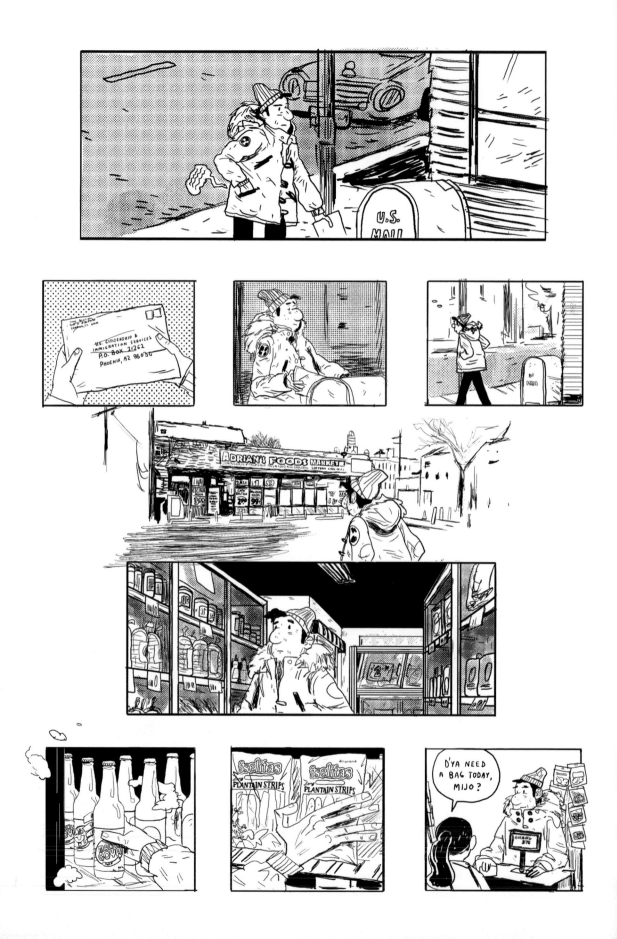

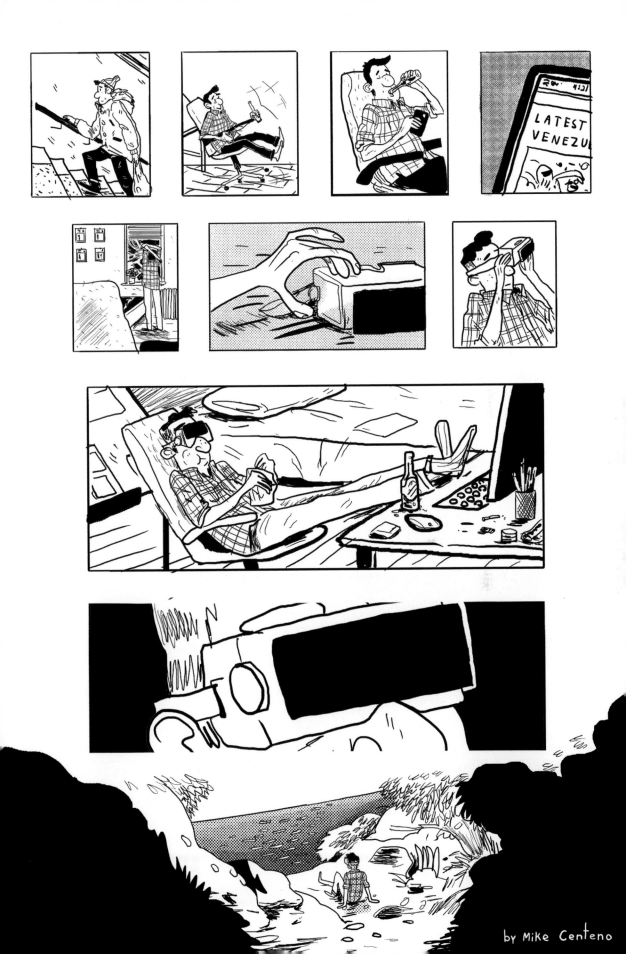

by Mike Centeno

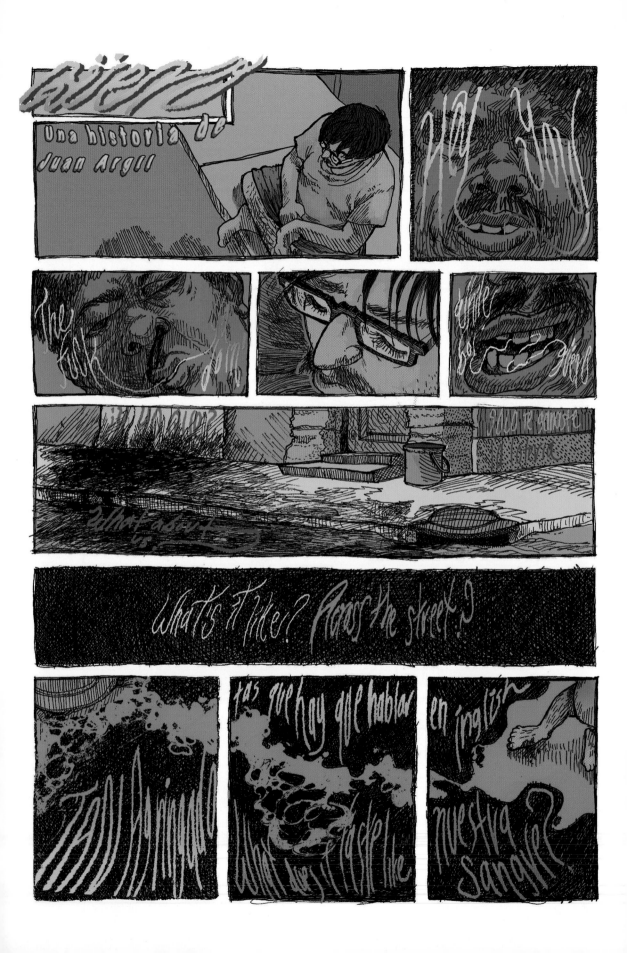

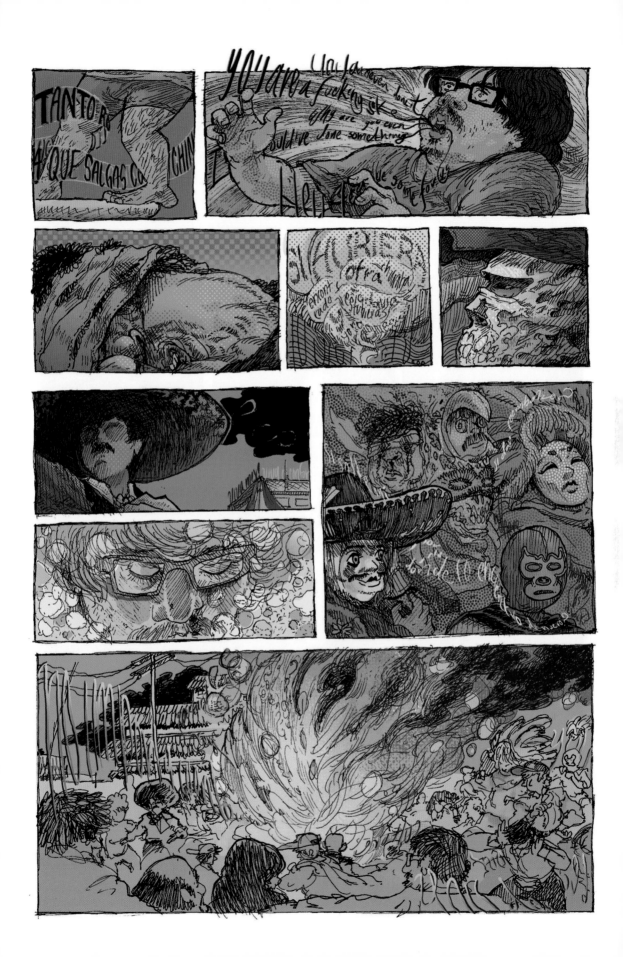

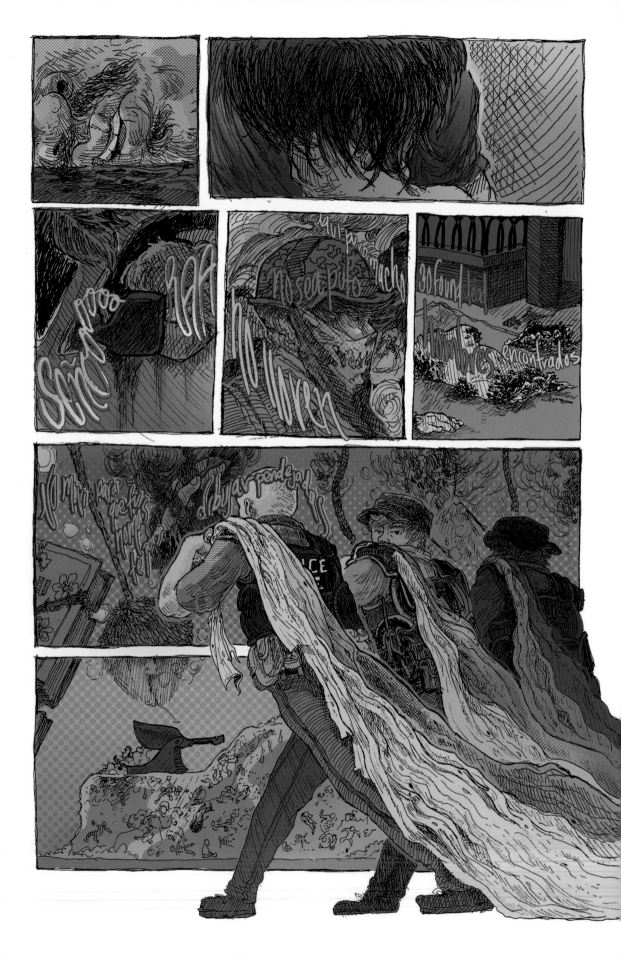

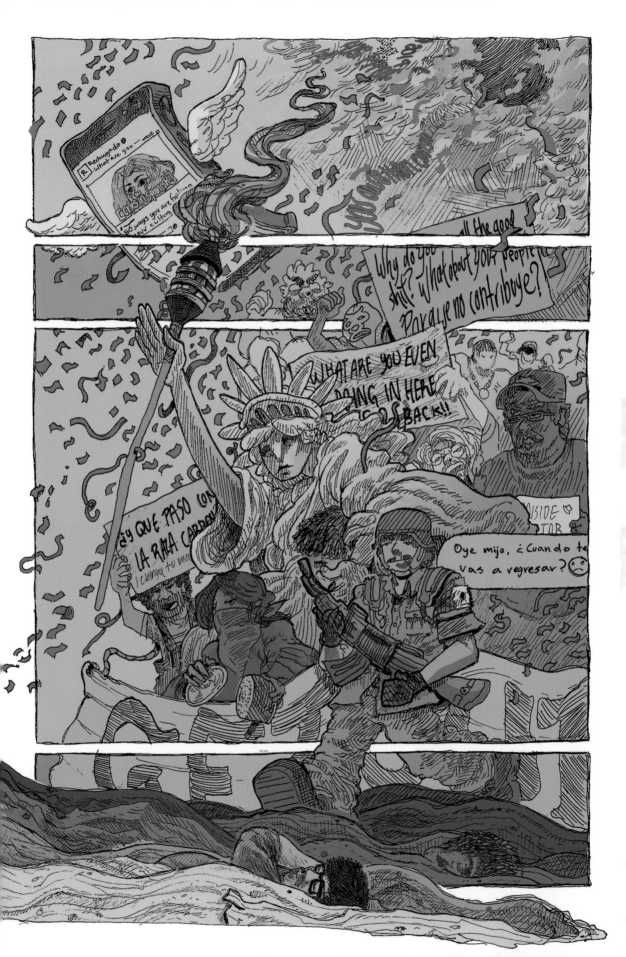

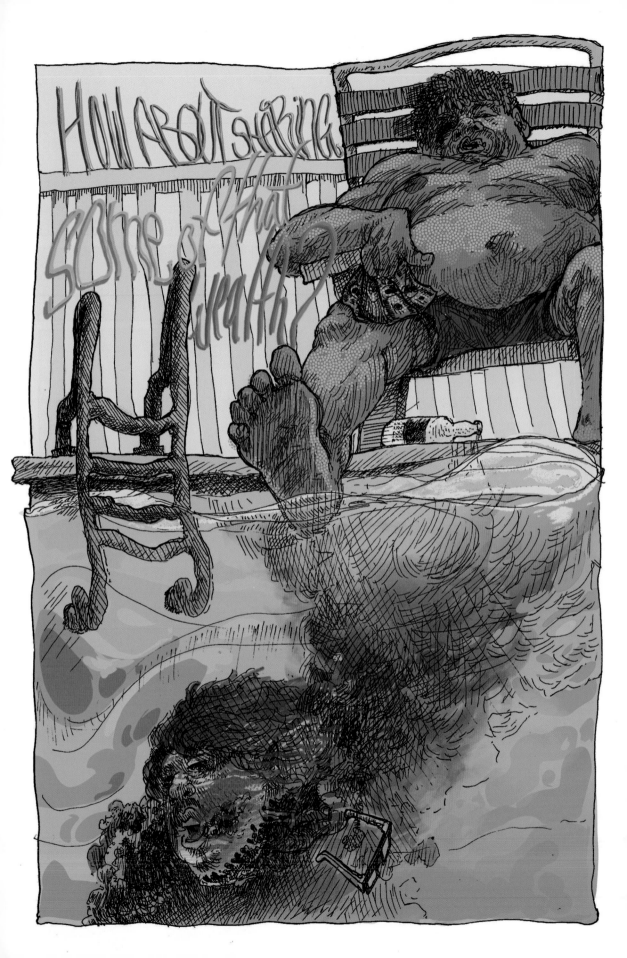

# POP CULTURA IS NOSOTROS

Mark Campos, "Mi Destino Es Comprenderla y No Olvidarla"

David Olivarez, "Inspiration"

Miguel Angel "Miky" Ruiz, "The Day I Discovered My Alter Ego"

John and Carlos Gonzalez (with Julian Aguilera and Michele Gonzalez), "Borax Boys"

Kat Fajardo, "Gringa"

Albert Morales, "Super Impacto vs. the World"

Javier Hernandez, "Mexican-American Splendor"

Ray Zepeda Jr. (with J. M. Hunter), "Nuevo Latino"

Richard Dominguez, "Wanna Know How I Got Started?"

Victor Avila, "One Time, One Night"

Carlos Saldaña, "Birth of Burrito"

David Herrera, "Commencement"

Ricardo Padilla (with Javier Hernandez), "Mi Barrio, 1976"

Dave Ortega, "Your Name Is the Rio Grande"

Rafael Navarro, "Mi Voz"

Chris Escobar, "No Room for a Marauder"

John Picacio, "A New Loteria"

# "MI DESTINO ES COMPRENDERLA Y NO OLVIDARLA..."

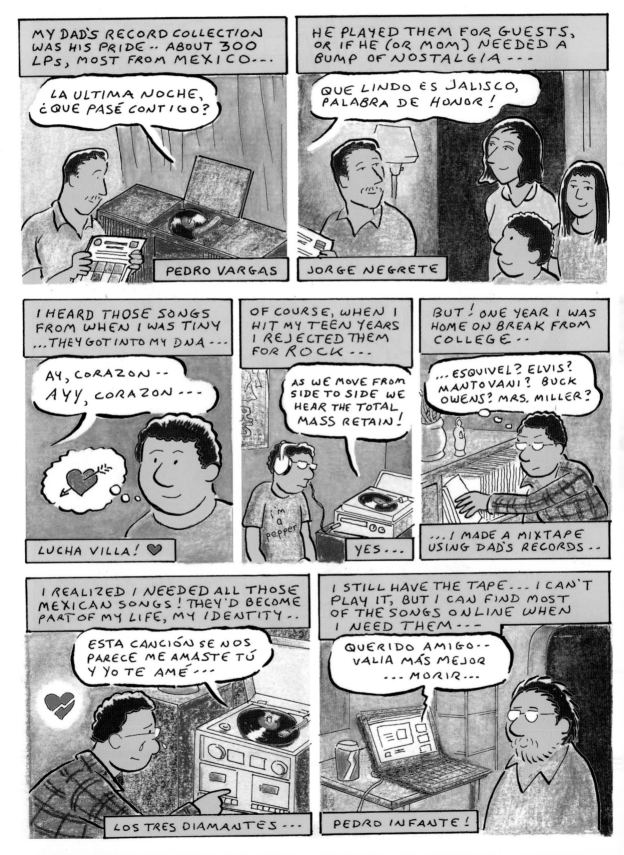

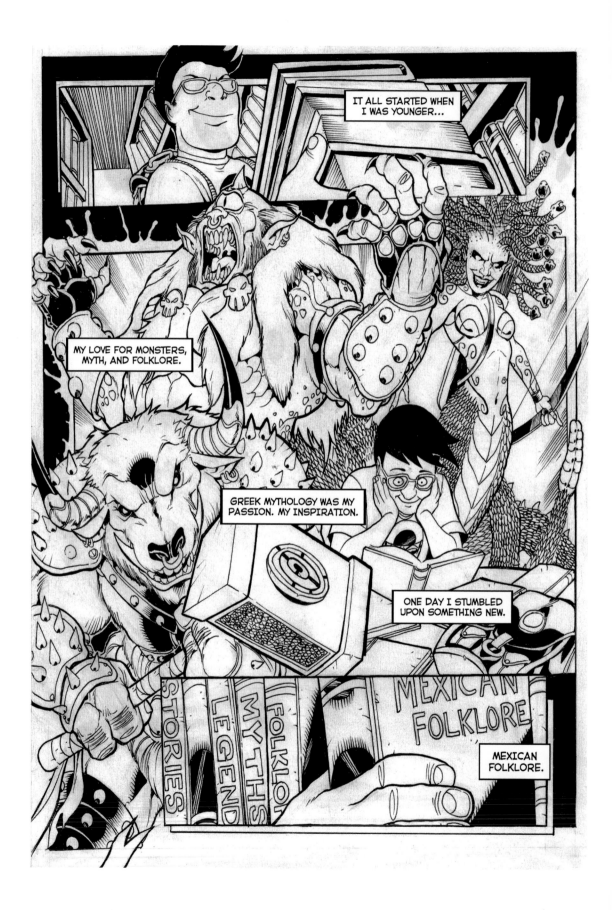

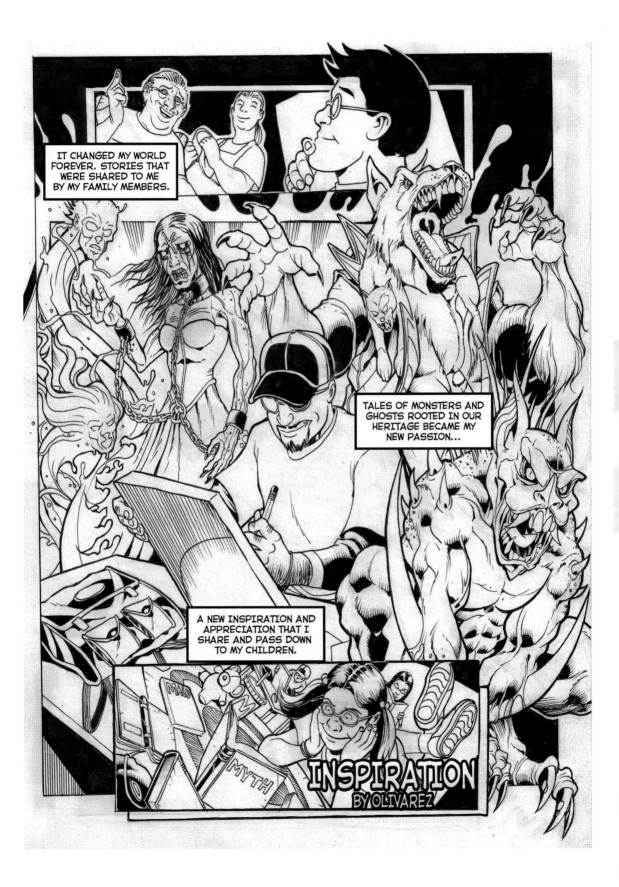

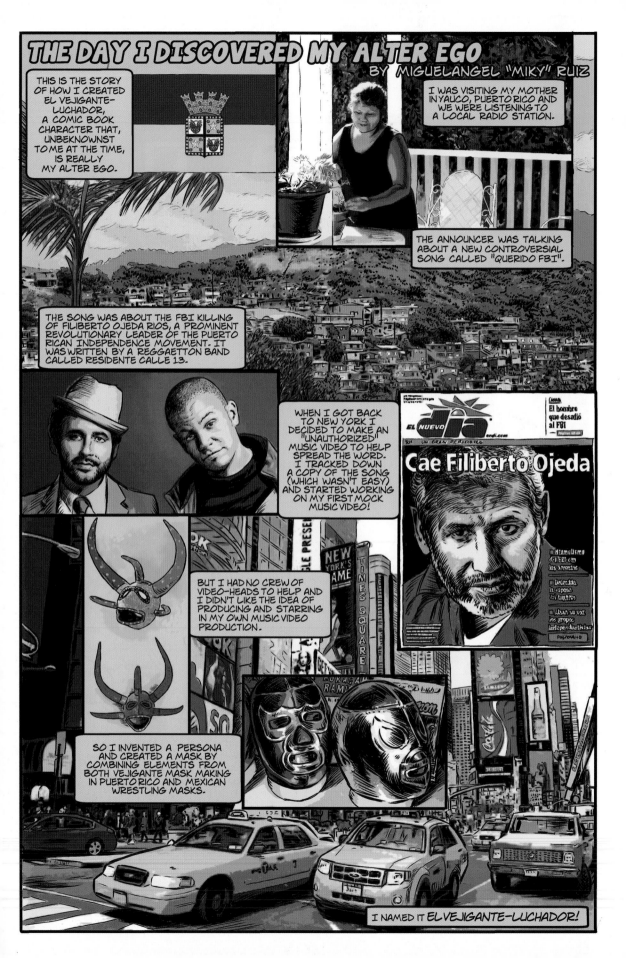

# THE DAY I DISCOVERED MY ALTER EGO

BY MIGUELANGEL "MIKY" RUIZ

THIS IS THE STORY OF HOW I CREATED EL VEJIGANTE-LUCHADOR, A COMIC BOOK CHARACTER THAT, UNBEKNOWNST TO ME AT THE TIME, IS REALLY MY ALTER EGO.

I WAS VISITING MY MOTHER IN YAUCO, PUERTO RICO AND WE WERE LISTENING TO A LOCAL RADIO STATION.

THE ANNOUNCER WAS TALKING ABOUT A NEW CONTROVERSIAL SONG CALLED "QUERIDO FBI".

THE SONG WAS ABOUT THE FBI KILLING OF FILIBERTO OJEDA RIOS, A PROMINENT REVOLUTIONARY LEADER OF THE PUERTO RICAN INDEPENDENCE MOVEMENT. IT WAS WRITTEN BY A REGGAETTON BAND CALLED RESIDENTE CALLE 13.

WHEN I GOT BACK TO NEW YORK I DECIDED TO MAKE AN "UNAUTHORIZED" MUSIC VIDEO TO HELP SPREAD THE WORD. I TRACKED DOWN A COPY OF THE SONG (WHICH WASN'T EASY) AND STARTED WORKING ON MY FIRST MOCK MUSIC VIDEO!

EL NUEVO DÍA

El hombre que desafió al FBI

Cae Filiberto Ojeda

BUT I HAD NO CREW OF VIDEO-HEADS TO HELP AND I DIDN'T LIKE THE IDEA OF PRODUCING AND STARRING IN MY OWN MUSIC VIDEO PRODUCTION.

SO I INVENTED A PERSONA AND CREATED A MASK BY COMBINING ELEMENTS FROM BOTH VEJIGANTE MASK MAKING IN PUERTO RICO AND MEXICAN WRESTLING MASKS.

I NAMED IT EL VEJIGANTE-LUCHADOR!

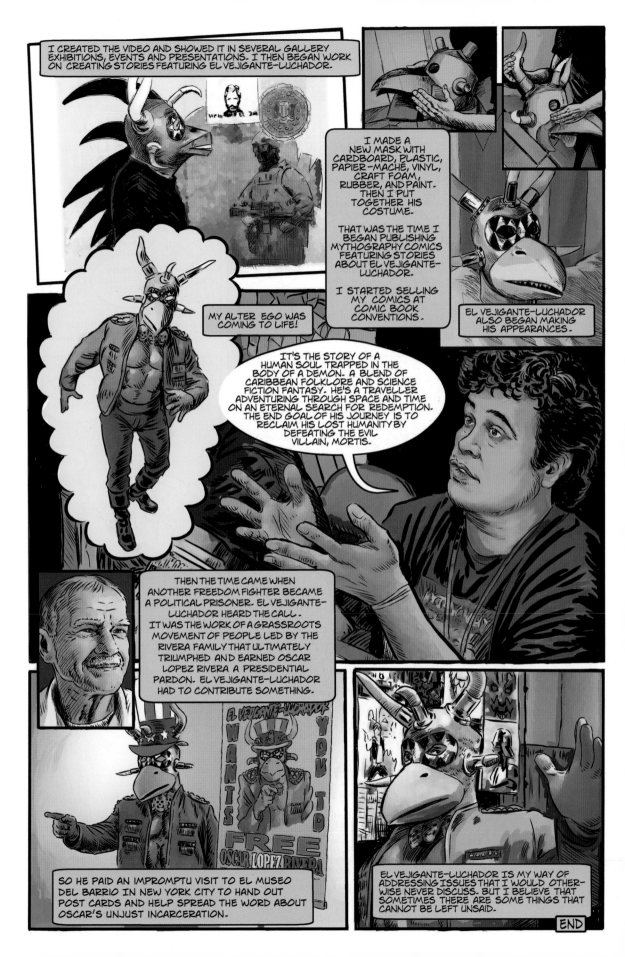

I CREATED THE VIDEO AND SHOWED IT IN SEVERAL GALLERY EXHIBITIONS, EVENTS AND PRESENTATIONS. I THEN BEGAN WORK ON CREATING STORIES FEATURING EL VEJIGANTE-LUCHADOR.

I MADE A NEW MASK WITH CARDBOARD, PLASTIC, PAPIER-MACHÉ, VINYL, CRAFT FOAM, RUBBER, AND PAINT. THEN I PUT TOGETHER HIS COSTUME.

THAT WAS THE TIME I BEGAN PUBLISHING MYTHOGRAPHY COMICS FEATURING STORIES ABOUT EL VEJIGANTE-LUCHADOR.

I STARTED SELLING MY COMICS AT COMIC BOOK CONVENTIONS.

EL VEJIGANTE-LUCHADOR ALSO BEGAN MAKING HIS APPEARANCES.

MY ALTER EGO WAS COMING TO LIFE!

IT'S THE STORY OF A HUMAN SOUL TRAPPED IN THE BODY OF A DEMON. A BLEND OF CARIBBEAN FOLKLORE AND SCIENCE FICTION FANTASY. HE'S A TRAVELLER ADVENTURING THROUGH SPACE AND TIME ON AN ETERNAL SEARCH FOR REDEMPTION. THE END GOAL OF HIS JOURNEY IS TO RECLAIM HIS LOST HUMANITY BY DEFEATING THE EVIL VILLAIN, MORTIS.

THEN THE TIME CAME WHEN ANOTHER FREEDOM FIGHTER BECAME A POLITICAL PRISONER. EL VEJIGANTE-LUCHADOR HEARD THE CALL. IT WAS THE WORK OF A GRASSROOTS MOVEMENT OF PEOPLE LED BY THE RIVERA FAMILY THAT ULTIMATELY TRIUMPHED AND EARNED OSCAR LOPEZ RIVERA A PRESIDENTIAL PARDON. EL VEJIGANTE-LUCHADOR HAD TO CONTRIBUTE SOMETHING.

SO HE PAID AN IMPROMPTU VISIT TO EL MUSEO DEL BARRIO IN NEW YORK CITY TO HAND OUT POST CARDS AND HELP SPREAD THE WORD ABOUT OSCAR'S UNJUST INCARCERATION.

EL VEJIGANTE-LUCHADOR IS MY WAY OF ADDRESSING ISSUES THAT I WOULD OTHER-WISE NEVER DISCUSS. BUT I BELIEVE THAT SOMETIMES THERE ARE SOME THINGS THAT CANNOT BE LEFT UNSAID.

END

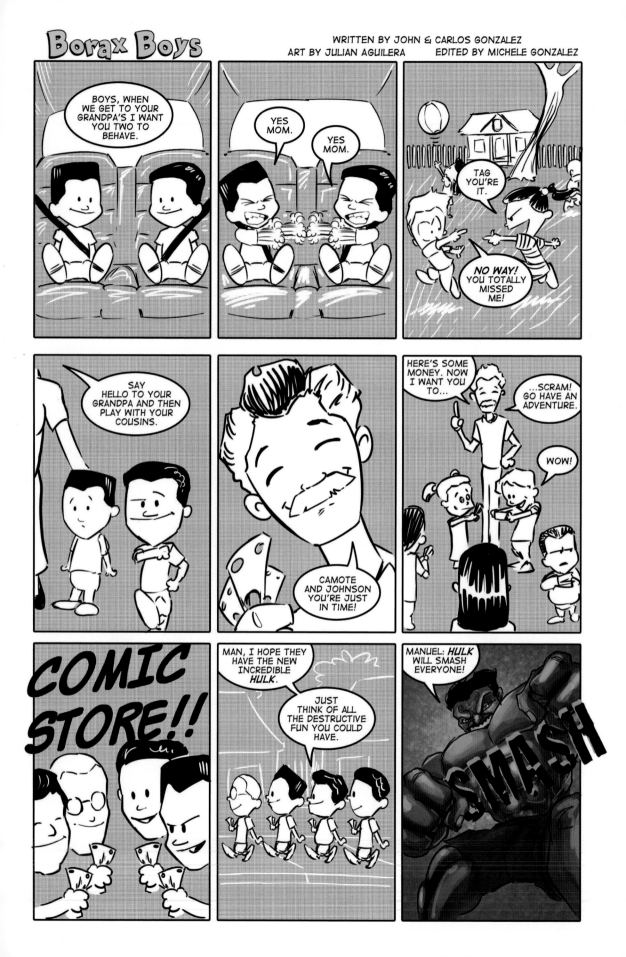

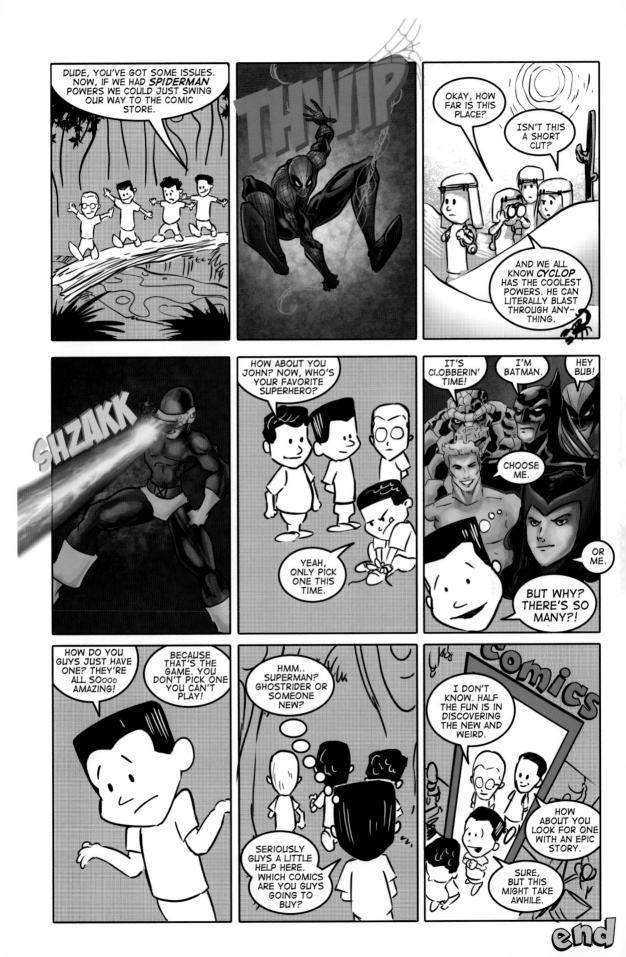

## "Gringa" by Kat Fajardo

For all reasons I felt more distant to my culture, and felt that I needed to "blend in"...

...I felt like I needed to feel acceptance somewhere else.

Because I was light skinned I thought I could get away with becoming a Buffy or Clarissa like in my shows.

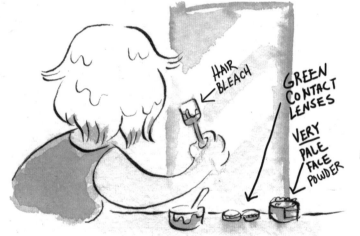

HAIR BLEACH

GREEN CONTACT LENSES

VERY PALE FACE POWDER

Anything remotely Latino was immediately discharged. It made me cringe and reminded me of what I could never be.

However, no matter how hard I tried to forget mi Raza managed to cling onto my guilty conscious.

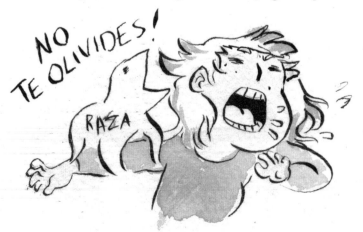

NO TE OLIVIDES!

RAZA

In some twisted way to my friends I was too Latina to be white...

...But to my own family I was too "gringa" to be Latina.

In the end, I was still unhappy with myself.

**So what the hell am I?**

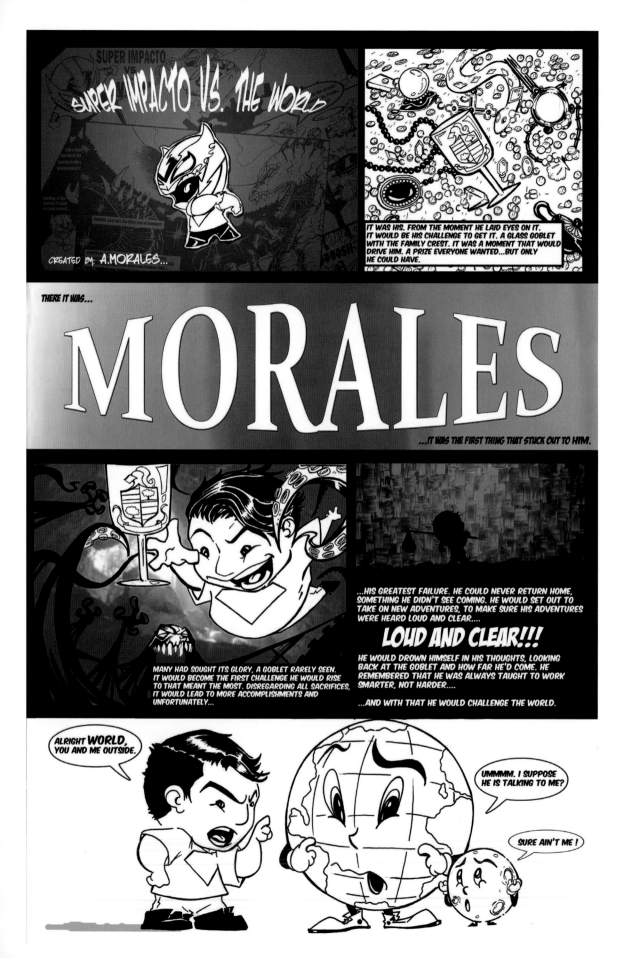

IN THAT MOMENT, HE PUT HIS TWO MAGIC HANDS TOGETHER AND THERE IT WAS....THE MASK. THE MASK ALLOWED HIM A NEW LOOK AT THINGS AND NEW OPPORTUNITIES. HIS MOVES WERE MORE CALCULATED. HIS PASSION WAS MORE MONSTROUS.

SLAM

HE'D GO ON TO CREATE WORKS OF MARVEL AND WONDER. -THE STORY GOES, A MAJOR CORPORATION SENT HIM HOME ONCE TO PUT THE OCEAN IN THE SKY (AND HIS NAME OF COURSE), SO EVERYONE COULD SEE. HAVING HIS FAITH AND HIS MASK HE WOULD MAKE AN IMPACT AT WHATEVER HE SET HIS EYES ON.

HE WAS DETERMINED.

S Padre Island Drive
Self-Storage

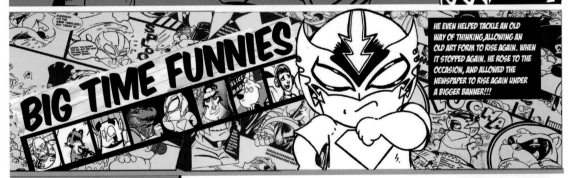

HE WRESTLED THE MONSTERS OF THE SQUARED CIRCLE, ALL TO DO WHAT HADN'T BEEN DONE BEFORE!!! (WHO DOES THAT?!?!)

BIG TIME FUNNIES

HE EVEN HELPED TACKLE AN OLD WAY OF THINKING, ALLOWING AN OLD ART FORM TO RISE AGAIN. WHEN IT STOPPED AGAIN. HE ROSE TO THE OCCASION, AND ALLOWED THE NEWSPAPER TO RISE AGAIN UNDER A BIGGER BANNER!!!

MIJOOOOO!!!
WHAT ARE YOU DOING?

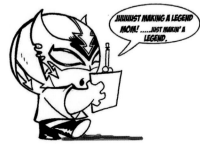

JUUUUST MAKING A LEGEND MOM! .....JUST MAKIN' A LEGEND.

HE WAS GOING TO MAKE HIS NAME LOUD ENOUGH TO HEAR ALL THE WAY HOME....AND IT ALL STARTED WITH AN EMPTY GOBLET FULL OF LOVE AND GANAS.

A.MORALES...
ROMANS 8:31

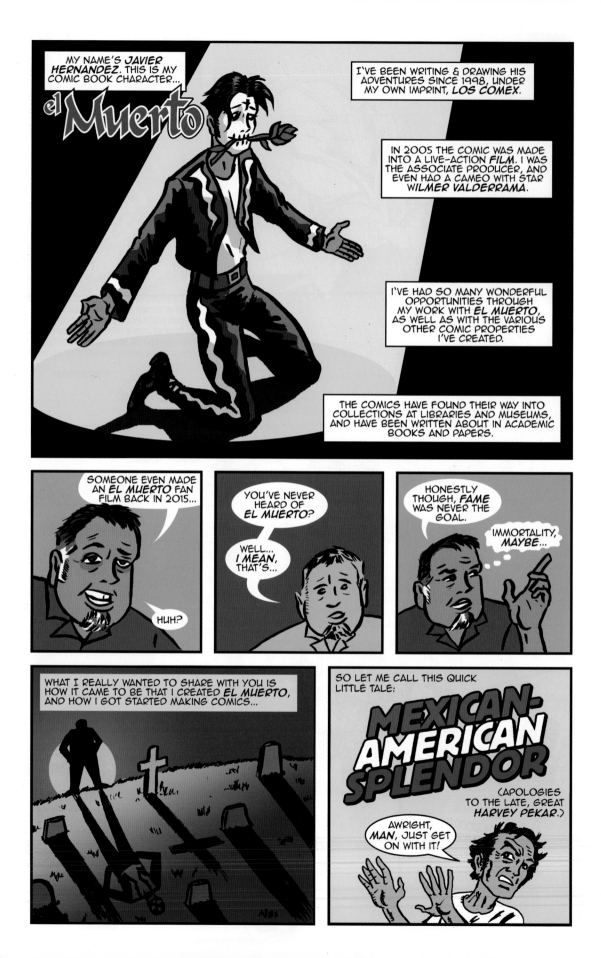

MY SIBLINGS AND I GREW UP IN A BILINGUAL HOME. *MOM & DAD* MOVED TO *EAST LA* AFTER GETTING MARRIED IN *MEXICO*.

I'D BE WATCHING EITHER *SPANISH* OR *ENGLISH* TV SHOWS IN ONE ROOM...

WHILE *THE BEATLES* OR *VICENTE FERNANDEZ* RECORDS PLAYED IN ANOTHER.

AS FAR AS ENGLISH LANGUAGE MEDIA, IT WAS RARE TO SEE ANY LATINO REPRESENTATION. SURE, *FREDDIE PRINZE* STARRED IN *CHICO & THE MAN*, MARVEL COMICS HAD THEIR PUERTO RICAN SUPERHERO *THE WHITE TIGER*... HECK, EVEN *LOONEY TUNES* HAD THEIR RESIDENT MEXICAN MOUSE.

THESE, AND OTHER CHARACTERS, REPRESENTED 'LATINO' IDENTITY. AUTHENTIC? IDEAL AS ROLE MODELS? WE COULD GO UP AND DOWN THE LIST WITH VARYING OPINIONS.

FOR ME THOUGH, THERE WAS ONE *MEXICAN-AMERICAN* WHO LEFT THE BIGGEST IMPACT ON ME, AS FAR AS INFLUENCING THE DIRECTION MY LIFE WOULD TAKE IN LATER YEARS.

I WAS ABOUT 7 OR 8 WHEN MY OLDER BROTHER *ALBERT* GAVE ME HIS COMICS. A TROVE OF LATE 60'S/EARLY 70'S TITLES. ALSO, I GOT MY LOVE OF DRAWING FROM HIM, AS HE USED TO HAVE A SKETCHBOOK FULL OF CARTOON SPORT CHARACTERS HE DREW. IT'S THE FIRST TIME I EVER SAW ORIGINAL ARTWORK.

DARE DEVIL

SUPER

IN MY 20'S I HAD STARTED A CAREER WORKING IN THE ART DEPARTMENT OF A SCREEN PRINTING COMPANY. THE STEADY INCOME WAS GOOD AND I EVENTUALLY BECAME ART DIRECTOR.

BUT THE IDEA OF WANTING TO DO COMICS PROVED TOO MUCH TO RESIST.

THE FUTURE

GREETINGS, MY FRIEND!

LOVE OF COMICS & DRAWING DROVE ME TO BE A CARTOONIST. BUT I WANTED TO CREATE SOMETHING THAT REFLECTED *MEXICAN CULTURE* IN A RICHER & MORE POSITIVE MANNER THAN I EXPERIENCED GROWING UP AS A YOUNG *MEXICAN-AMERICAN*.

SO *EL MUERTO* BECAME BOTH MY PASS KEY INTO THE COMICS INDUSTRY & MY WAY OF ASSERTING MY CULTURAL IDENTITY.

*DIA DE LOS MUERTOS* FOLKLORE & *AZTEC* MYTHOLOGY WOULD BE THE STARTING POINT. BUT ALL THE IMAGINATIVE NARRATIVE & VISUAL TOOLS AVAILABLE TO A STORYTELLER IN COMICS WOULD BE THE GUIDING FORCE BEHIND MY WORK.

FOR ME IT'S THE ONLY WAY TO PROPERLY CALL MYSELF A CARTOONIST.

THINKING BACK ON THAT JOURNEY INFORMS ME, EVEN *TODAY*, OF WHAT...

POW

ZIP

HEY, SWELL! BUT DAW-GUNNIT WE WANNA SEE SOME NEW COMICS!

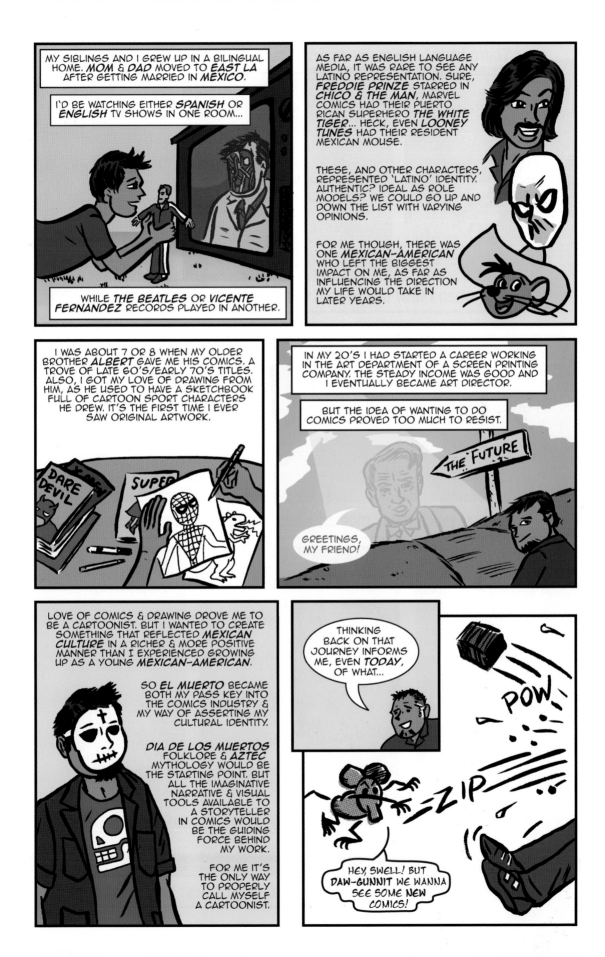

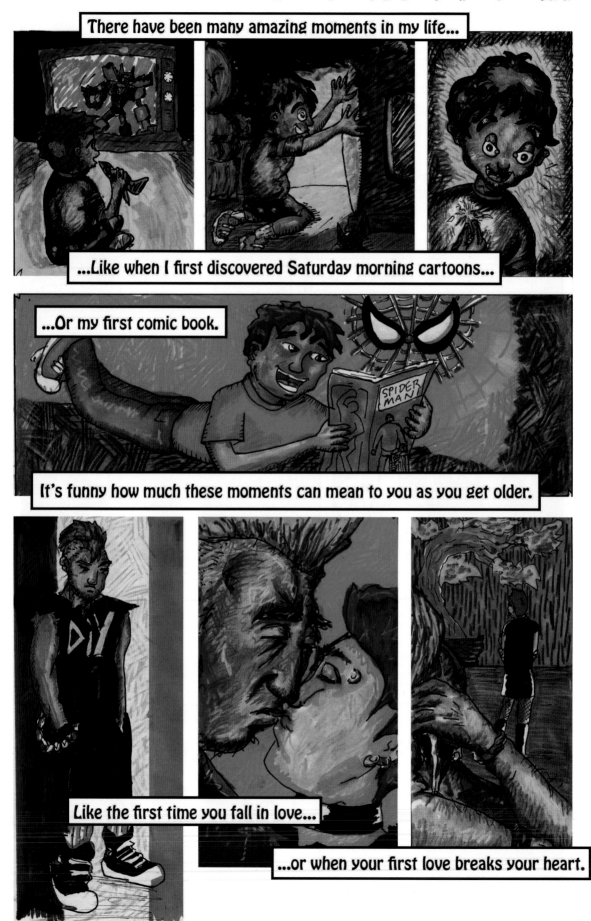

Rediscovering my love for comics put me on an unbelievable path.

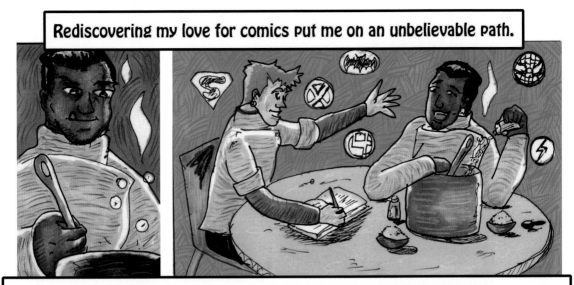

After a few years, I found more love in the woman who would become my wife.

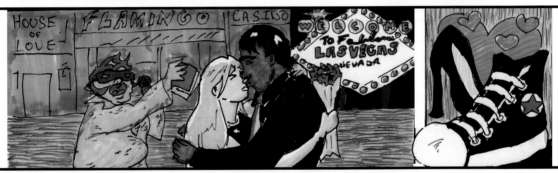

And while all, if not most of these seem like they would be my greatest moments...

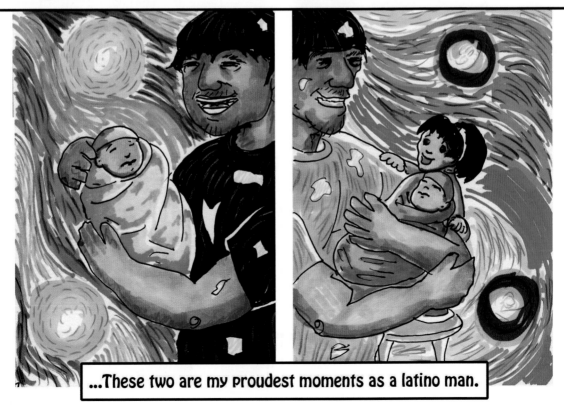

...These two are my proudest moments as a latino man.

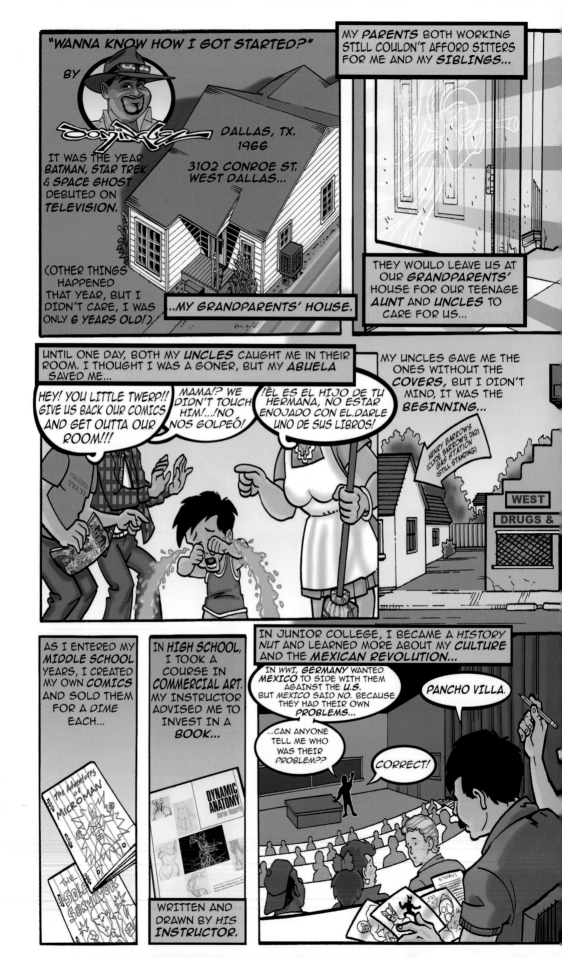

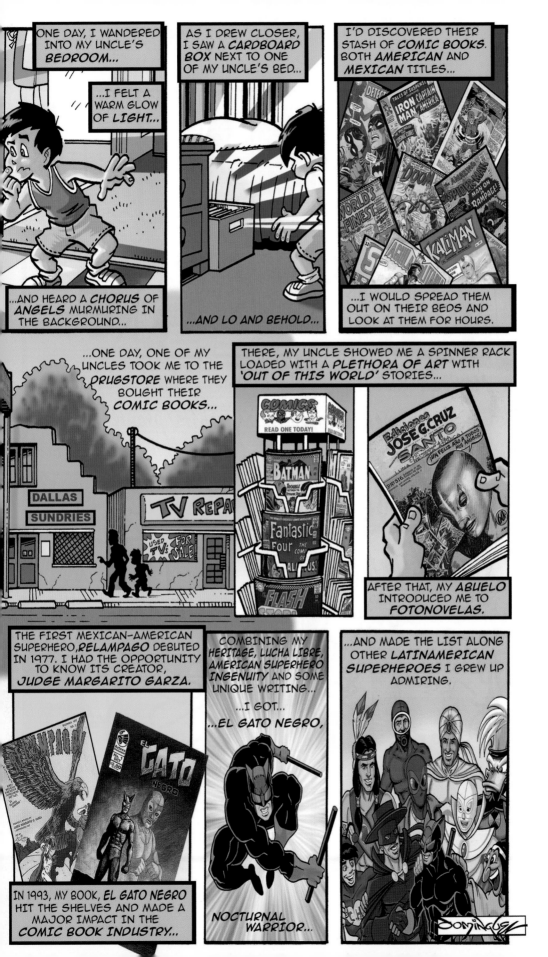

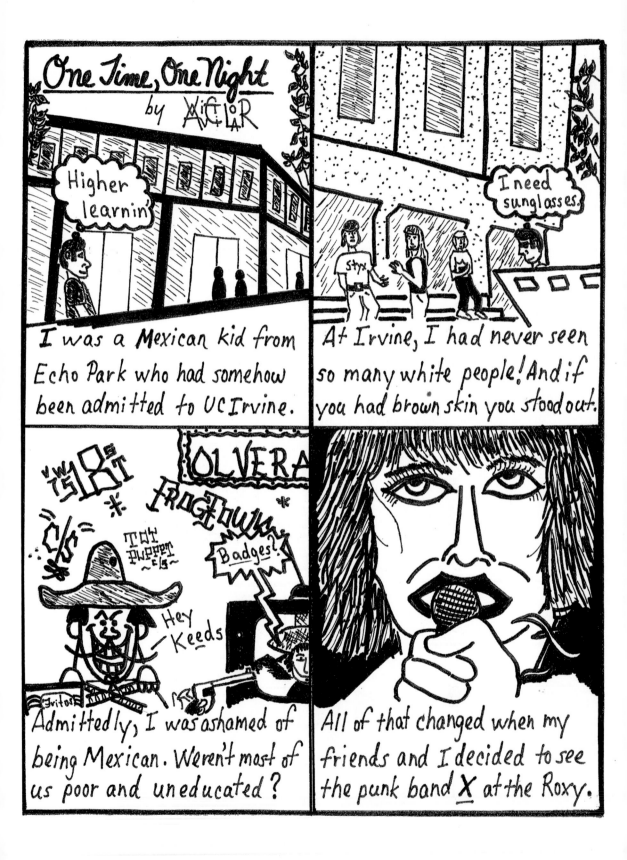

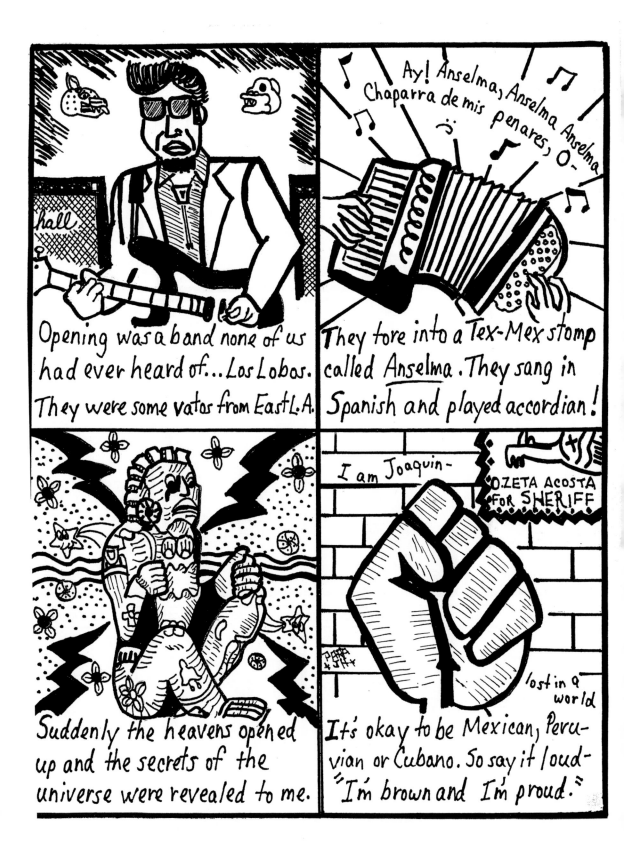

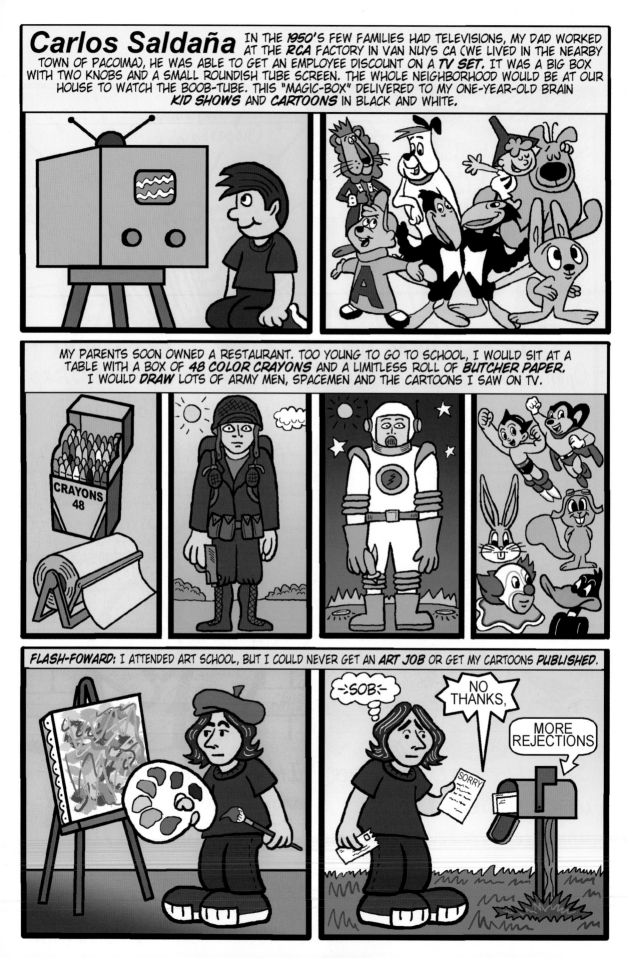

**Carlos Saldaña** IN THE *1950'S* FEW FAMILIES HAD TELEVISIONS, MY DAD WORKED AT THE *RCA* FACTORY IN VAN NUYS CA (WE LIVED IN THE NEARBY TOWN OF PACOIMA), HE WAS ABLE TO GET AN EMPLOYEE DISCOUNT ON A *TV SET*. IT WAS A BIG BOX WITH TWO KNOBS AND A SMALL ROUNDISH TUBE SCREEN. THE WHOLE NEIGHBORHOOD WOULD BE AT OUR HOUSE TO WATCH THE BOOB-TUBE. THIS "MAGIC-BOX" DELIVERED TO MY ONE-YEAR-OLD BRAIN *KID SHOWS* AND *CARTOONS* IN BLACK AND WHITE.

MY PARENTS SOON OWNED A RESTAURANT. TOO YOUNG TO GO TO SCHOOL, I WOULD SIT AT A TABLE WITH A BOX OF *48 COLOR CRAYONS* AND A LIMITLESS ROLL OF *BUTCHER PAPER*. I WOULD *DRAW* LOTS OF ARMY MEN, SPACEMEN AND THE CARTOONS I SAW ON TV.

CRAYONS 48

*FLASH-FOWARD:* I ATTENDED ART SCHOOL, BUT I COULD NEVER GET AN *ART JOB* OR GET MY CARTOONS *PUBLISHED*.

=SOB=

NO THANKS,

MORE REJECTIONS

SORRY

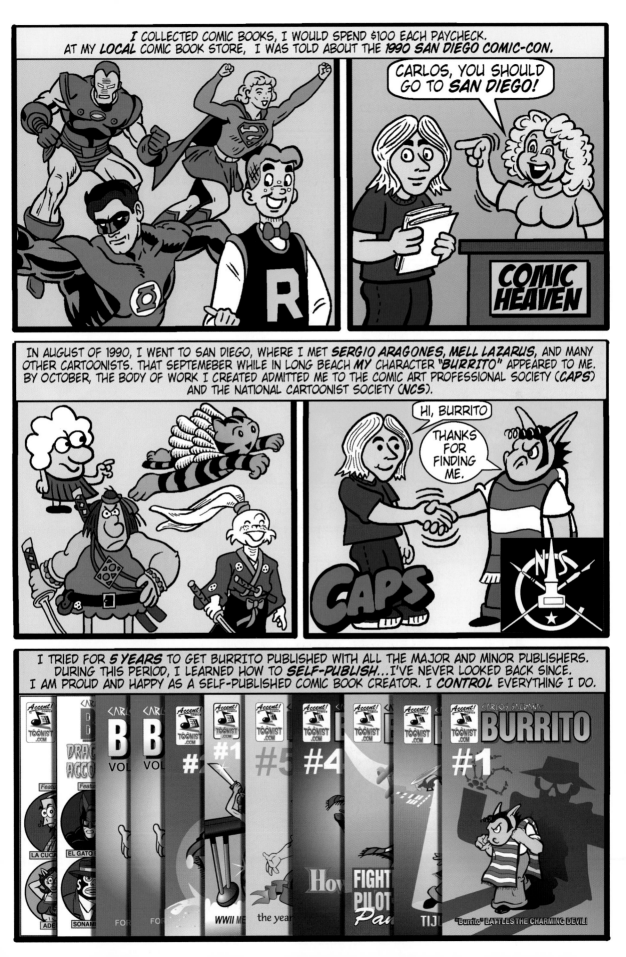

I COLLECTED COMIC BOOKS, I WOULD SPEND $100 EACH PAYCHECK. AT MY **LOCAL** COMIC BOOK STORE, I WAS TOLD ABOUT THE **1990 SAN DIEGO COMIC-CON**.

CARLOS, YOU SHOULD GO TO **SAN DIEGO**!

COMIC HEAVEN

IN AUGUST OF 1990, I WENT TO SAN DIEGO, WHERE I MET **SERGIO ARAGONES, MELL LAZARUS,** AND MANY OTHER CARTOONISTS. THAT SEPTEMEBER WHILE IN LONG BEACH **MY** CHARACTER "**BURRITO**" APPEARED TO ME. BY OCTOBER, THE BODY OF WORK I CREATED ADMITTED ME TO THE COMIC ART PROFESSIONAL SOCIETY (**CAPS**) AND THE NATIONAL CARTOONIST SOCIETY (**NCS**).

HI, BURRITO

THANKS FOR FINDING ME.

CAPS

I TRIED FOR **5 YEARS** TO GET BURRITO PUBLISHED WITH ALL THE MAJOR AND MINOR PUBLISHERS. DURING THIS PERIOD, I LEARNED HOW TO **SELF-PUBLISH**...I'VE NEVER LOOKED BACK SINCE. I AM PROUD AND HAPPY AS A SELF-PUBLISHED COMIC BOOK CREATOR. I **CONTROL** EVERYTHING I DO.

BURRITO #1

"Burrito" BATTLES THE CHARMING DEVIL!

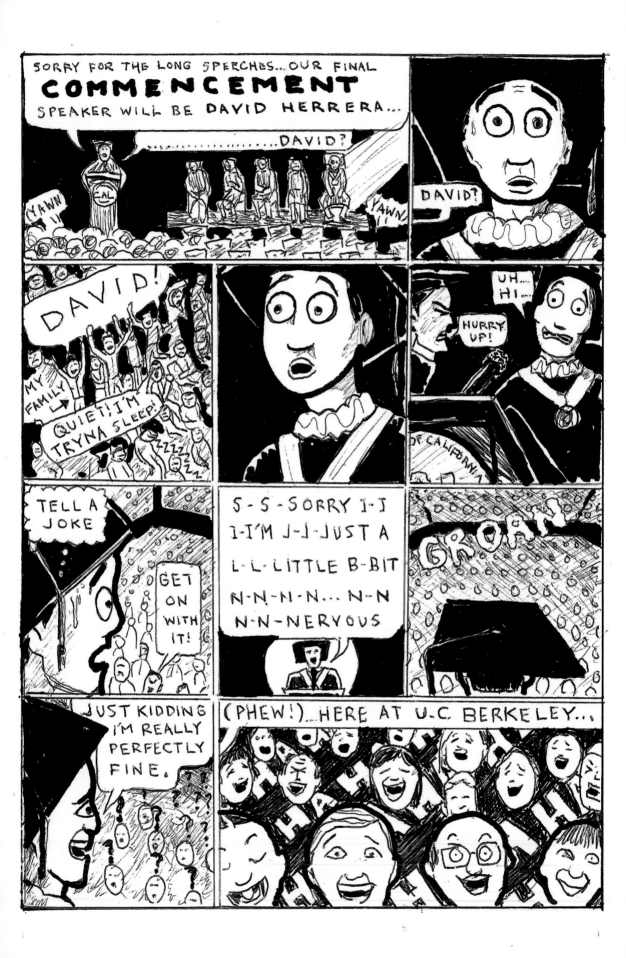

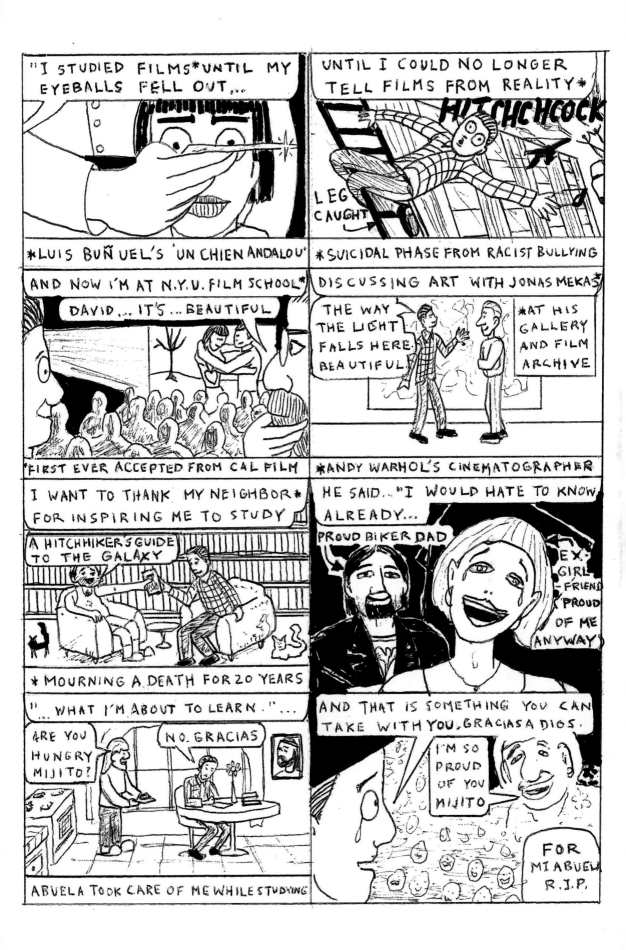

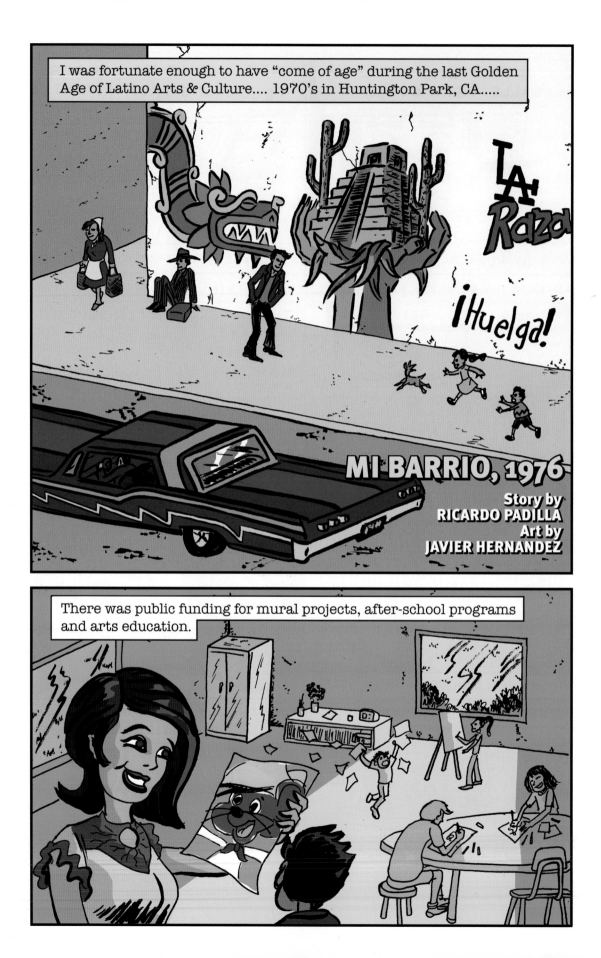

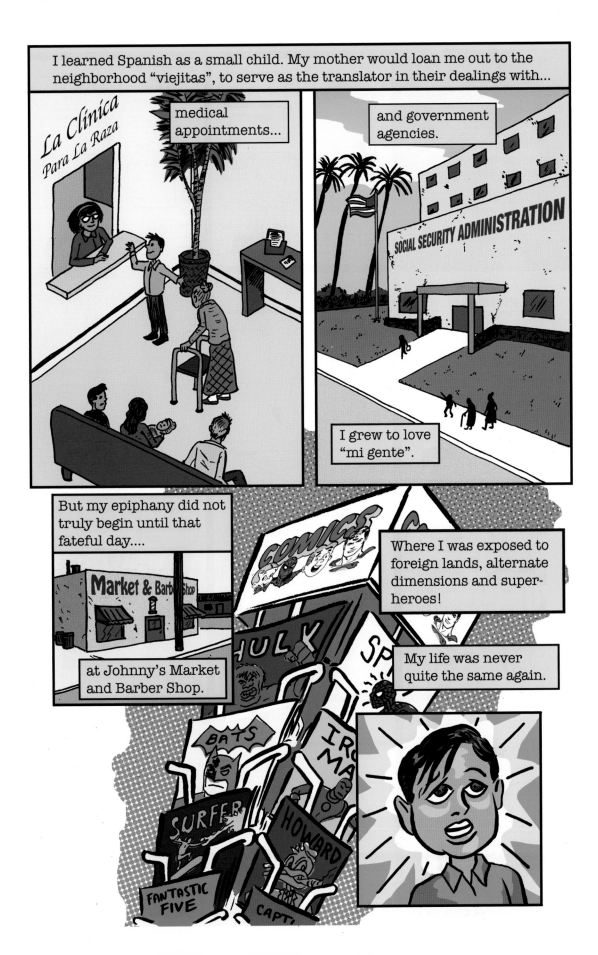

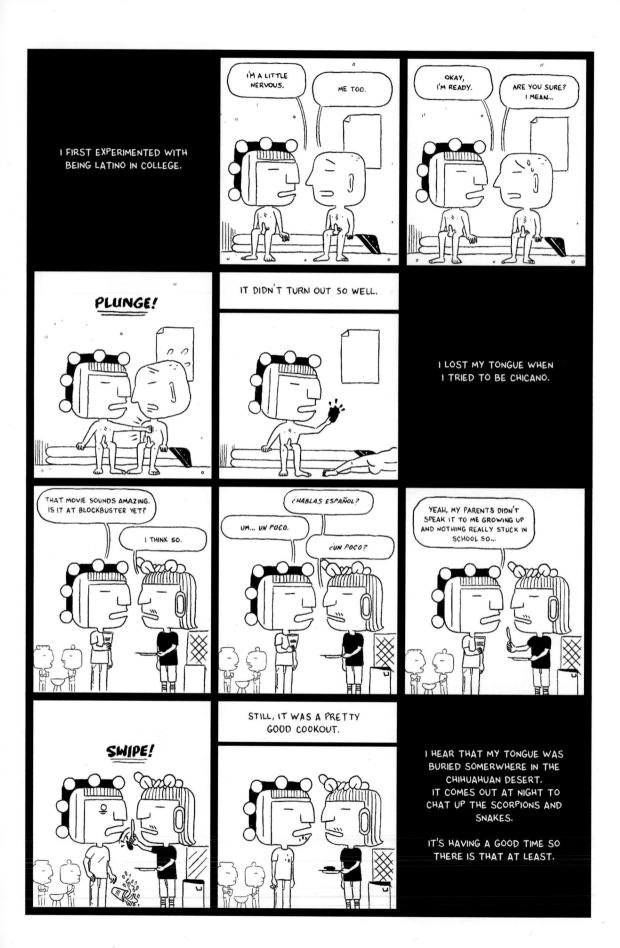

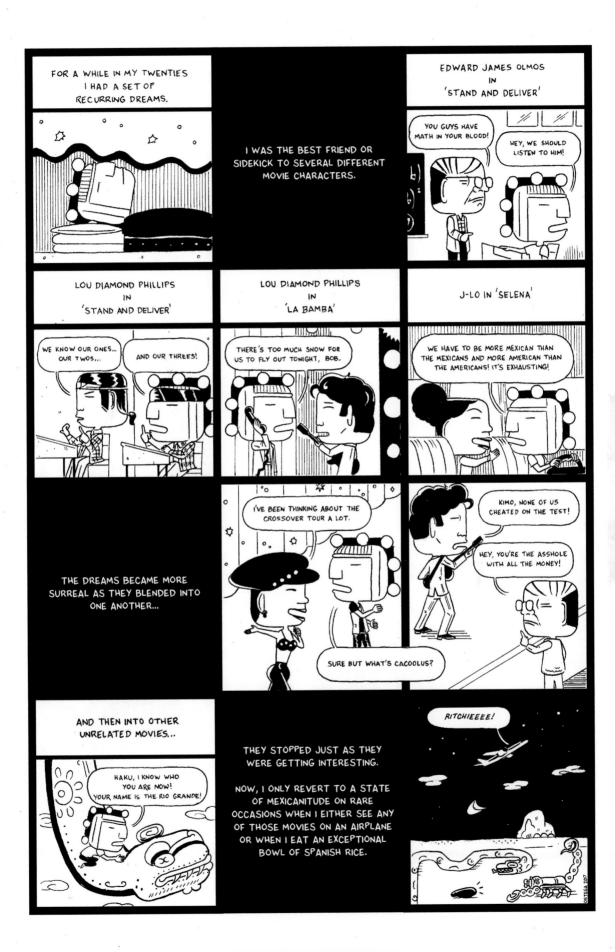

MI VOZ

BY RAFAEL NAVARRO.

I was always told I was born with a pencil in my hand.

Whether it was true or not, the storyteller in me always hoped it was...

For it made me ready...

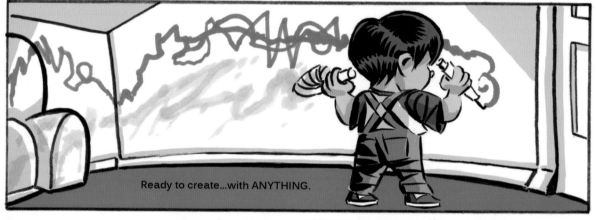

Ready to create...with ANYTHING.

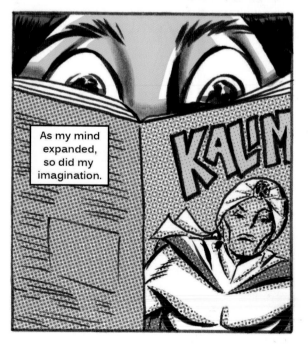

As my mind expanded, so did my imagination.

KALIM

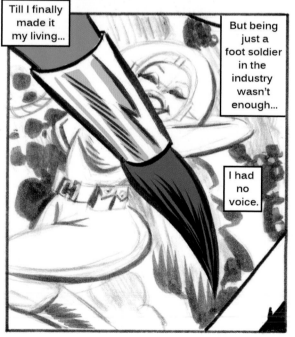

Till I finally made it my living...

But being just a foot soldier in the industry wasn't enough...

I had no voice.

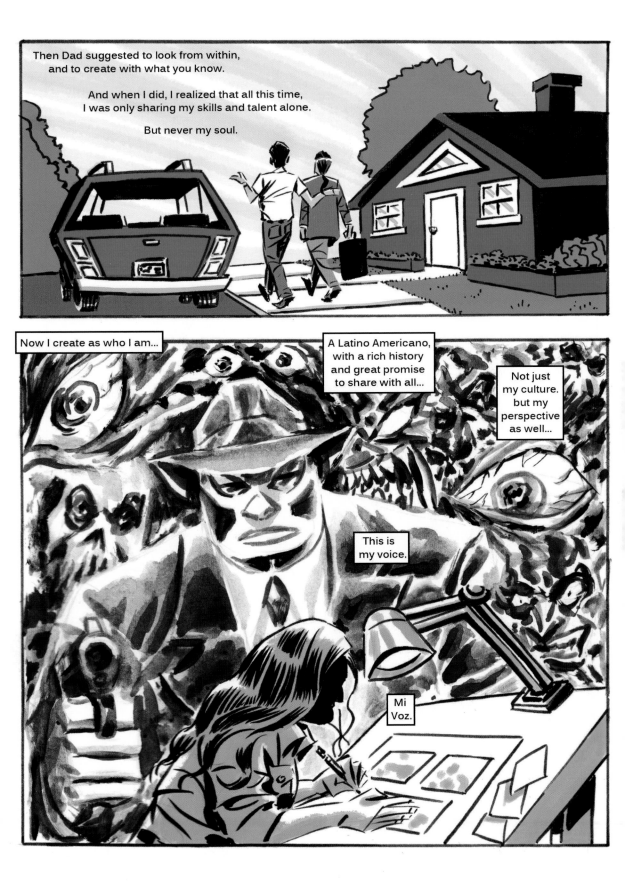

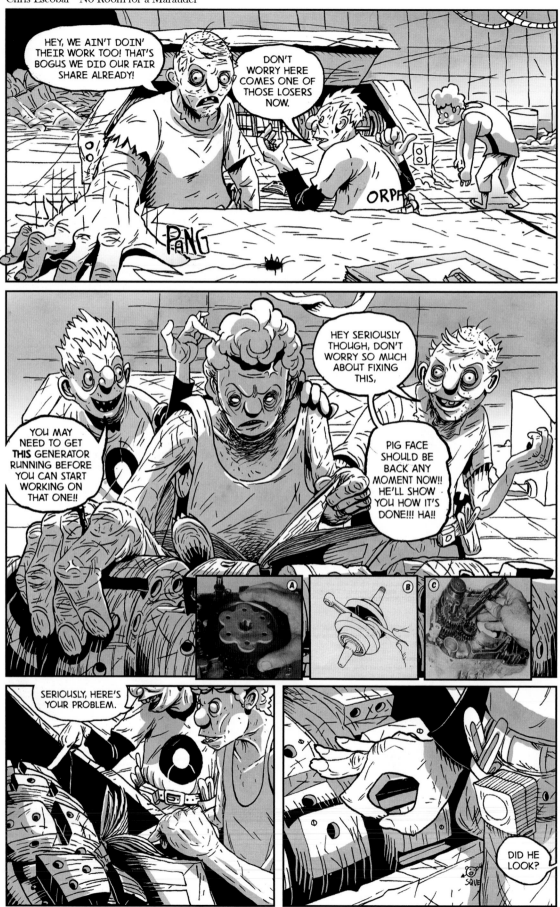

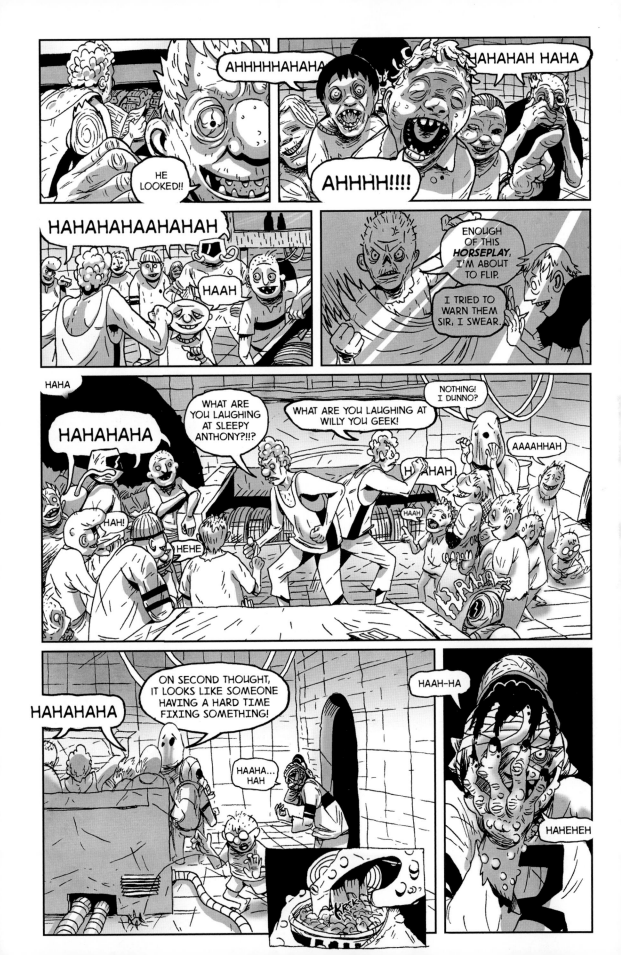

# A NEW LOTERIA

**by John Picacio**

It was shinier than I ever expected.

When I held it in my hands, something unimaginable happened and I was flying.

I won the Hugo Award in 2012, and in the science fiction world, that's like winning an Oscar. The congratulations poured down. Applause thundered in my ears. When your dreams become real, you don't want to wake up.

The shiny rocket morphed into a key and a locked door appeared. Stay with success? Or chance the unknown? I unlocked the door-- and as a wise man once said, I took my first step into a larger world.

And that's when I saw it.

The view was breathtaking—
a constellation of the magical,
the mundane, and the cosmic.

I saw a centillion Mexican souls
staring across time and space,
bridging my youngest days playing
Loteria with my family, to a future
past where those infinite legions
could be seen anew by the whole world—
with all of their nobility, their passion,
their mystery, their cool, and their fire.

These constellations are my compass
through a wild frontier where the
'M' word is caged code awaiting
liberation. Each step is perilous and
uncertain. The gravity is crushing. The
valleys can kill. If I keep climbing
though, I hope to find a place in the sun
where all of us can fly again.

John Picacio

# CONTRIBUTORS

JULIAN AGUILERA is cocreator with John Gonzalez, Carlos Gonzalez, and Michele Gonzalez of *The Elites*.

JOSÉ ALANIZ is associate professor at the University of Washington, Seattle, as well as author of *Komiks: Comic Art in Russia* and *Death, Disability and the Superhero: The Silver Age and Beyond*.

FREDERICK LUIS ALDAMA is Arts and Humanities Distinguished Professor and University Distinguished Scholar at The Ohio State University as well as an award-winning author of fiction and nonfiction books.

VICKO ALVAREZ is a native Tejana and creator and illustrator of the ScholaR Comics web series. Vicko is a member of the For The People (FTP) Artists Collective in Chicago where she creates art for radical movements that center Black lives and prison abolition. http://scholarcomics.com/

JUAN ARGIL is a sociopolitical abstract cartoonist living in Columbus, Ohio. http://www. thatjuanartist.com/

VICTOR AVILA is an award-winning poet, creator of the comic series *Hollywood Ghost Comix*, and teacher in the California public schools.

FERNANDO BALDERAS RODRIGUEZ is cocreator with Horacio Luis Balderas of *Aztec of the City*. Fernando has also written screenplays, created a short film, and been involved in theatre. He currently lives in Cabo San Lucas, Mexico.

CANDY BRIONES is illustrator and comic book creator of *Taco El Gato*.

JOSÉ CABRERA is award-winning creator of *Crying Macho Man* as well as publisher of *Up and Over: Bilingual Books for Kids* (https://www.upandover.xyz/).

MARK CAMPOS was the creator of *Places That Are Gone, Moxie My Sweet,* and *Wow, They're Playing My Songs on the Radio, I Must Be Dead*.

MIKE CENTENO is a cartoonist and illustrator originally from Caracas, Venezuela. http://www.mikecenteno.com/

JAIME CORTEZ is a writer and visual artist and creator of the graphic novel *Sexile*—a biography of the Cuban transgender HIV activist Adela Vasquez. www.jaimecortez.org

JAIME CRESPO is a musician, writer, poet, and cartoonist known for *Tales from the Edge of Hell* and *Slice O' Life/Slices, Narcolepsy Dreams, Numb Skull,* and *Tortilla*.

FEDERICO "RICO" Cuatlacuatl is an artist, an animator, and a teacher who grew up as an undocumented immigrant in the United States. His work focuses on the

current social, political, and cultural issues that Hispanic immigrants face in the United States. Federico's independent productions have been screened in various national and international film festivals. www.cuatlacuatl.com

RICHARD DOMINGUEZ is the creator of the popular comic book series *El Gato Negro, Nocturnal Warrior*. He publishes his comics through his imprint and art studio, Azteca Productions. http://www.sb3m.com/richard/

CHRIS ESCOBAR is a cartoonist and print maker who is heavily influenced by a love of the horror genre. http://www.worserbeings.com/

ERIC ESQUIVEL is a Los Angeles–based author whose previous clients include Archie, Boom Studios, DC Comics, Dynamite, Heavy Metal, IDW, Papercutz, Vertigo, and Zenescope. He is also the Writing for Comics instructor at Meltdown University in Hollywood.

KAT FAJARDO is an award-winning cartoonist and illustrator known for her *Gringa!* and as editor of *La Raza Anthology*. http://www.katfajardo.com/

KELLY FERNANDEZ is a cartoonist and an illustrator known for *La Ciguapa* among many other comics inspired by Dominican folklore, American monsters, video games, and brave women. www.kelly-fernandez.com

ALEJANDRO "JANDRO" GAMBOA is an award-winning writer of comics known recently for his *Monty Gomez is the Luchador* that draws inspiration from history and mythology. https://www.facebook.com/JusticeIsDIY/

DUSTIN "DUST" GARCÍA is a Cuban-Nicaraguance illustrator and animator based in Oakland, California. He is known for his comics series *Tucker Toon* and the animated short "The Adventures of Mr. Bundt." His work is heavily inspired by The Roots music, history, and philosophy. http://dustooned.com

ERIC J. GARCÍA served in the military, earned an MFA degree from the School of the Art Institute of Chicago, and now works in a wide variety of media, from hand-printed posters to sculptural installations. He is creator of the political cartoon series *El Machete Illustrated* and the author of *Drawing on Anger: Portraits of U.S. Hypocrisy* (also available in the Latinographix series from Mad Creek Books). www.ericjgarcia.com

CARLOS GONZALEZ is creator of *The Elites* with Michele and John Gonzalez.

CRYSTAL GONZALEZ is a cartoonist known for her horror graphic novel *In The Dark*—a humorous and satirical story that looks at religions and customs through the eyes of the demons in hell. She is completing an animation series titled *Skitzo the 1920s Killer Bear*. http://crystalgonzalez.cleanfolio.com/

JASON "J-GONZO" GONZÁLEZ is a comic book artist and illustrator known for his *La Mano del Destino*. http://castleandkeypublications.com/wordpress/

JENNY GONZALEZ-BLITZ is a painter and musician, studies butoh dance, and is a comic book creator. She is a contributor to *World War 3 Illustrated*, *House of 12 Comics*, *Not My Small Diary*, and other projects. https://jennydevildoll.wordpress.com/

JOHN GONZALEZ is creator of the sci-fi comic book series *The Elites* as well as cofounder, director, and producer for his film company Dream Destinations.

MICHELE GONZALEZ is creator of *The Elites* with John and Carlos Gonzalez.

RAÚL GONZÁLEZ is illustrator, artist, and cocreator with Cathy Camper of the *Lowriders in Space* graphic novel series.

ROBERTA GREGORY has been creating comics since the early 1970s and has received several industry awards and nominations. She has a very wide variety of work but is best known for her forty-issue series from Fantagraphics, *Naughty Bits*, starring the notorious Bitchy Bitch. Much more is in the works, so follow her at robertagregory.com.

ISRAEL FRANCISCO HAROS LOPEZ is an educator, an art instructor, and a visual artist who creates and collaborates across the visual, poetic, performance, music, and visual arts. His work addresses a multitude of historical and spiritual layered realities of border politics, identity politics, and the reinterpretation of histories. https://waterhummingbirdhouse.com/about/

ADAM HERNANDEZ is a Columbus, Ohio–based visual artist influenced by the graffiti arts, abstract expressionism, the lowbrow art movement, and comic books. www.ahernandezart.com

CELINA HERNANDEZ is a published sequential artist from Chicago, Illinois. She is cofounder (with Michael Murphy) of CHIBI COMICS, a comic studio based in Portland, Oregon. https://www.patreon.com/chibicelina

GILBERT "BETO" HERNANDEZ is an award-winning comic book creator known especially for his work with Jaime Hernandez on the award-winning series *Love and Rockets*. http://gilbertbetohernandez.blogspot.com/

JAIME HERNANDEZ is an award-winning comic book creator known especially for his work with Gilbert Hernandez on the award-winning series *Love and Rockets*.

JAVIER HERNANDEZ is the creator of *El Muerto, Maniac Priest*, and *Weapon Tex-Mex* as well as cofounder and creative director of the Latino Comics Expo. He teaches comic book workshops in schools, libraries, and museums. http://javiersblog.blogspot.com/

DAVID HERRERA is a writer, an artist, a music video director, and a filmmaker, recently publishing the graphic novel *GÖLDEN*. http://www.rebus101.com/

LEIGHANNA HIDALGO is creator of fotonovelas such as *Reproductive Rebel* as well as being a doctoral student at UCLA. http://www.leighannahidalgo.com

J. M. HUNTER is publisher of *BAM TOO!*, comic book creator, and illustrator. He is creator of *The Indy Gazelle* and *Pirate Santa Claus: Agent of Constantinople*.

JOHN JENNINGS is a professor at UC Riverside as well as an Eisner award–winning author and illustrator.

MARINA JULIA is an illustrator and cartoonist known for her comic *Lowtide, Warm Blood, Spera*, and her work on *Lumberjanes*. www.marjulia.com

ALEJANDRO JUVERA is a musician and comic book creator influenced by 1960s manga artists. He is creator of *Xeno-Guardian Red Visor GO!*

JEREMIAH LAMBERT illustrates, inks, colors, letters, and writes comics. He is illustrator for properties such as Transformers and Masters of the Universe. Find Jeremiah online as @JeremiahLambertArt.

MYRA LARA is a designer, architect, artist, and activist known for her comic *Witchaus* and *Planet Hop*, among others. http://www.myralara.com/

JOHN JOTA LEAÑOS is professor at UC Santa Cruz as well as media artist and animator. His work has been shown at the Sundance Film Festival, Cannes Short Corner, PBS.org, the Whitney Biennial, and San Francisco Museum of Modern Art, among others. http://leanos.net/

ALBERTO LEDESMA is Graduate Diversity Director at UC Berkeley, award-winning poet, and author of *Diary of a Reluctant Dreamer: Undocumented Vignettes from a Pre-American Life* (also available in the Latinographix series from Mad Creek Books).

MICHAEL MACROPOULOS is the Xeric Award–winning creator of Super Soul Puddin' Comics and Spookgirl.

MAPACHE STUDIOS comprises FERNANDO DE PEÑA and RODRIGO VARGAS, a creative dynamic duo of underground comic book creators from Santiago, Chile. They are known for their comic book *Elisa y los mutantes*. https://mapachestudios.org/

LIZ MAYORGA is director of the San Francisco Zine Festival, illustrator, graphic designer, and creator of the comic *Bread & Butter*.

ALBERT MORALES is the creator of *Super Impacto vs. The World* and *Destructo Boy* as well as the comic strip newspaper *Big Time Funnies*. He's worked for HBO and Marvel/Upper Deck.

RAFAEL NAVARRO is award-winning comic book creator of *Sonambulo* and *Guns A' Blazin'*.

WILLIAM ANTHONY NERICCIO (aka Guillermo Nericcio García) is professor at San Diego State University as well as creator and curator of the traveling exhibit Mextasy. http://mextasy.blogspot.com/

BREENA NUÑEZ PERALTA is a musician and artist known for her zines and illustrations. She creates zines and art for the community. http://breenache.tumblr.com/

DAVID OLIVAREZ is an artist and a writer living known for *MALO, Dark Vigil,* and *Unearthed.*

DAVE ORTEGA is a cartoonist known for his series *Dias de Consuelo* about his abuela's young life in Mexico during the Mexican Revolution. He created an interactive educational comics project in collaboration with the Art Lab at the Institute of Contemporary Art in Boston. http://vivaortegacy.com/

AMBER PADILLA is an arts educator, a cartoonist, and an illustrator with an MFA in comics known for her comics *Ophelia, Old Man Manolo,* and *Real Love: A Catfish Story.* www.amberpadilla.com

RICARDO PADILLA is executive director and cofounder of the Latino Comics Expo. He is the creator of *Esperanza, A Journal of Latino/a Arts & Culture.* http://www.latinocomicsexpo.com/

DANIEL PARADA is artist, illustrator, and comic book creator known for his graphic novel *Zotz: Serpent and Shield,* which is set in an alternate history of Mesoamerica. http://www.zotzcomic.com/

ZEKE PEÑA is a cartoonist, an illustrator, and a painter who intermixes history with contemporary events. http://zpvisual.com/

CARLOS "LOSO" PÉREZ is a Dominican American Latinx comics creator with an MFA in sequential art. Loso is known for *Saint Love: City Funk, Cimarron Mountain,* and his work on *Lung Girl.* http://www.primevice.com/

JOHN PICACIO is a World Fantasy and Hugo Award–winning artist known for his work on George R. R. Martin's *A Song of Ice and Fire* series, among many others. He

is writing and illustrating a Loteria book coming to a future near you. www.johnpicacio.com

LILA QUINTERO WEAVER is author-illustrator of *Darkroom: A Memoir in Black and White*, the *Cuarto Oscuro*, and *My Year in the Middle*.

JULES RIVERA is an illustrator and a comic book creator known for *Valkyrie Squadron* and *Misfortune High* as well as work for IDW, Mattel, and Action Lab Entertainment. http://julesrivera.com/

GRASIELA RODRIGUEZ is an LA-based graphic artist, illustrator, independent animator, and founder of Not Your Friend Comic Books. Drawing from life experiences and people and their romantic feelings is a central theme throughout her work.

HÉCTOR RODRÍGUEZ is the creator of *El Peso Hero* and cofounder of Rio Bravo Comics and the Texas Latino Comic Con.

STEPHANIE RODRIGUEZ is illustrator and comic book creator known for *Igualita y tu mama* and *All I Want is Fruit,* among others. http://www.stephguez.com/

THERESA ROJAS is a professor at Modesto Junior College and an artist. http://people.mjc.edu/rojast

RAFAEL ROSADO is director, storyboard artist, animator, and cocreator of the *Giants Beware* graphic novel series.

MIGUEL ANGEL "MIKY" RUIZ creates comic books, paintings, drawings, prints, costumes, masks, installations, and performances. He draws inspiration from his Puerto Rican culture and its place within the broader American art scene. Miky currently serves as art instructor to children after school and seniors at community centers in New York City. www.miguelangelruizus.ipage.com

CARLOS SALDAÑA is a comic book creator known for his comic *Burrito.* He is also a member for twenty-five years of the National Cartoonist Society (NCS) and the Comic Art Professional Society (CAPS). http://www.toonist.com/burrito.html

SERENITY SERSECIÓN is a professor and a creator of LGBTQ and Latinx comics such as *Serenity's Dream.*

ILAN STAVANS is a professor as well as publisher of Restless Books and cocreator of *Latino USA: A Cartoon History* (with Lalo Alcaraz), *Mister Spic Goes to Washington* (with Roberto Weil), *A Most Imperfect Union* (with Lalo Alcaraz), and *Angelitos* (with Santiago Cohen, also available in the Latinographix series from Mad Creek Books).

SAMUEL TEER is cocreator of the all-ages graphic novel *VEDA: Assembly Required.* www.crapcatch.com

IVAN VELEZ is an educator and a comic book creator who uses cartooning to help raise awareness about the LGBTQ community and to create social change. He is known for his LGBTQ youth-oriented *Tales of the Closet,* his work for Marvel and DC, and his comic series *The Ballad of Wham Kabam.* www.planetbronx.com

ANDRÉS VERA MARTÍNEZ is illustrator and comic book creator known for his award-winning graphic novel *Little White Duck: A Childhood in China.* He has illustrated for the *New York Times,* Scholastic, Simon & Schuster, CBS/Showtime, and ESPN, and his work has been recognized by The Society of Illustrators. http://www.andresvera.com/

STEPHANIE VILLARREAL MURRAY is an educator and a creator and publisher of comics out of Michigan.

DARRELL "DT" WATSON is an illustrator, a storyboard artist for Nickelodeon, and a comic book creator with training in Nickelodeon's Artist Program. He holds an MFA in comics from the California College of the Arts in San Francisco.

ROBERTO WEIL is an internationally known, award-winning plastic artist from Caracas, Venezuela. His work has been exhibited in the United States and Europe. www.WEIL.com.ve

RAY ZEPEDA JR. is creator of comic books such as *AntiHero 113* and *Tragic Hero Comics*.

## LATINOGRAPHIX
### Frederick Luis Aldama, Series Editor

This series showcases trade graphic and comic books—graphic novels, memoir, nonfiction, and more—by Latinx writers and artists. The series aims to be rich and complex, bringing on projects with any balance of text and visual narrative, from larger graphic narratives to collections of vignettes or serial comics, in color and black and white, both fiction and nonfiction. Projects in the series take up themes of all kinds, exploring topics from immigration to family, education to identity. The series provides a place for exploration and boundary pushing and celebrates hybridity, experimentation, and creativity. Projects are produced with quality and care and exemplify the full breadth of creative visual work being created by today's Latinx artists.

*Tales from la Vida: A Latinx Comics Anthology*
Edited by Frederick Luis Aldama

*Drawing on Anger: Portraits of U.S. Hypocrisy*
Eric J. García

*Angelitos: A Graphic Novel*
Ilan Stavans and Santiago Cohen

*Diary of a Reluctant Dreamer: Undocumented Vignettes from a Pre-American Life*
Alberto Ledesma